ILLINOIS
ACROSS THE LAND

ILLINOIS
ACROSS THE LAND

Lee Mandrell *and* DeeDee Niederhouse-Mandrell

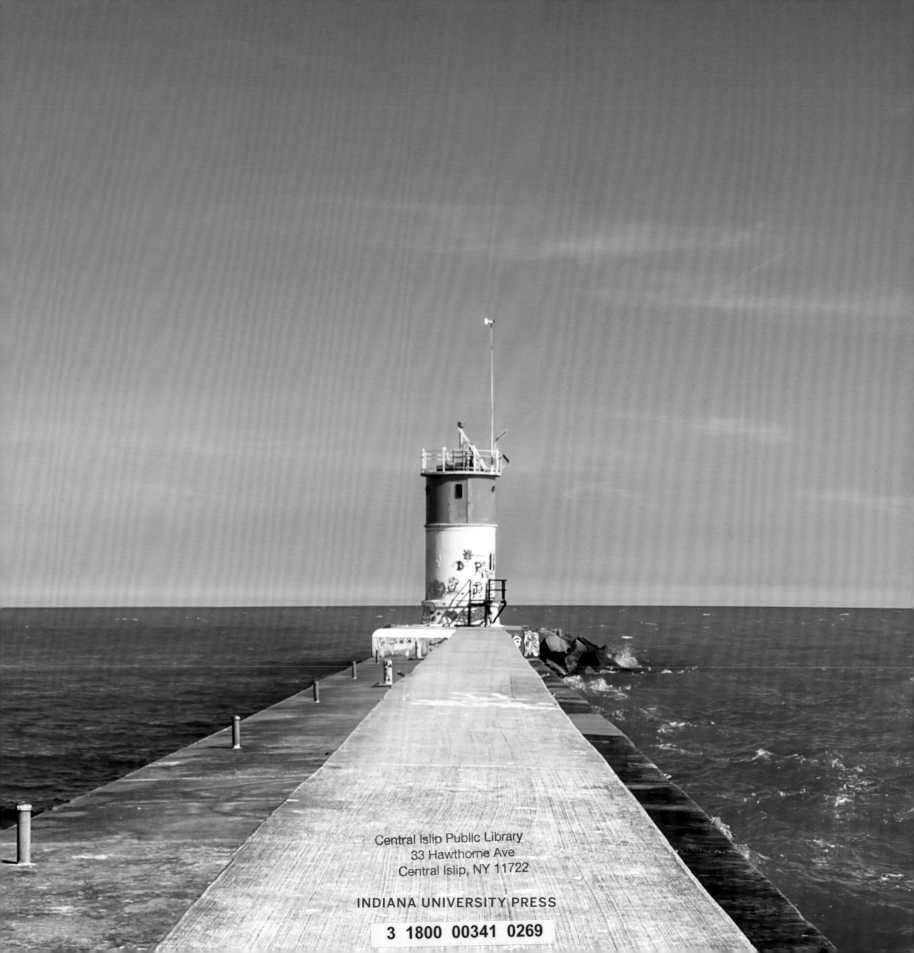

This book is a publication of

Indiana University Press
Office of Scholarly Publishing
Herman B Wells Library 350
1320 East 10th Street
Bloomington, Indiana 47405 USA

iupress.indiana.edu

This book is printed on acid-free paper.

Manufactured in China

Cataloging information is available
from the Library of Congress.

ISBN 978-0-253-03428-1 (cloth)
ISBN 978-0-253-03431-1 (ebook)

1 2 3 4 5 23 22 21 20 19 18

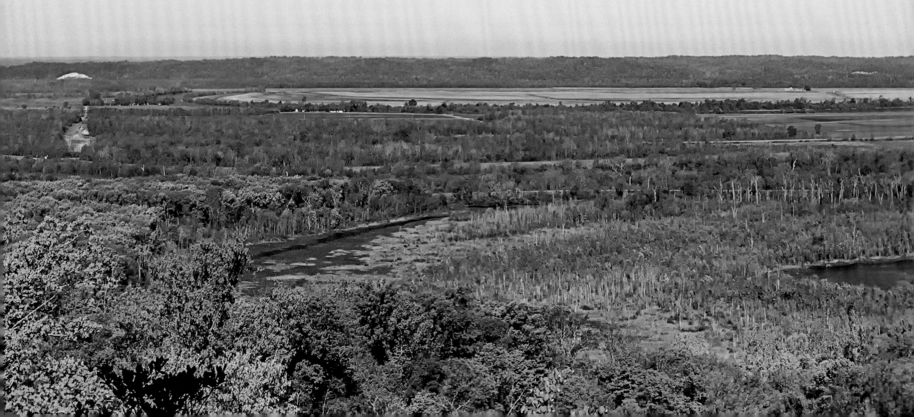

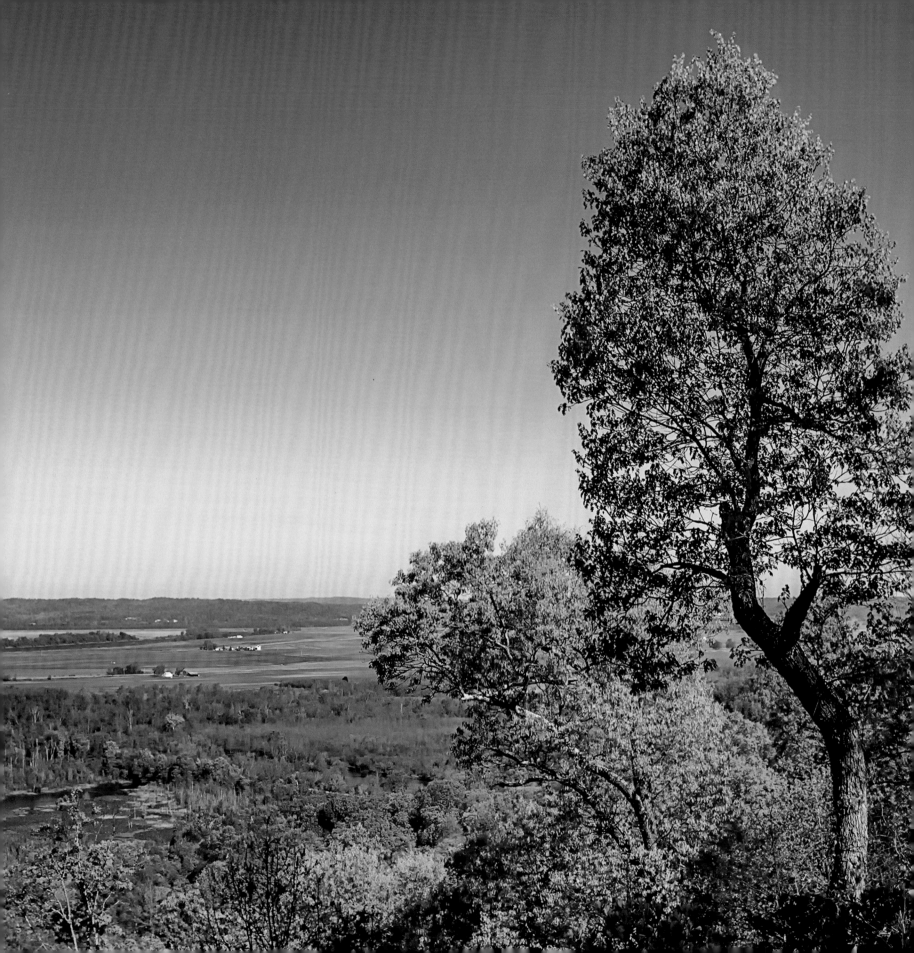

CONTENTS

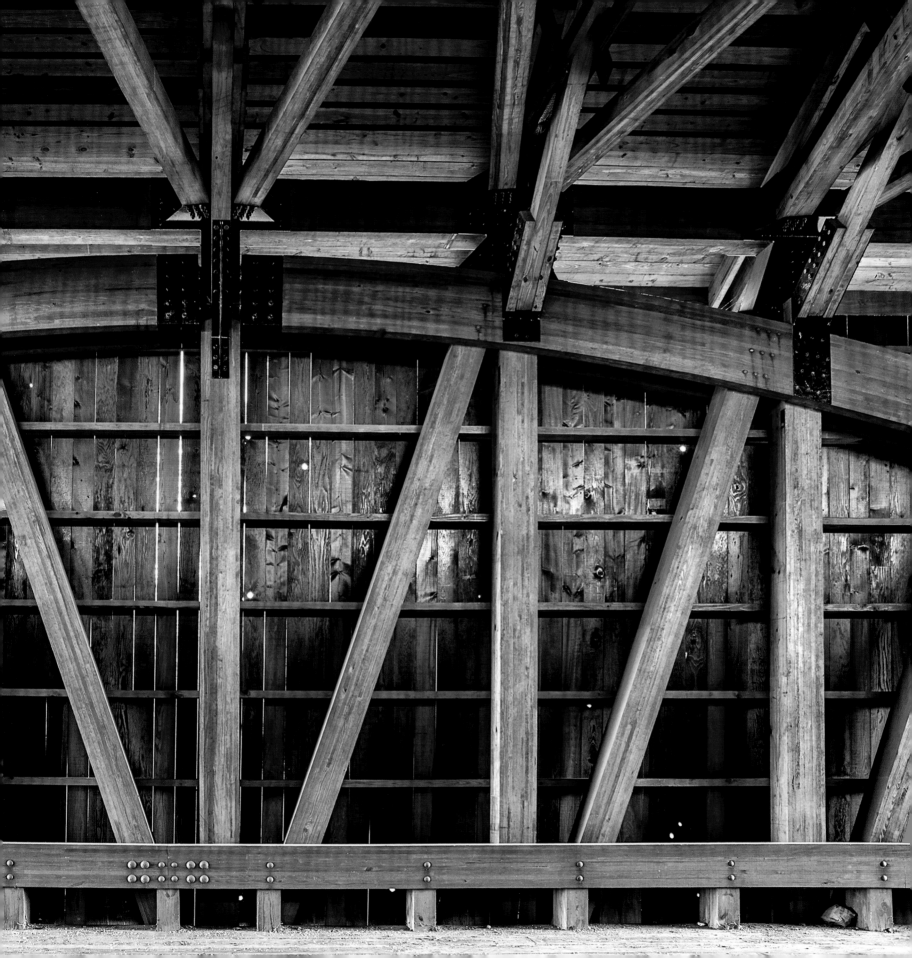

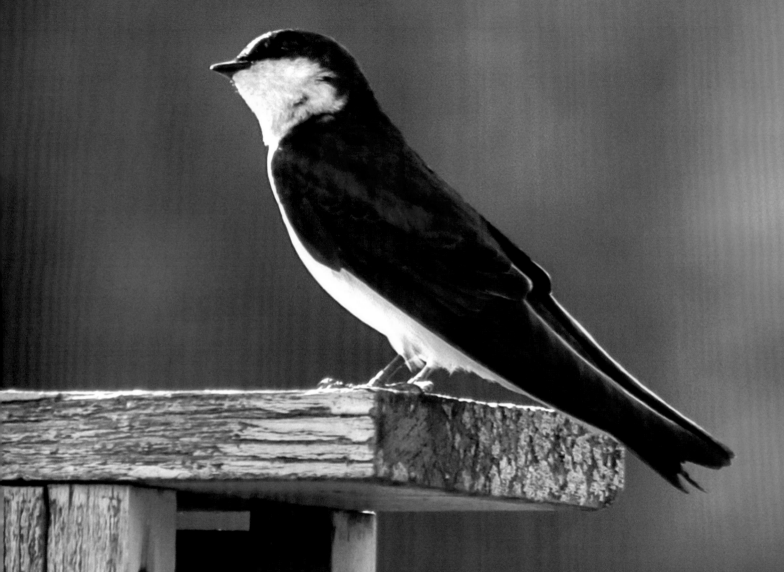

ACKNOWLE

From Lee:

Randy, Roxanne, Tiffany and Samantha, thanks for all you have done
over the years. I appreciate you more than you know.

Cousin Vicki, thanks for all of the instant weather texts and calls to help us get the shots!

From DeeDee:

Ashley and Daniel,
As a Mom you always hope to inspire your children to be creative in who they are. I certainly
am no different. However, I never expected to feel that I am the one who is inspired.
You both have inspired me in more ways than I can count! Thank you, I love you!

From Lee and DeeDee:

The staff at IU Press: we can't say thank you enough to each of you. We appreciate
the attention to detail, all of the honest feedback, and helping us to make the best
books we can possibly make. It really is a good collaboration. Thank you all.

All of the people that live in the great state of Illinois: we hope everyone enjoys
the results of our efforts and gets out to enjoy all that the state has to offer.

DGMENTS

ILLINOIS
ACROSS THE LAND

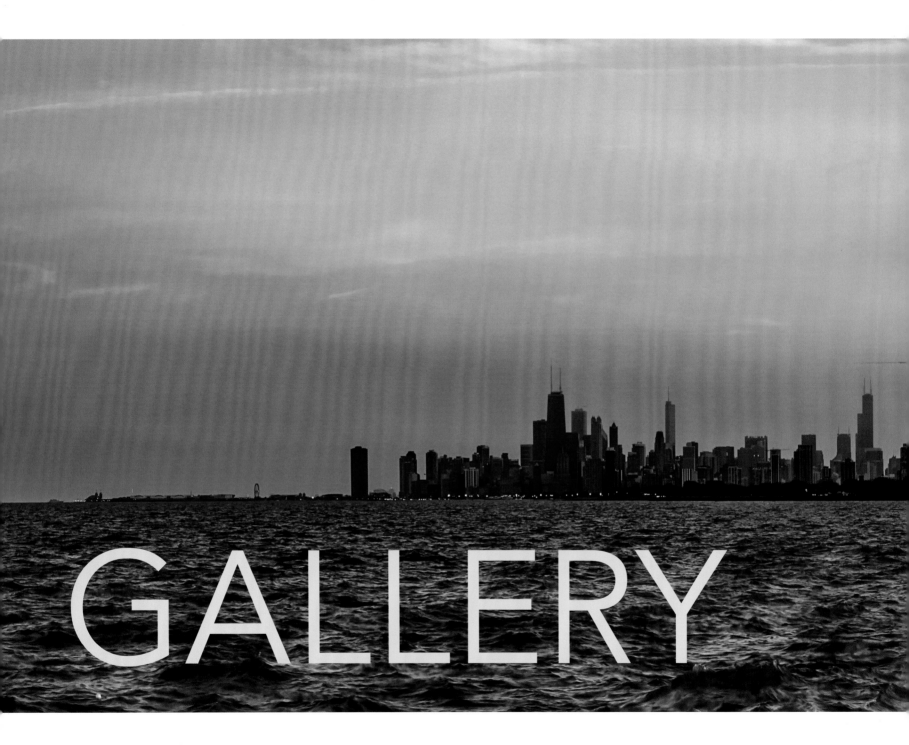

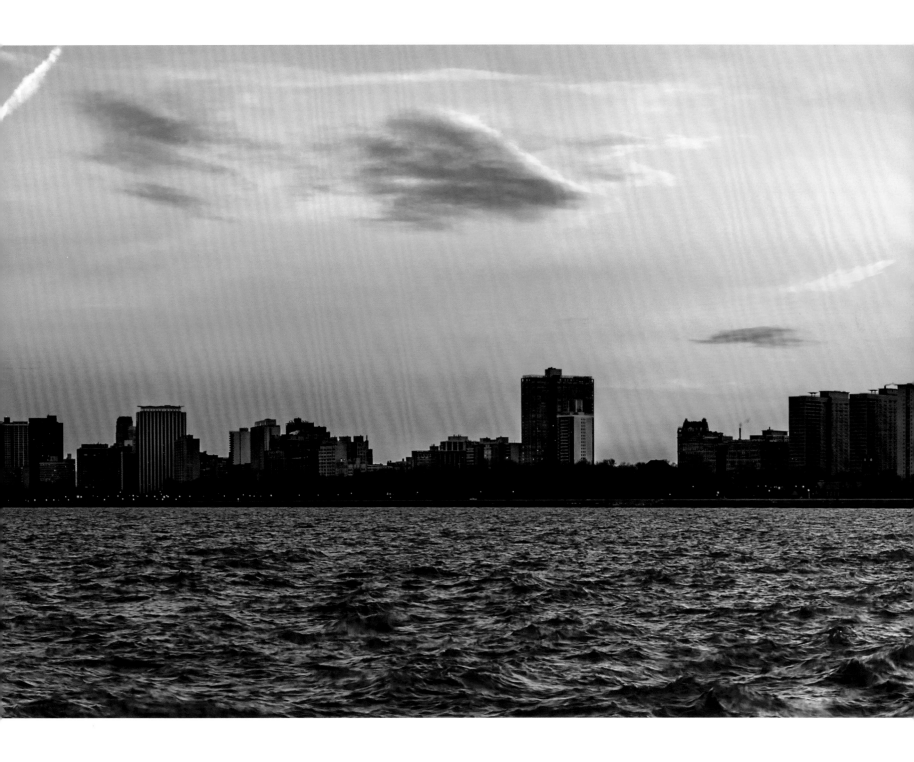

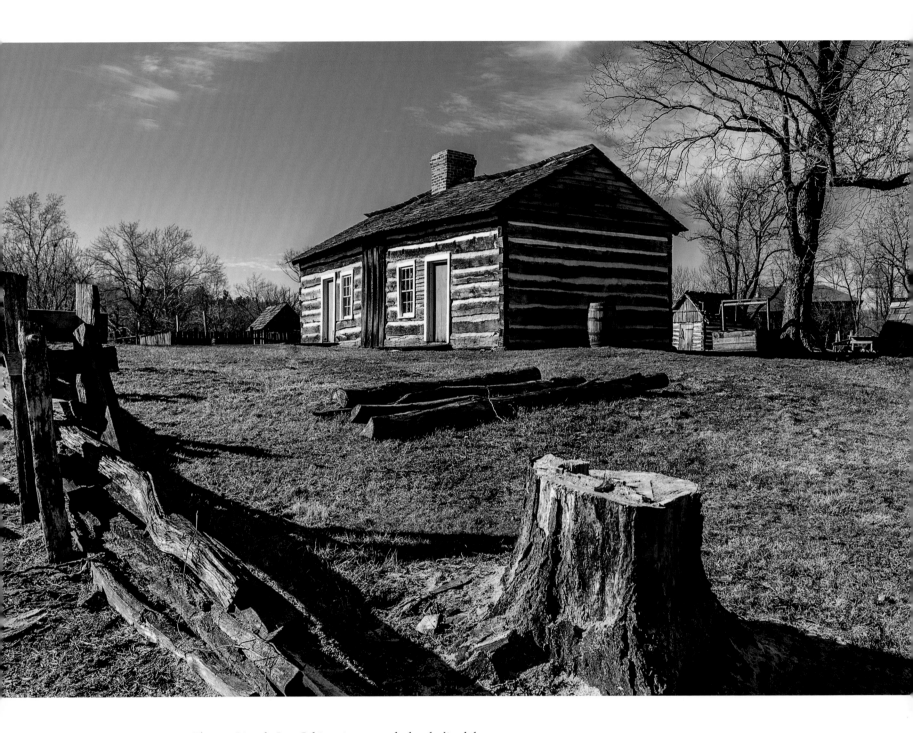

Thomas Lincoln Log Cabin as it appeared when he lived there.

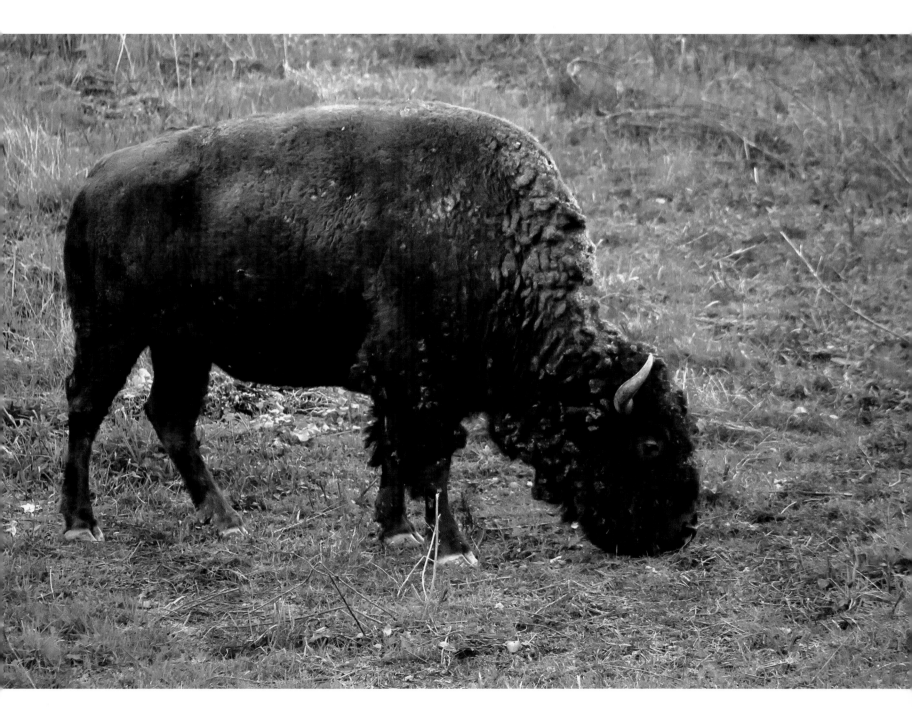

A lone buffalo grazes at Buffalo Rock State Park.

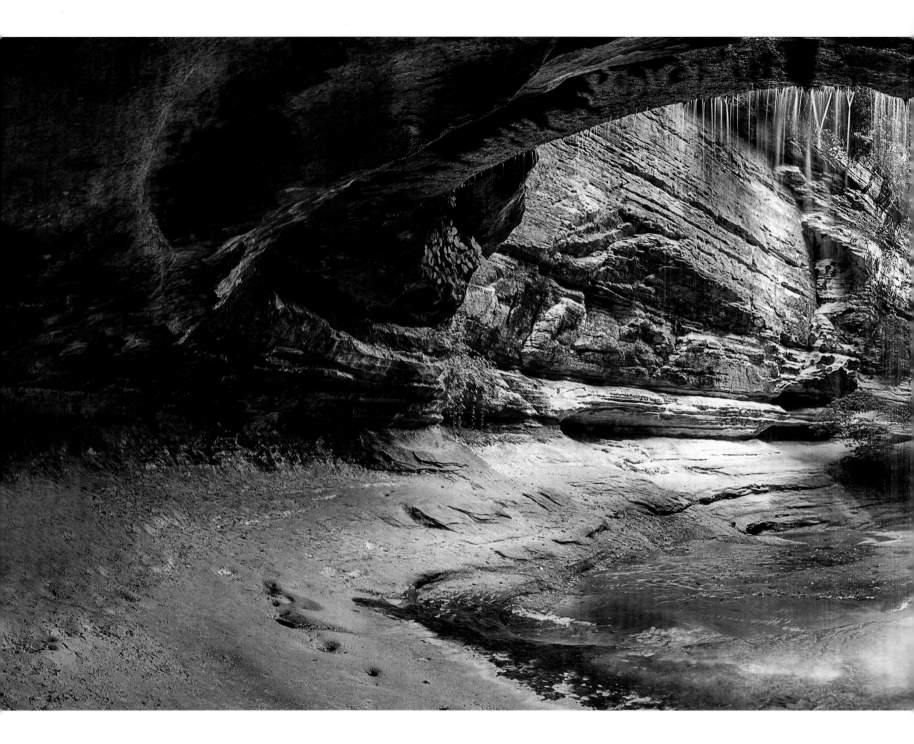

Under the waterfall at LaSalle Canyon. *Starved Rock State Park*

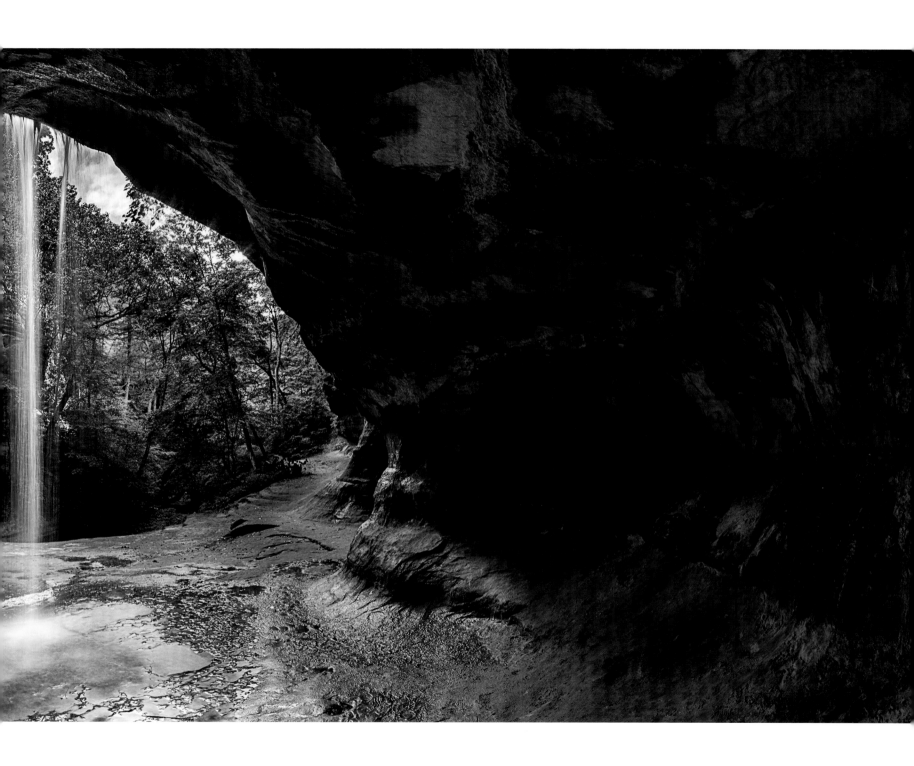

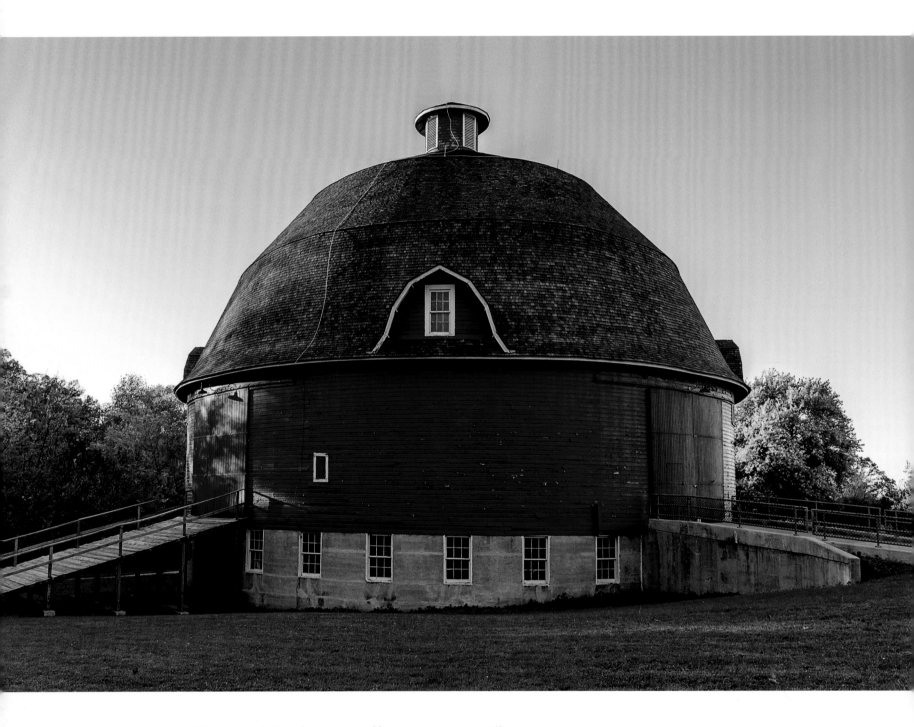

Historic Ryan's Round Barn is one of forty-two remaining in Illinois.

One of the many statues adorning President Lincoln's Tomb.

Early morning sun peeks through the trees. *Henderson Recreation Area*

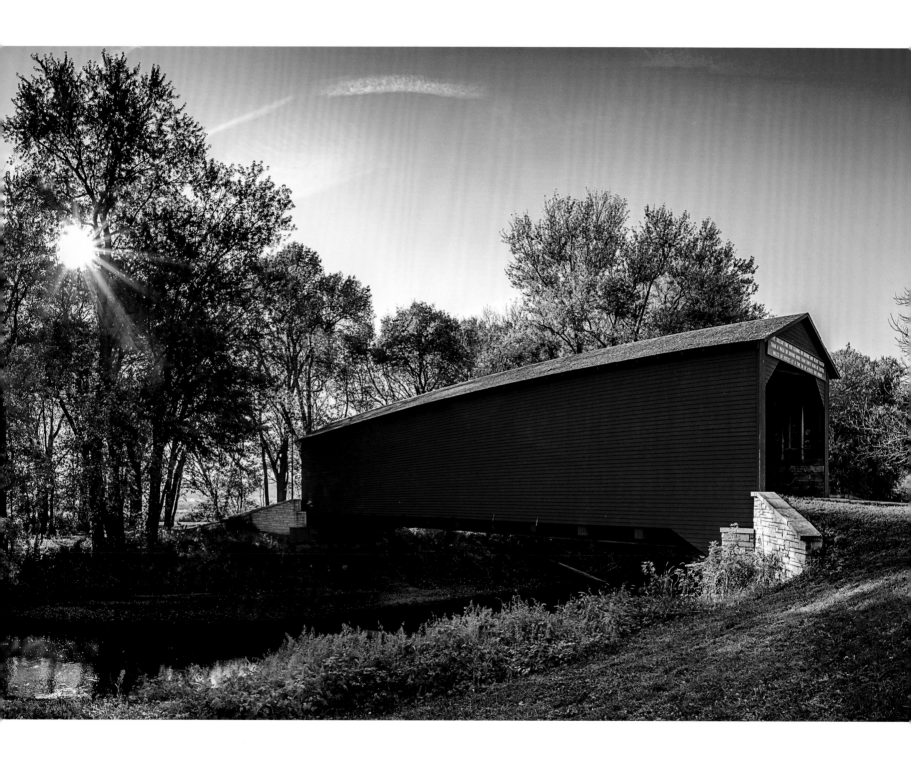

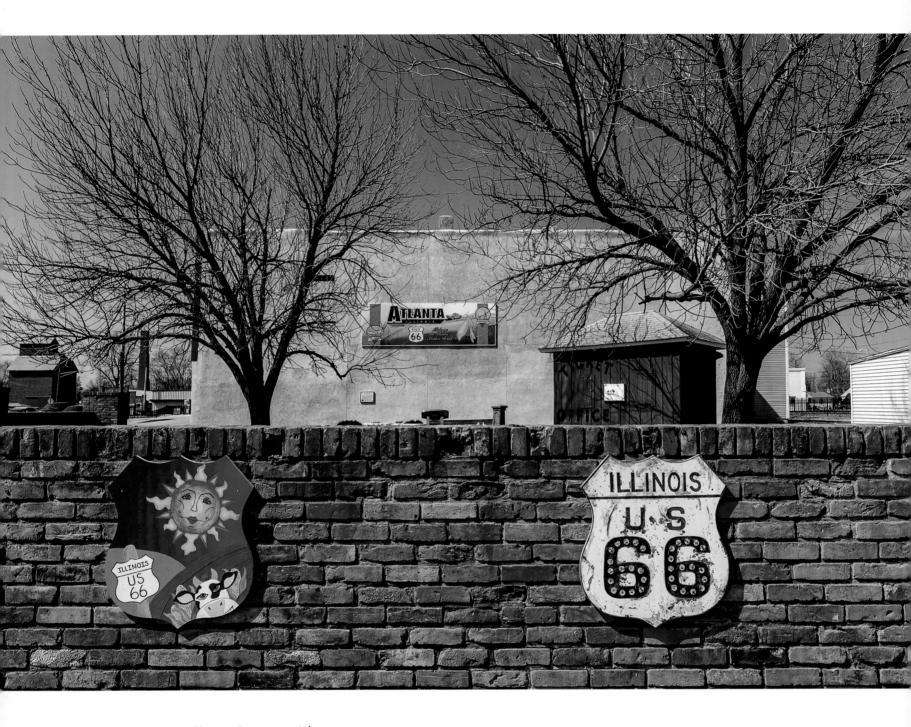

Historic Route 66 in Atlanta.

FACING Summer is almost here. *Fox Lake*

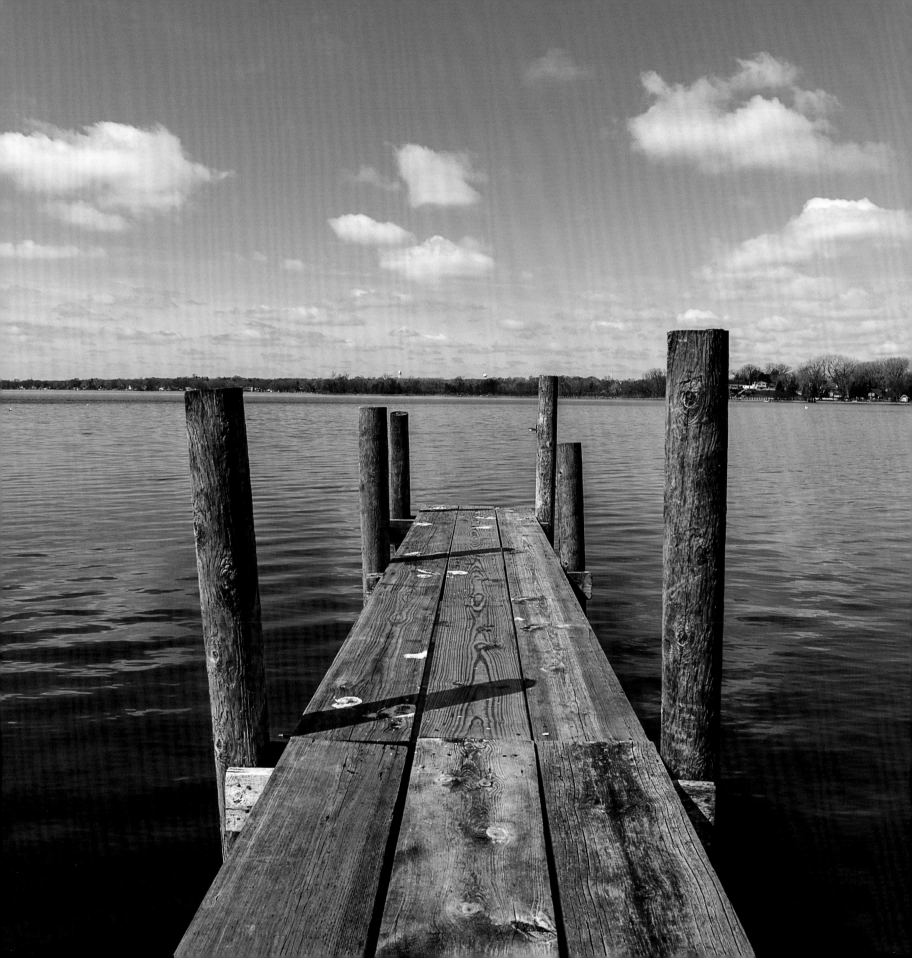

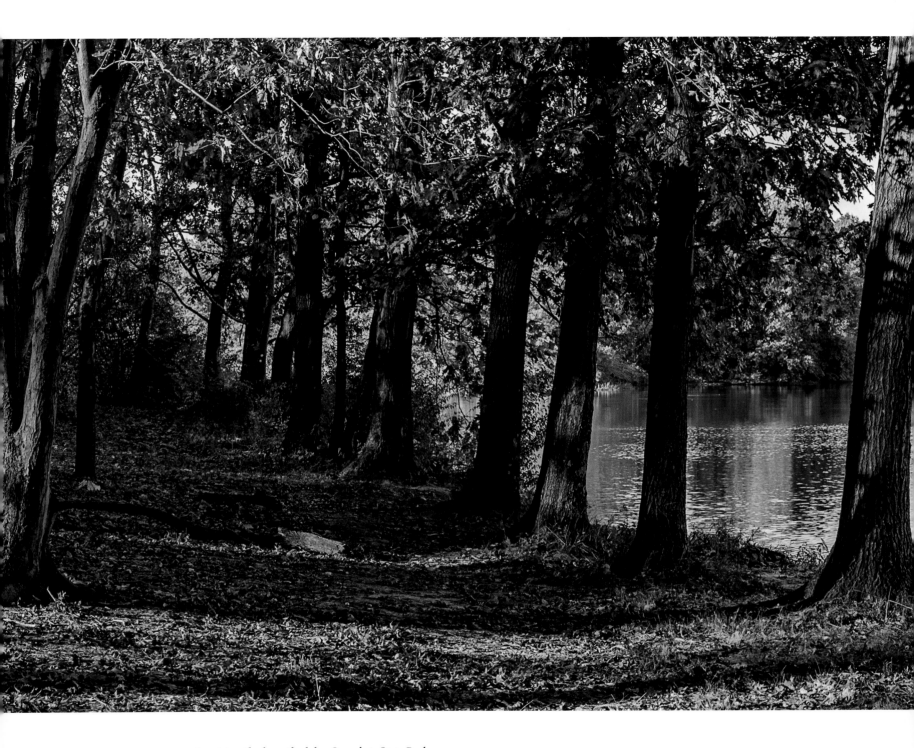

A quiet path along the lake. *Sangchris State Park*

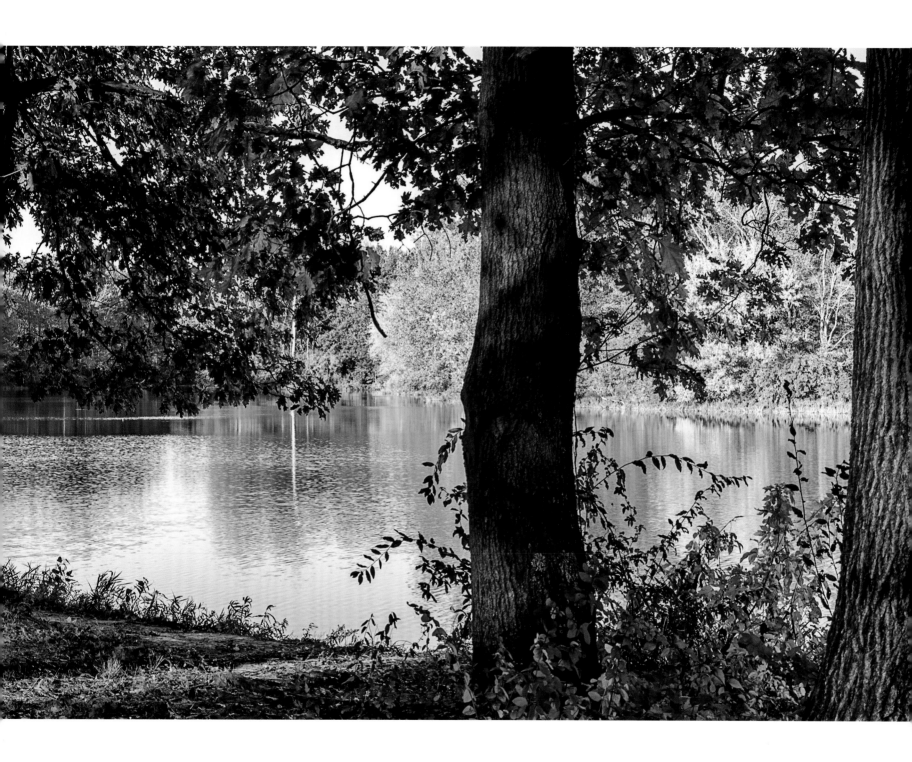

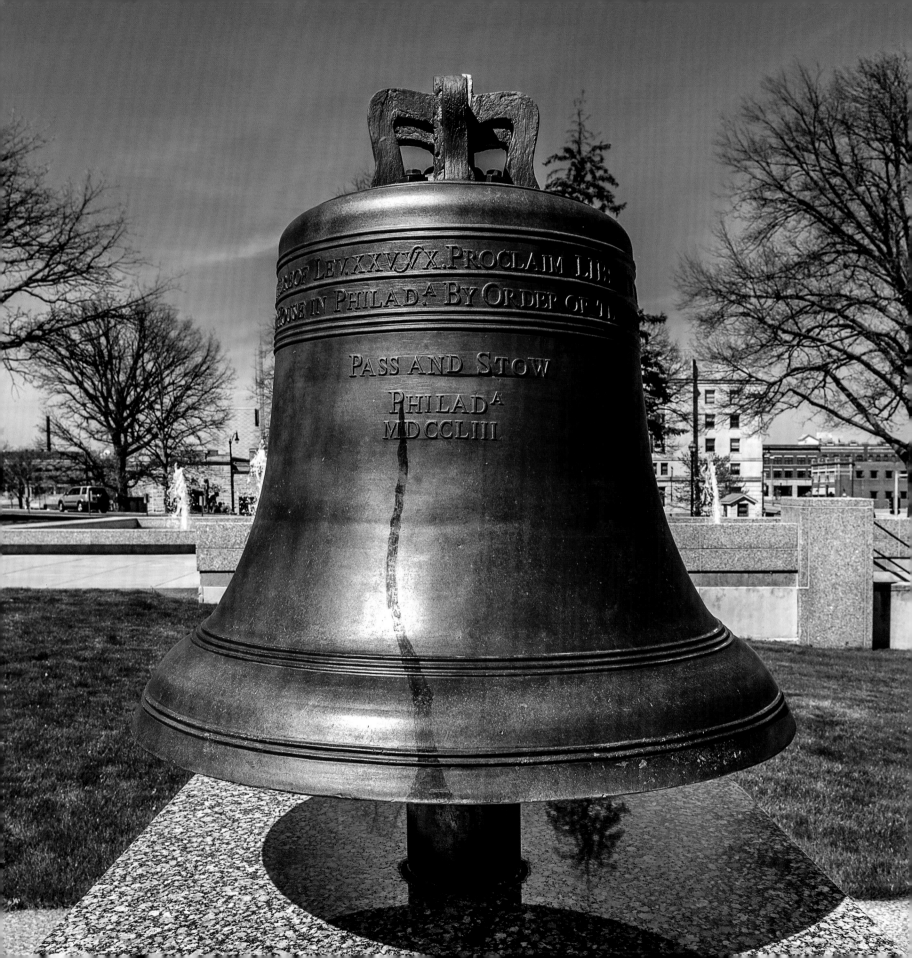

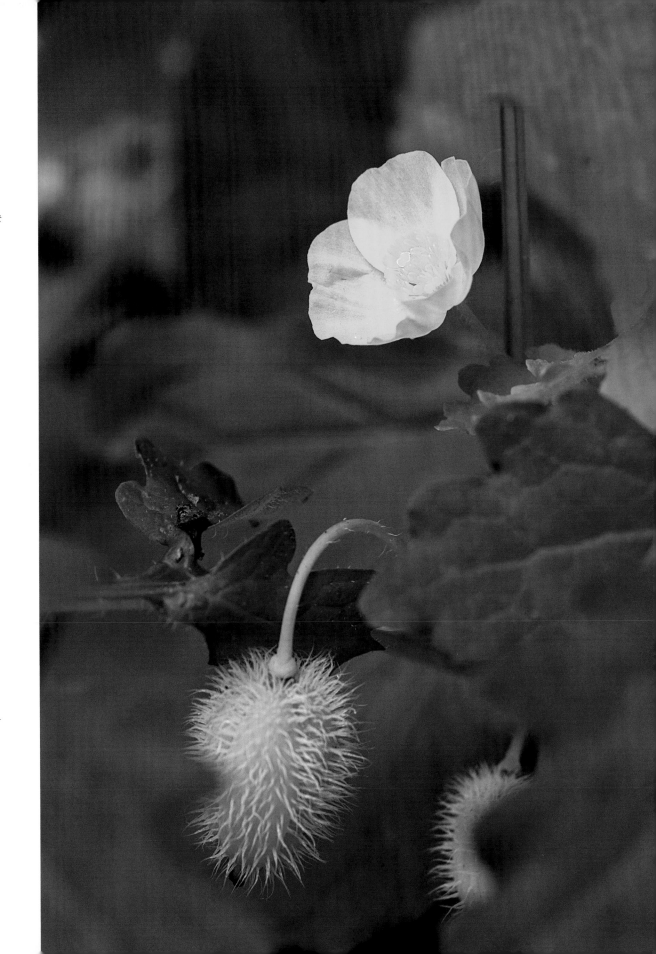

A colorful spring
wildflower. *Giant
City State Park*

FACING
Rich in history,
Springfield has
a replica Liberty
Bell. *Springfield
State Capital*

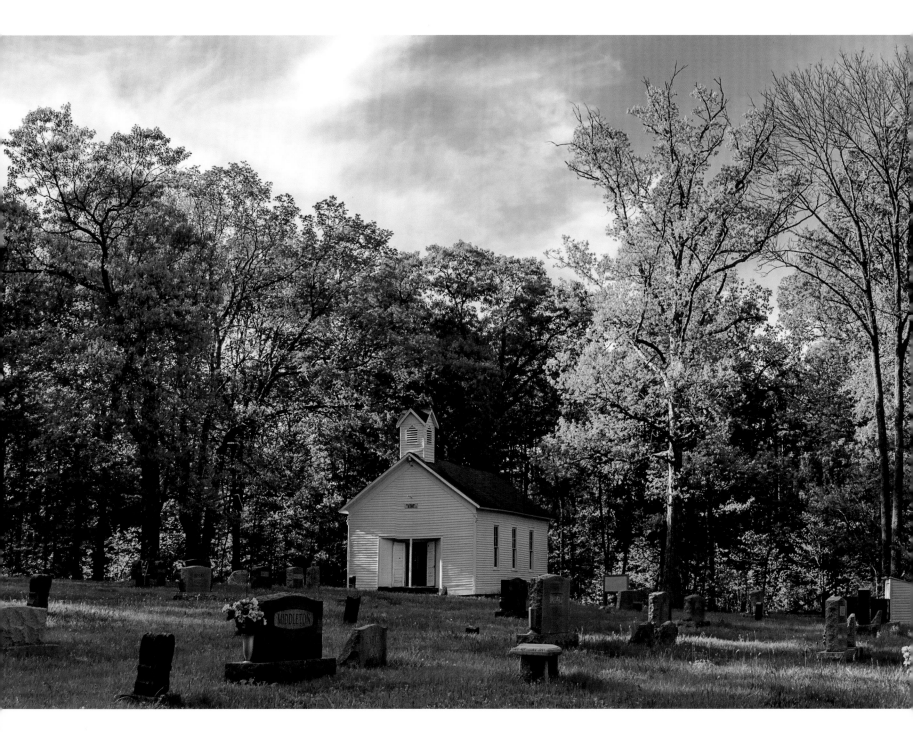

Historic Pleasant Ridge Church in the Shawnee National Forest.

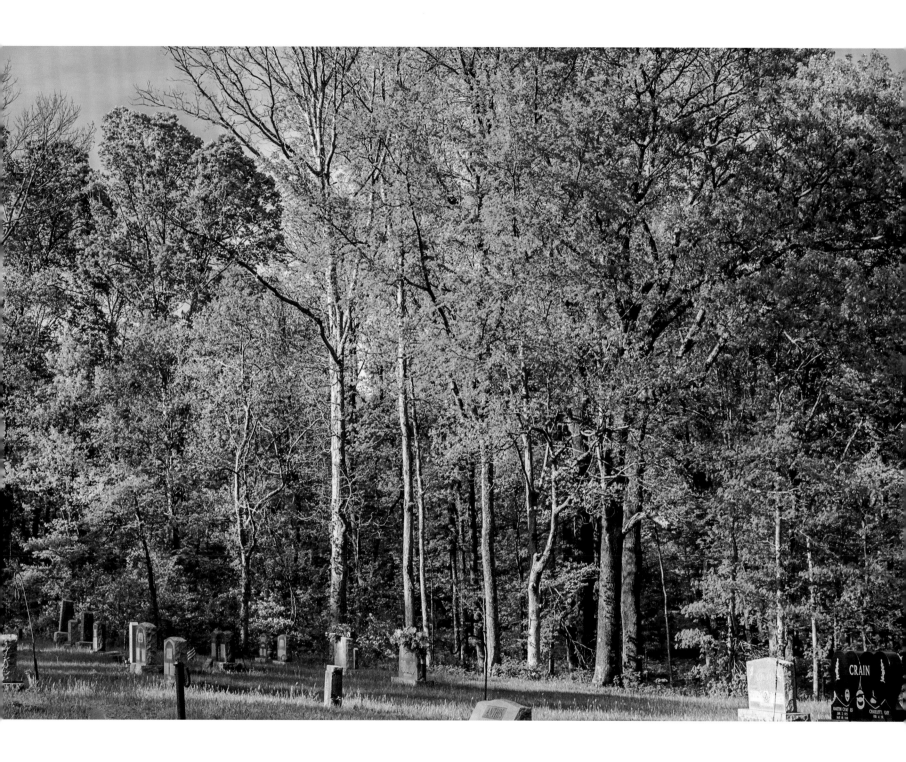

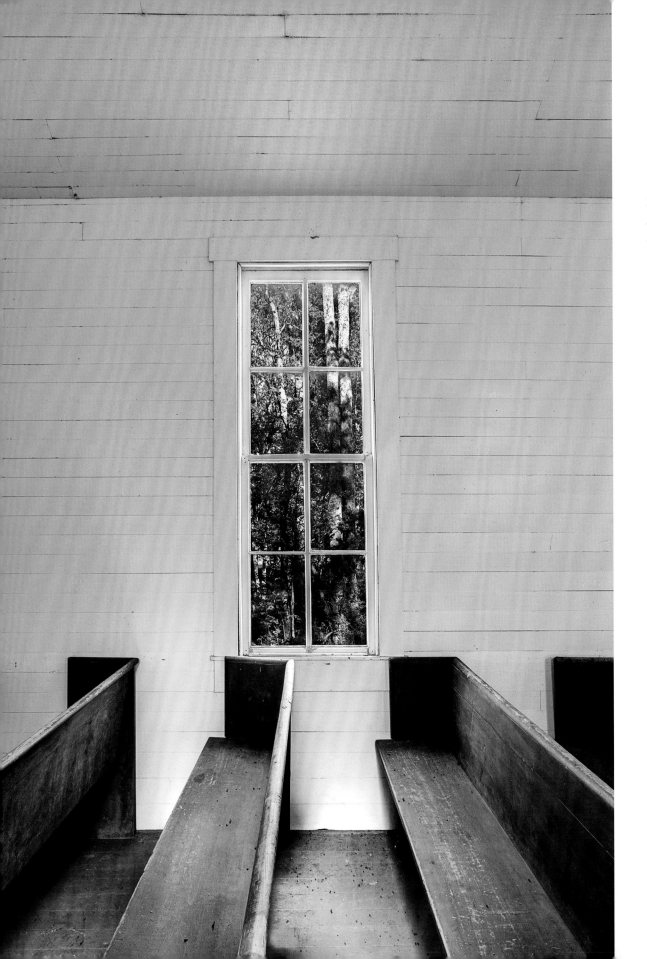

Pews and ladybugs.
Historic Pleasant
Ridge Church

Whitetail deer
are abundant in
the Crab Orchard
Wildlife Refuge.

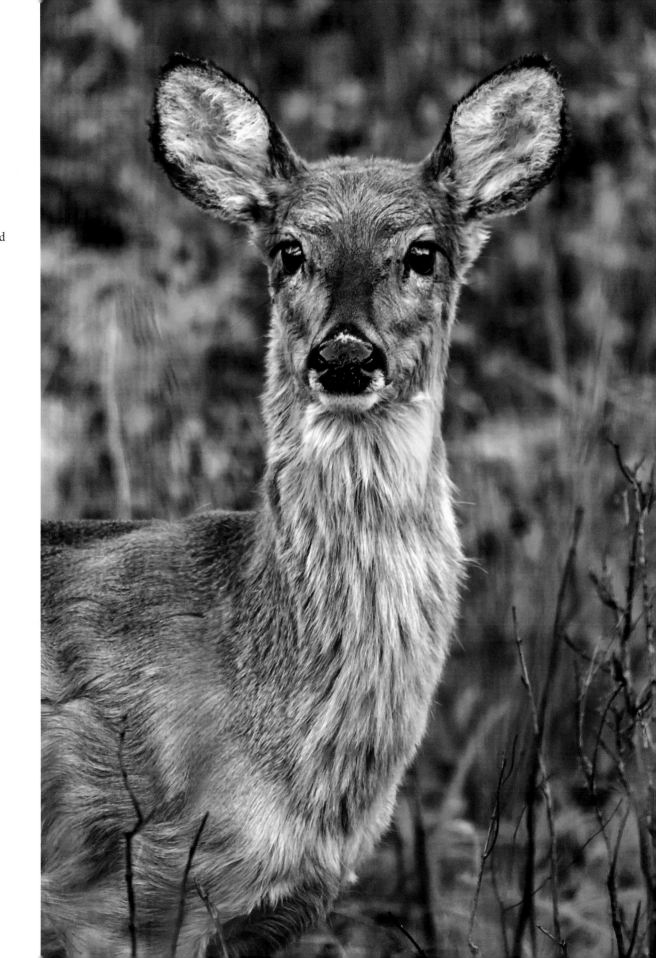

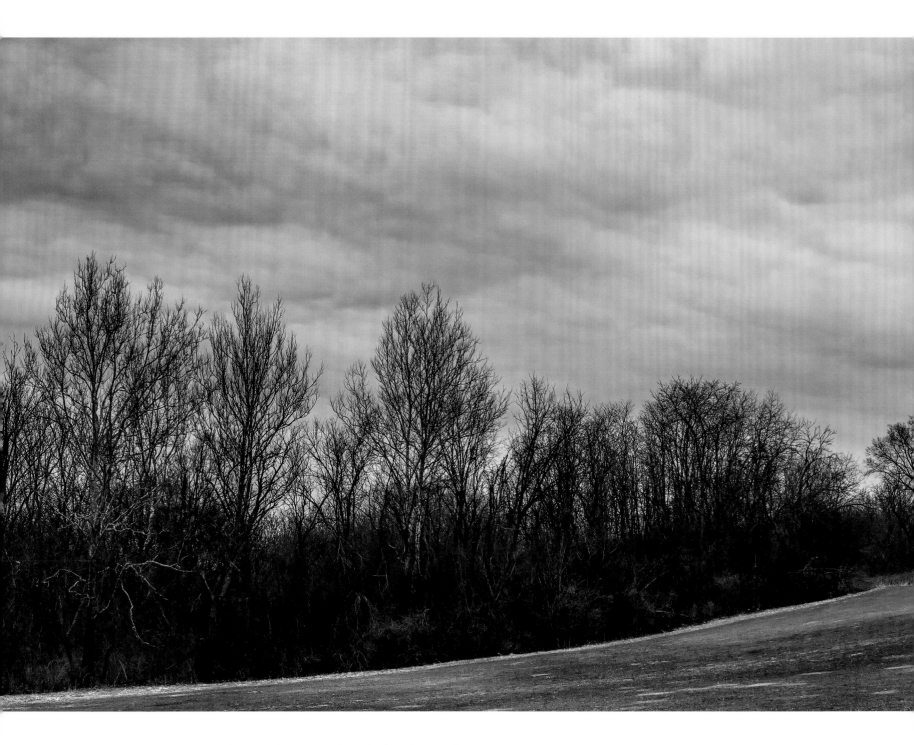

An authentic mid-1800s Dutch windmill. *Fabyan Park*

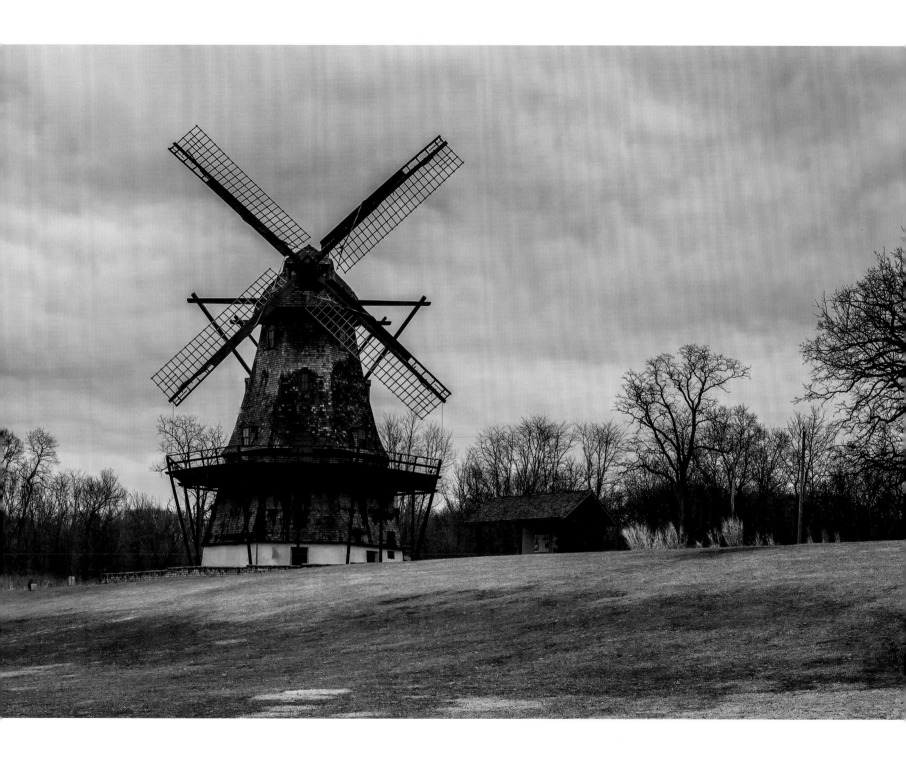

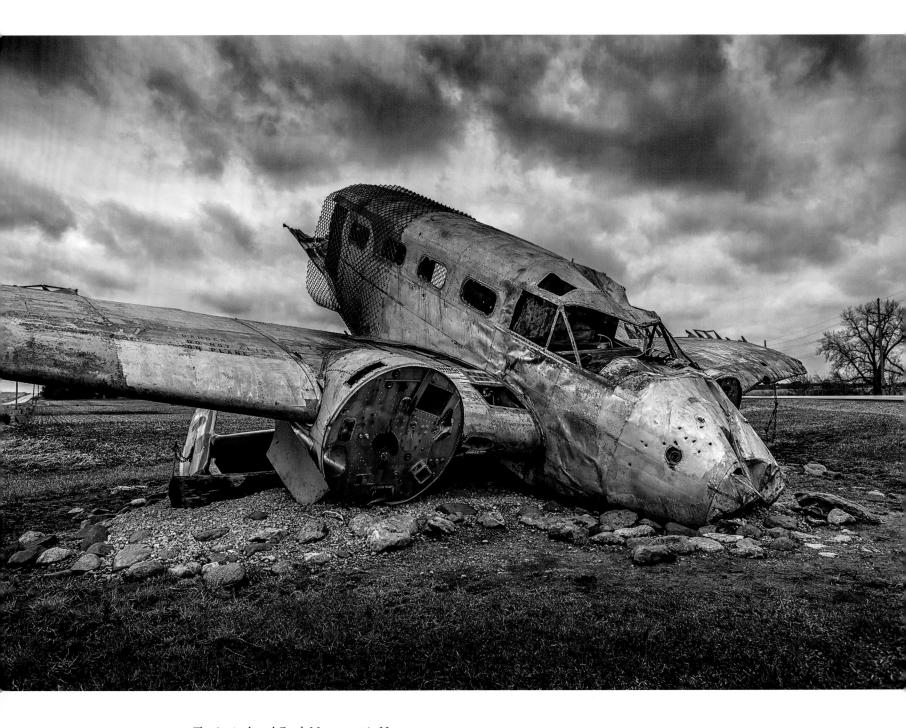

The Agricultural Crash Monument in Norway.

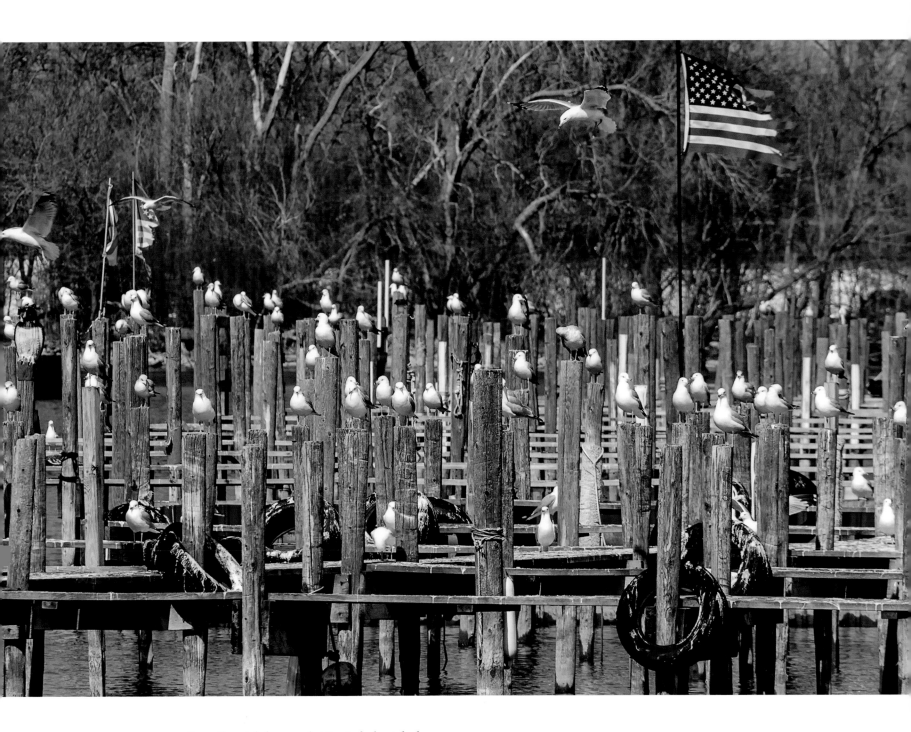

Seagulls watch for a meal at Fox Lake boat dock.

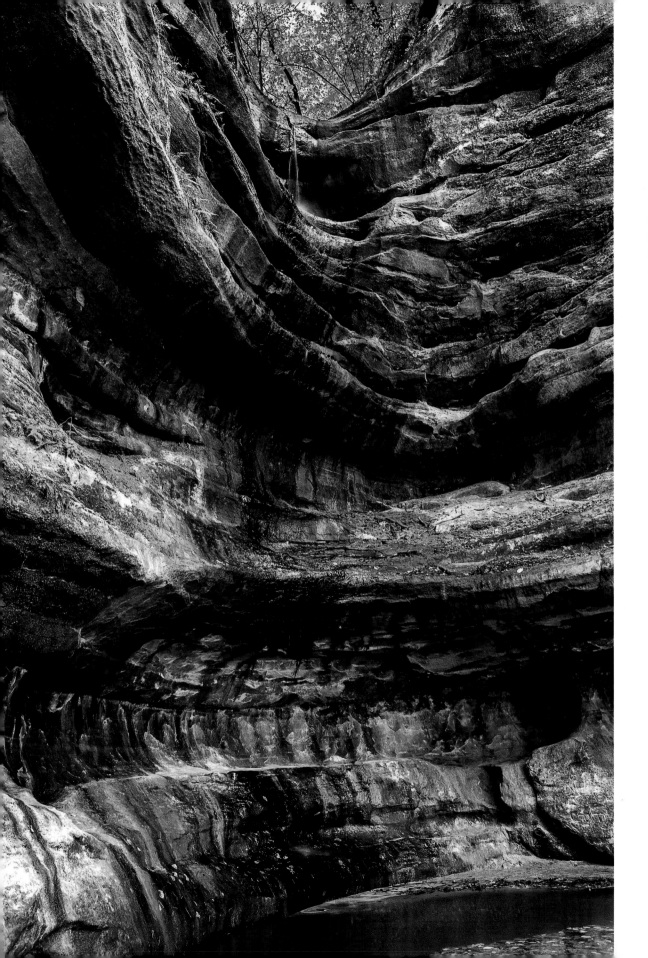

The falls are dry
in late fall at St.
Louis Canyon.
*Starved Rock
State Park*

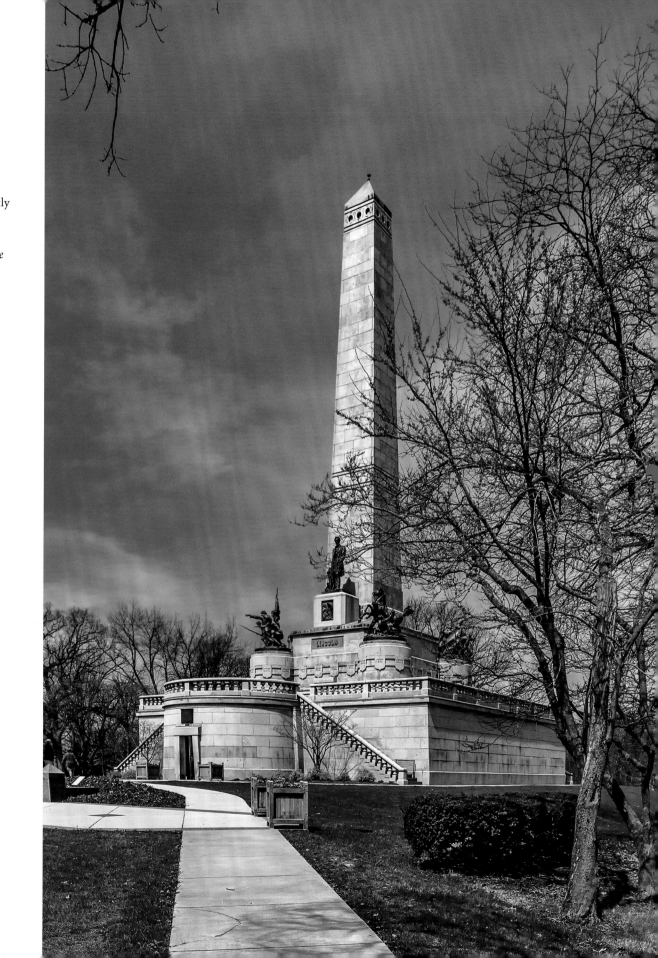

Redbuds perfectly
frame the scene.
*Lincoln Tomb
State Historic Site*

Land and water meet at Stephen Forbes State Park.

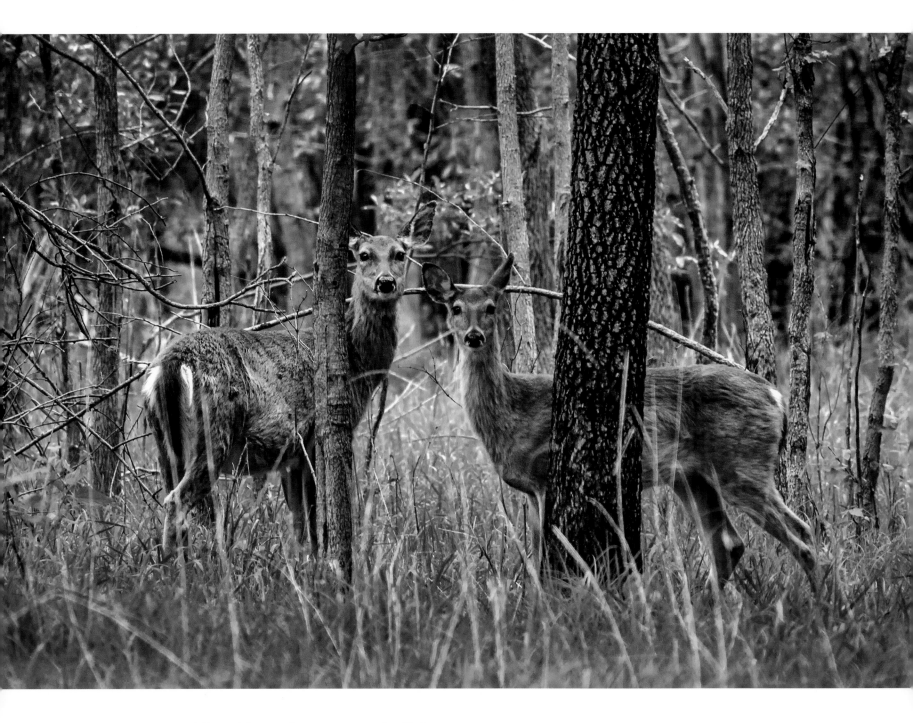

Whitetail deer watch our every move. *Rend Lake*

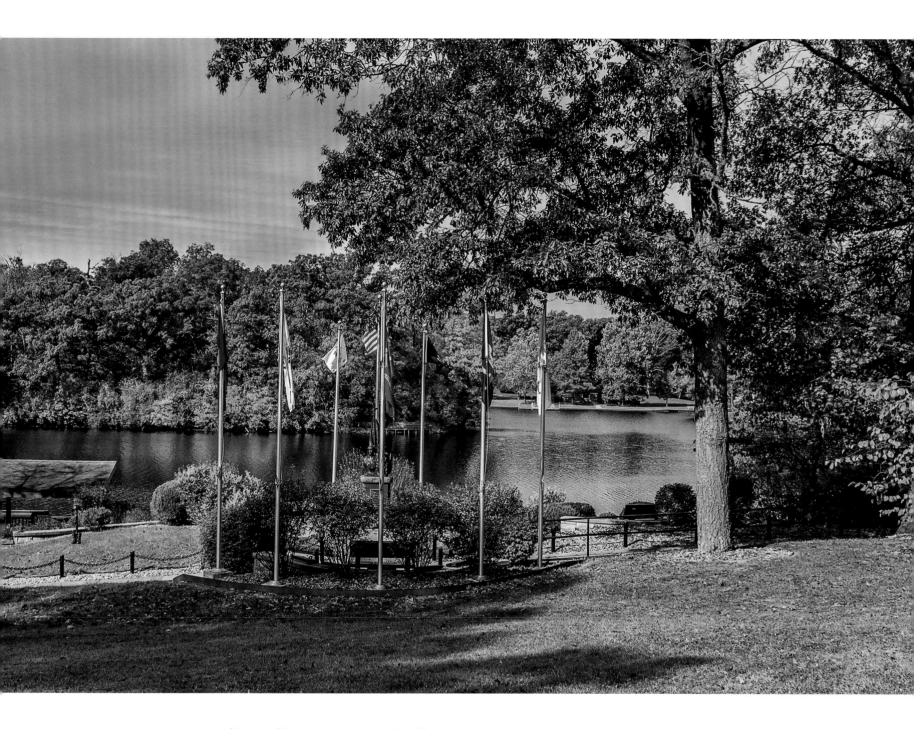

A peaceful view of the Veterans Memorial. *Weldon Springs*

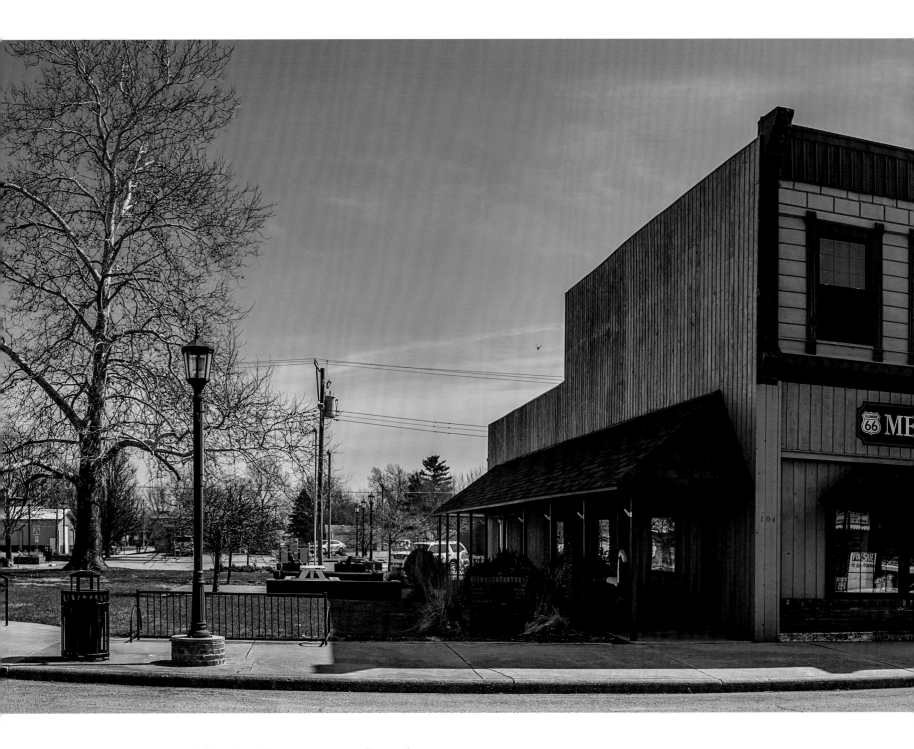

Atlanta along Route 66 is pure small town charm.

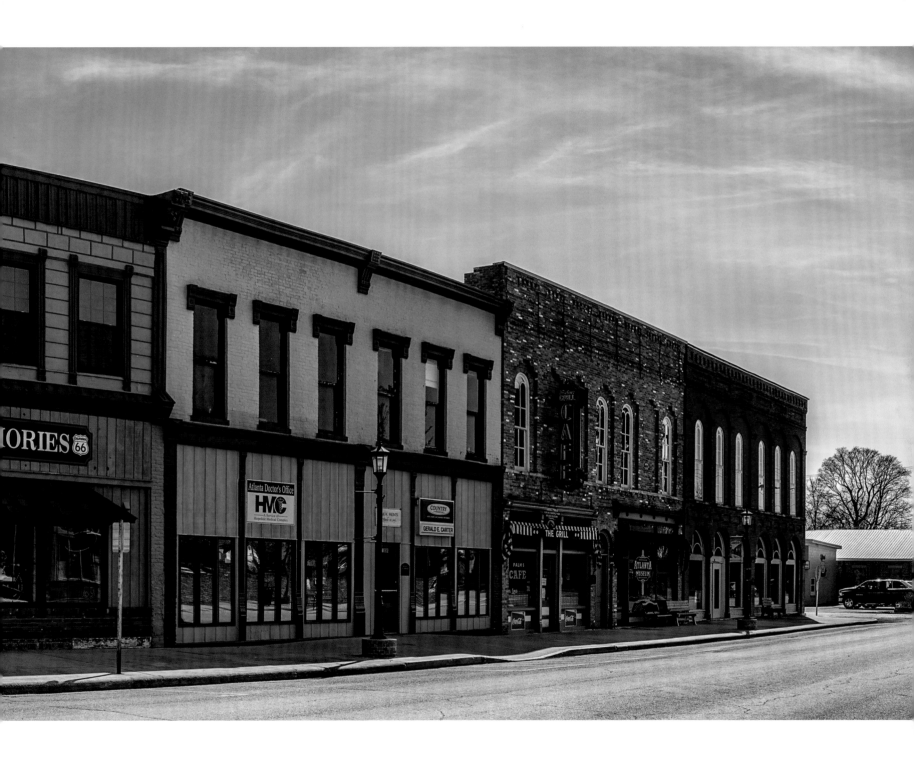

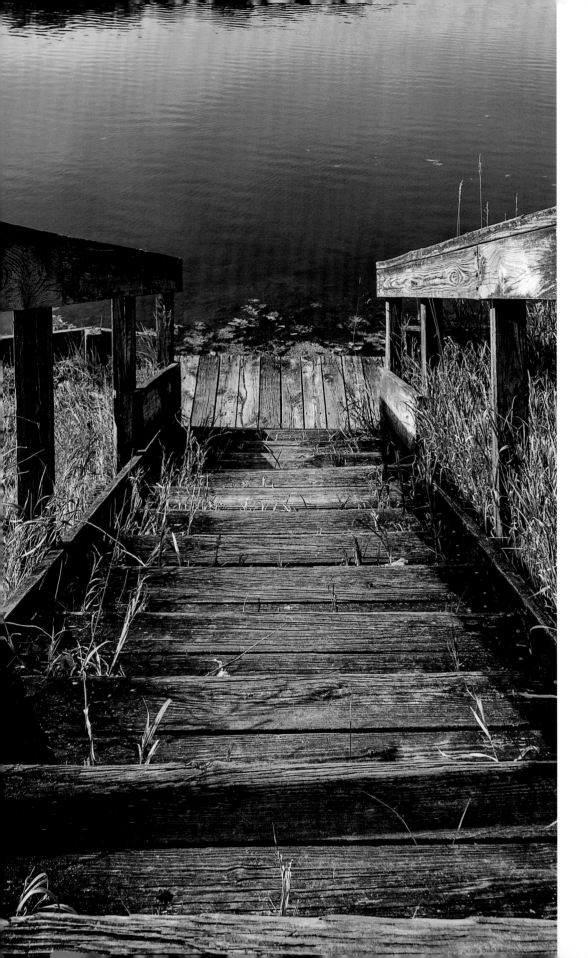

Fishing is merely a few steps away. *Weldon Springs State Park*

FACING A leaf that appears to defy gravity. *Starved Rock State Park*

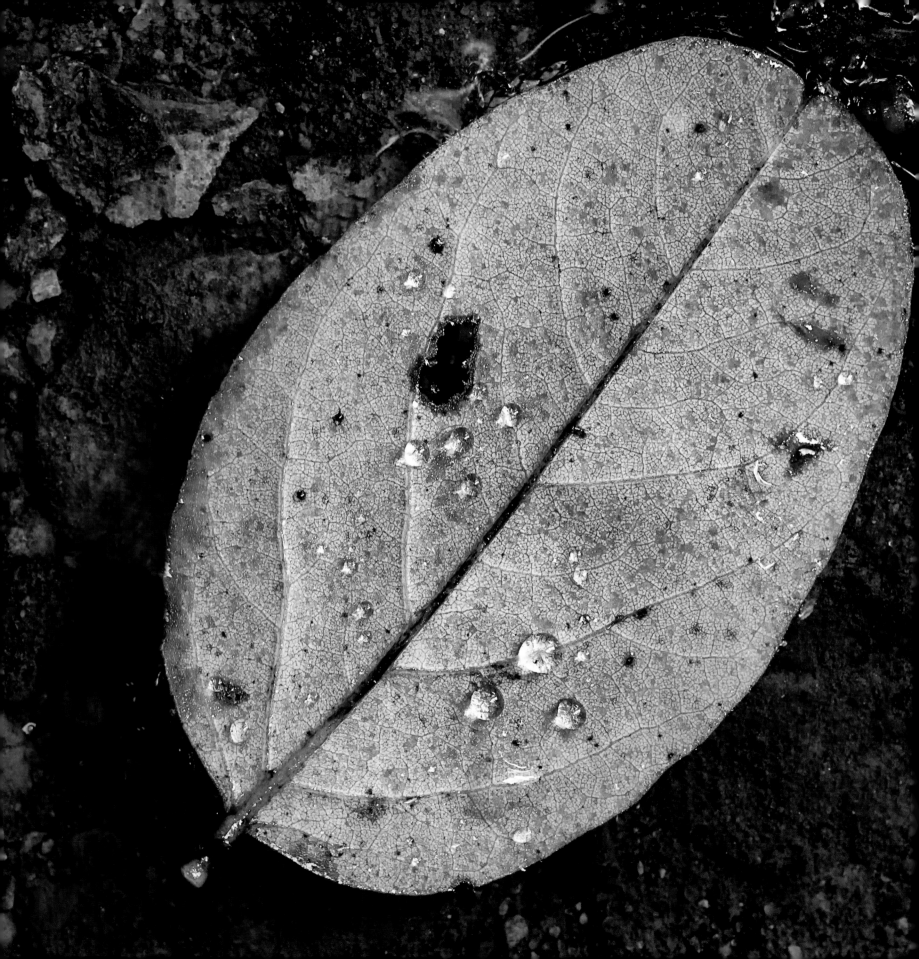

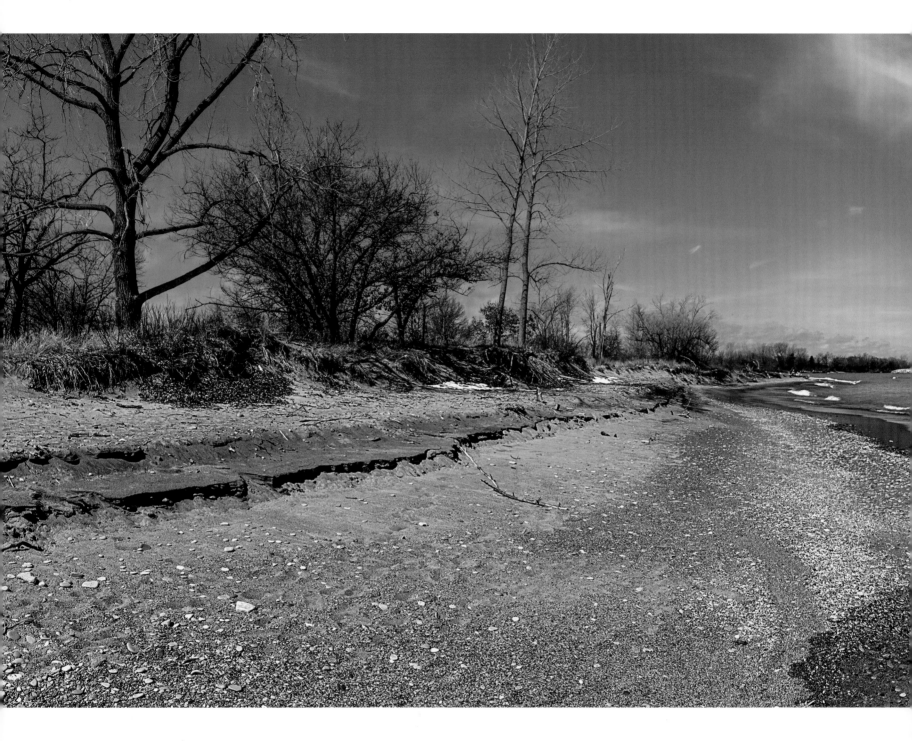

Lake Michigan rolls onto many beaches in northern Illinois.

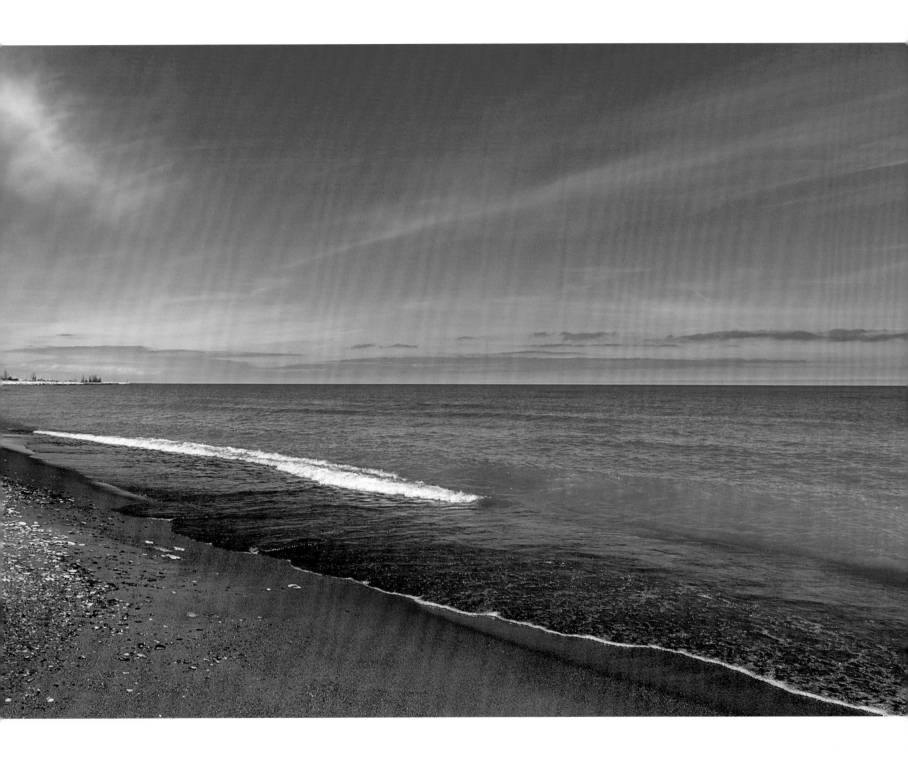

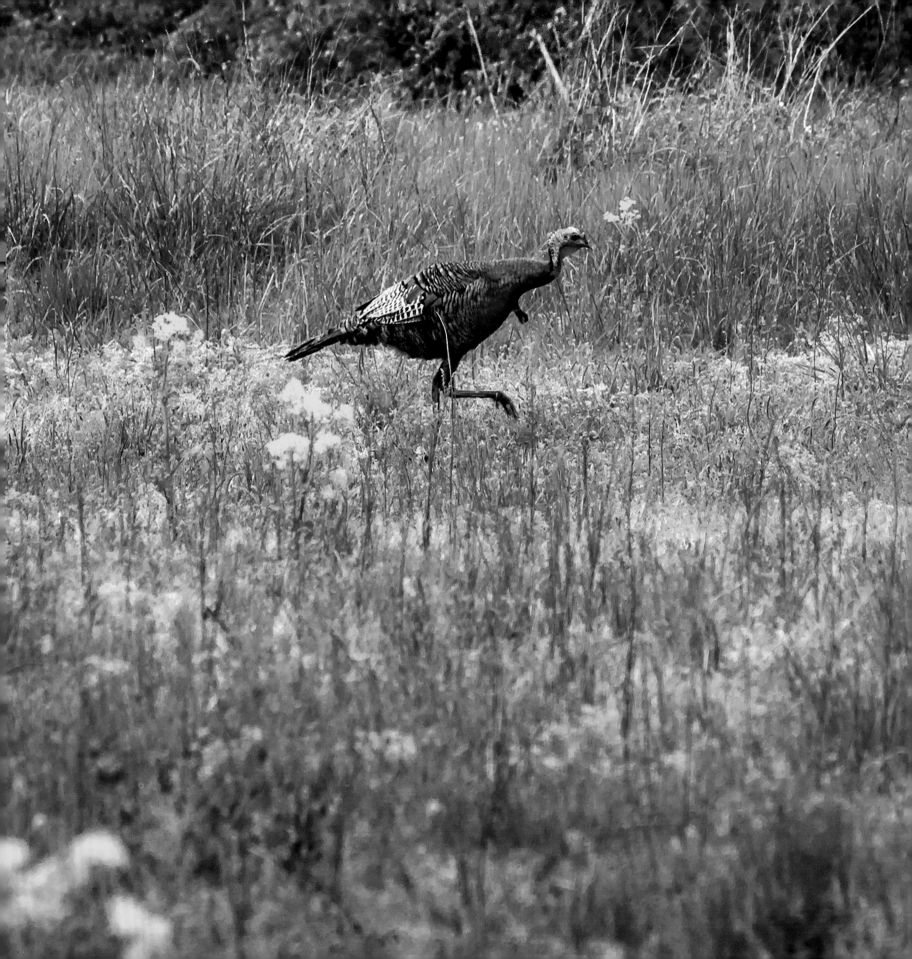

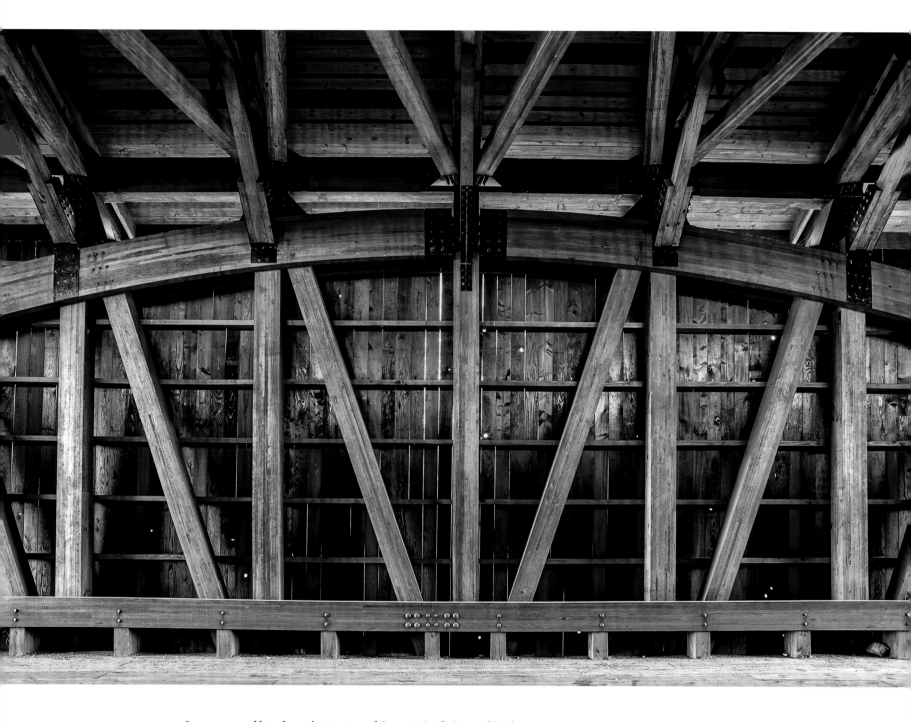

Symmetry and line form the interior of Captain Swift Covered Bridge.

FACING A wild turkey heads for cover. *Crab Orchard National Wildlife Refuge*

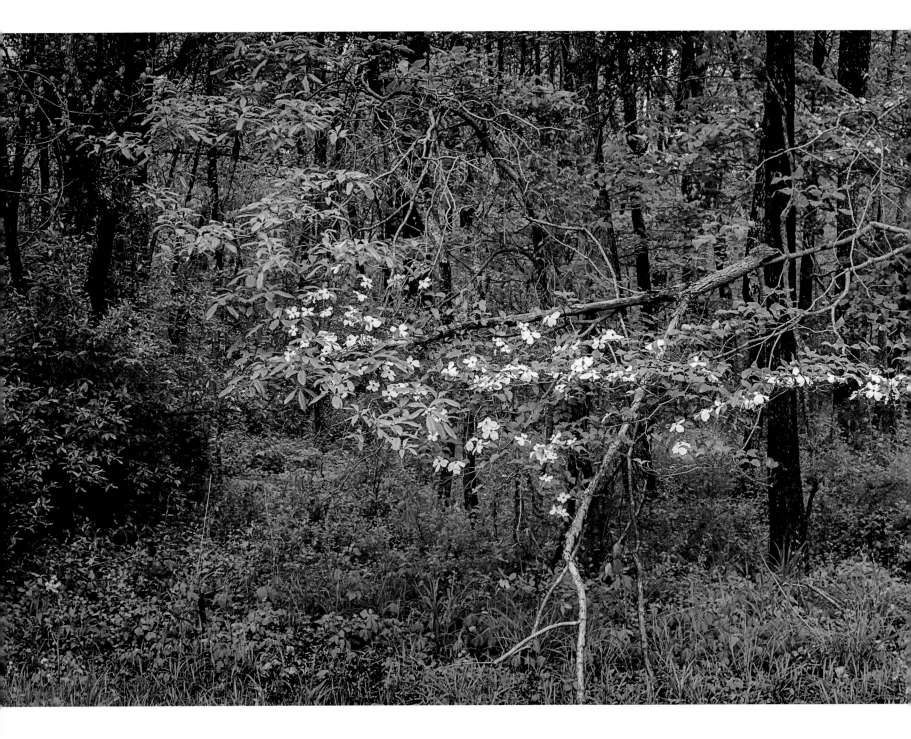

Dogwood blooms in Wayne Fitzgerrell State Recreation Area.

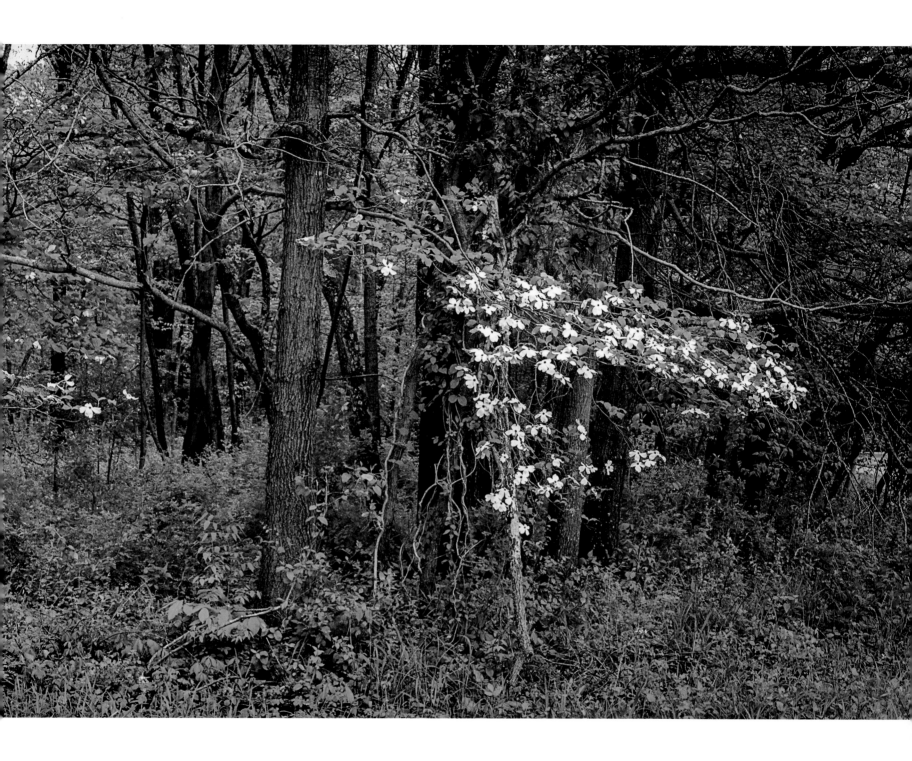

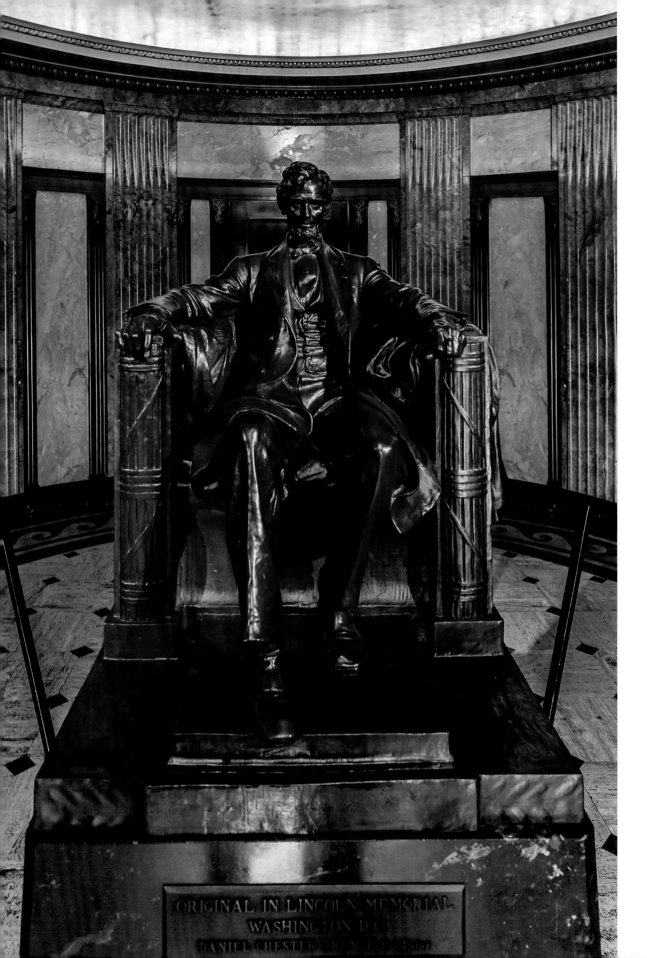

A replica of
the Lincoln
Statue that is in
Washington, DC.
Lincoln Tomb
State Historic Site

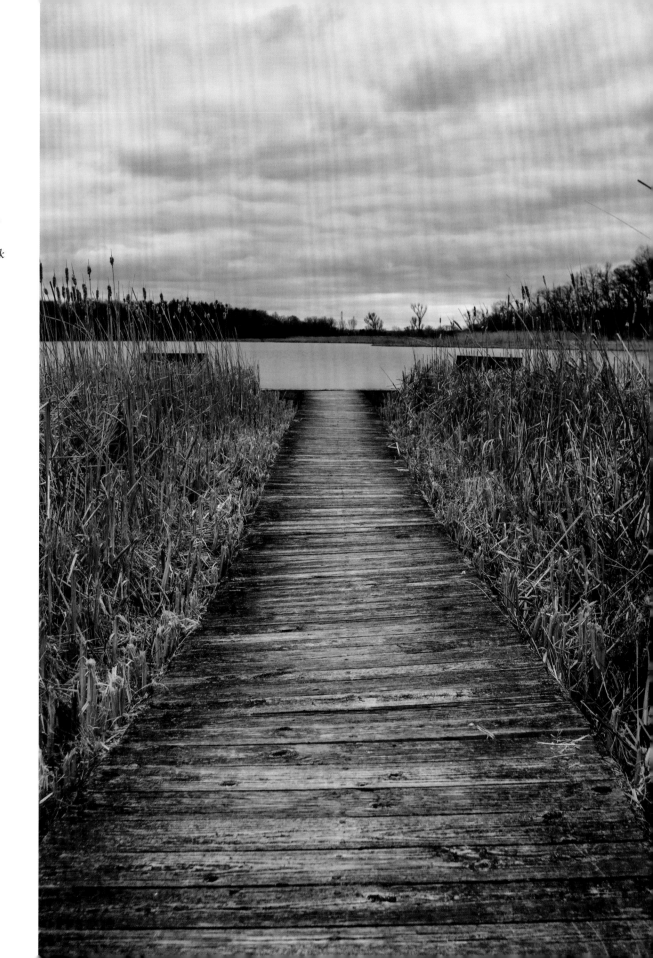

A boardwalk leads us to the lake. *Moraine Hills State Park*

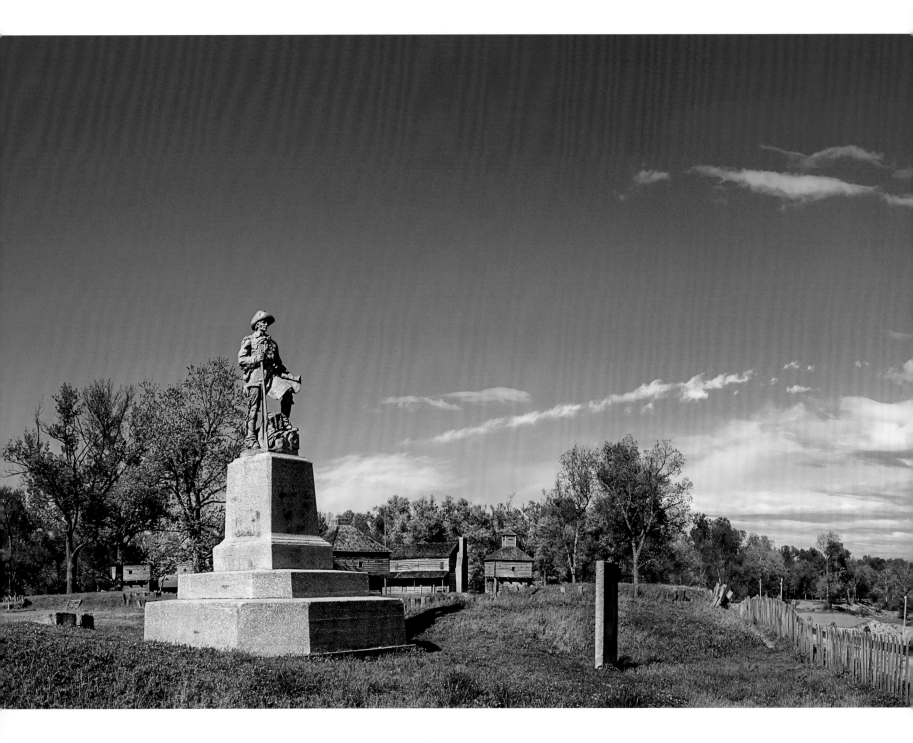

A statue depicting Col. George Rogers Clark as he looks across the Ohio River. *Fort Massac State Park*

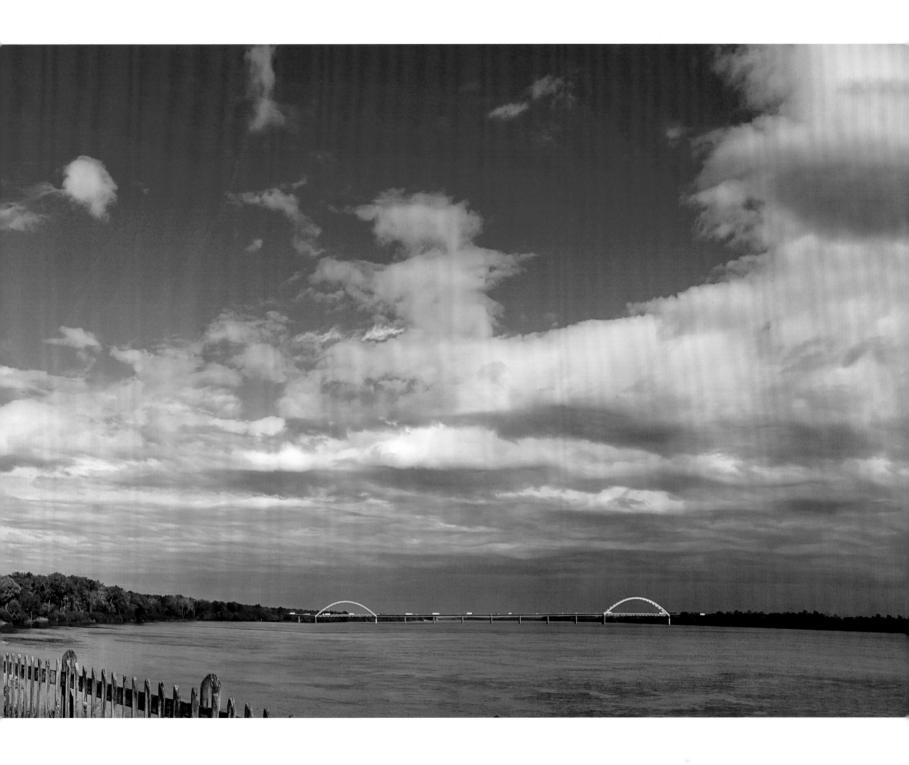

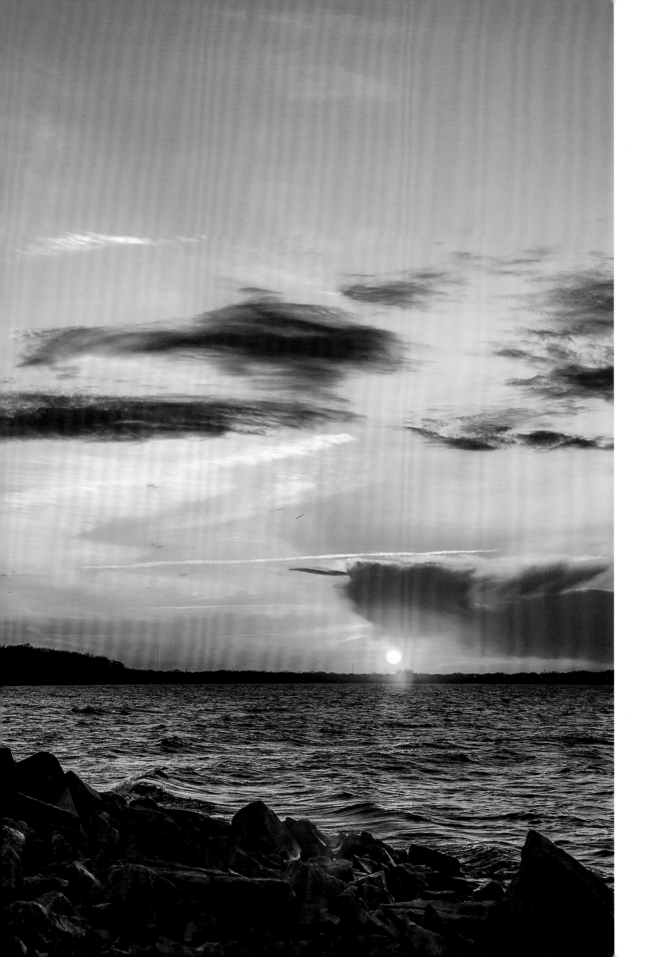

Last light of day.
Carlyle Lake

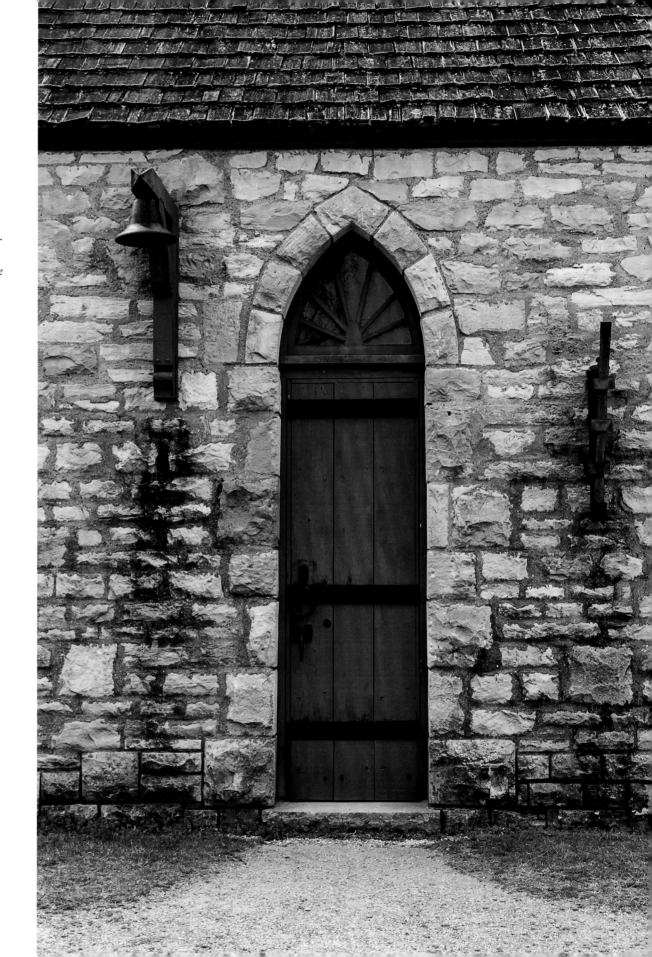

Eighteenth-
century design
and architecture.
*Fort De Chartres
State Historic Site*

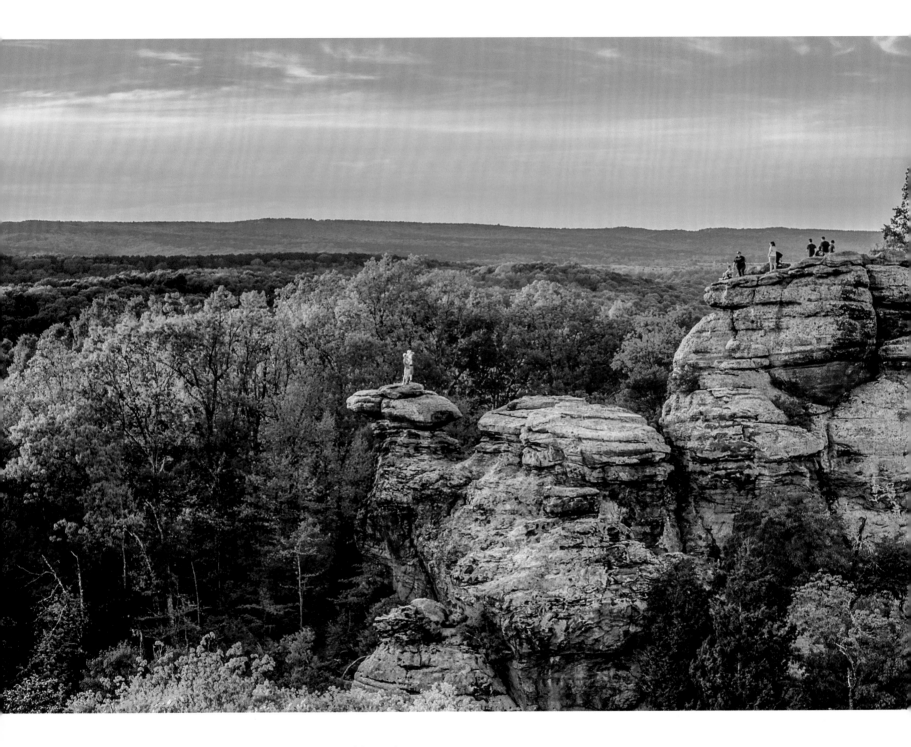

A glowing sunset from Garden of the Gods.

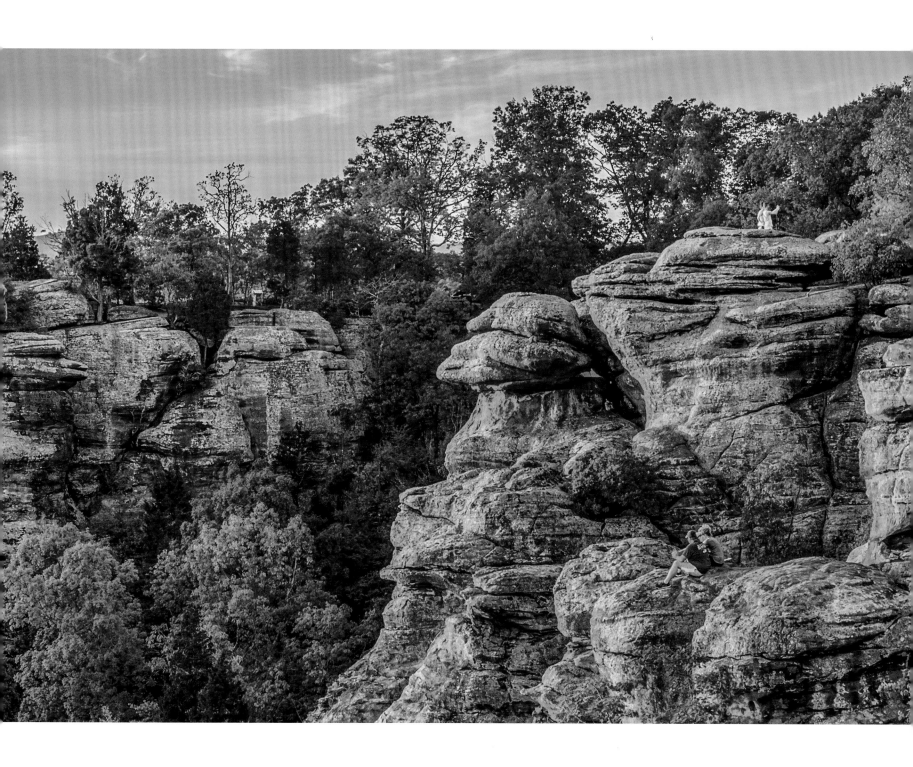

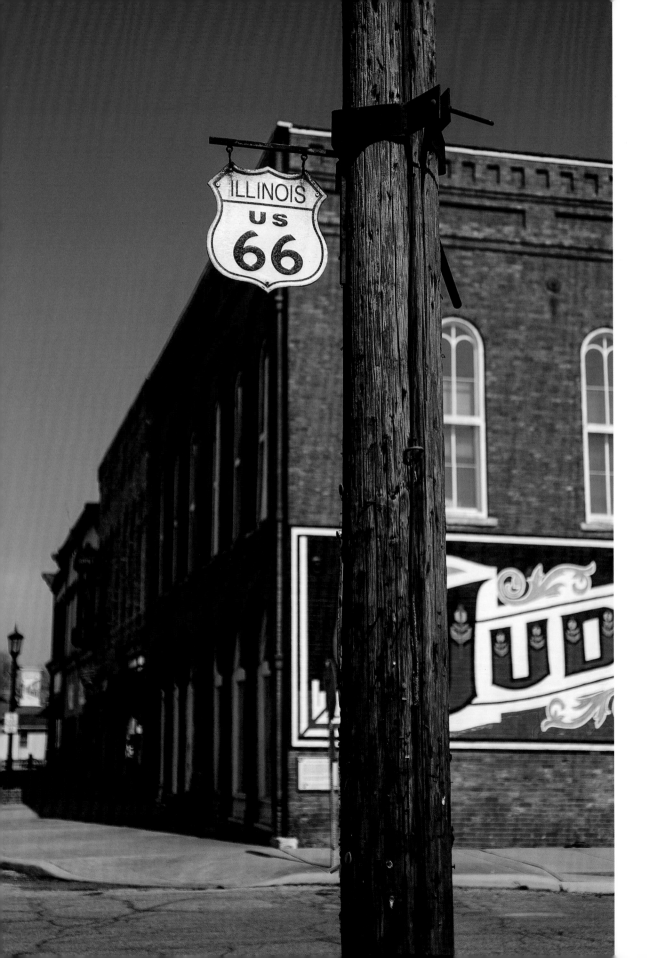

Historic Route 66,
Atlanta.

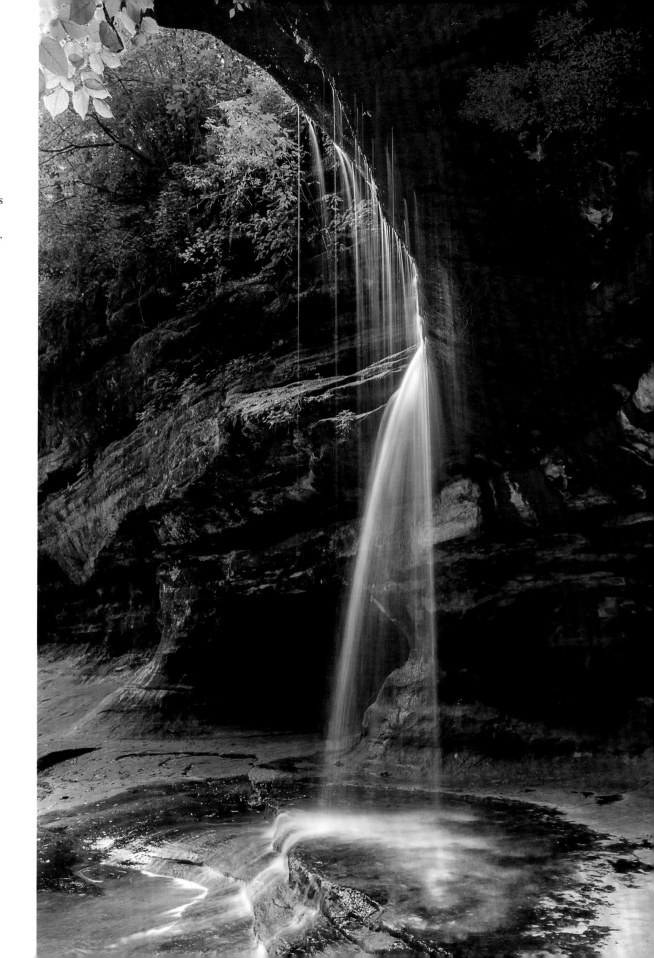

Water plummets
over the edge at
LaSalle Canyon.
*Starved Rock
State Park*

It's hard to believe Cave-In-Rock was carved by water of the Ohio River.

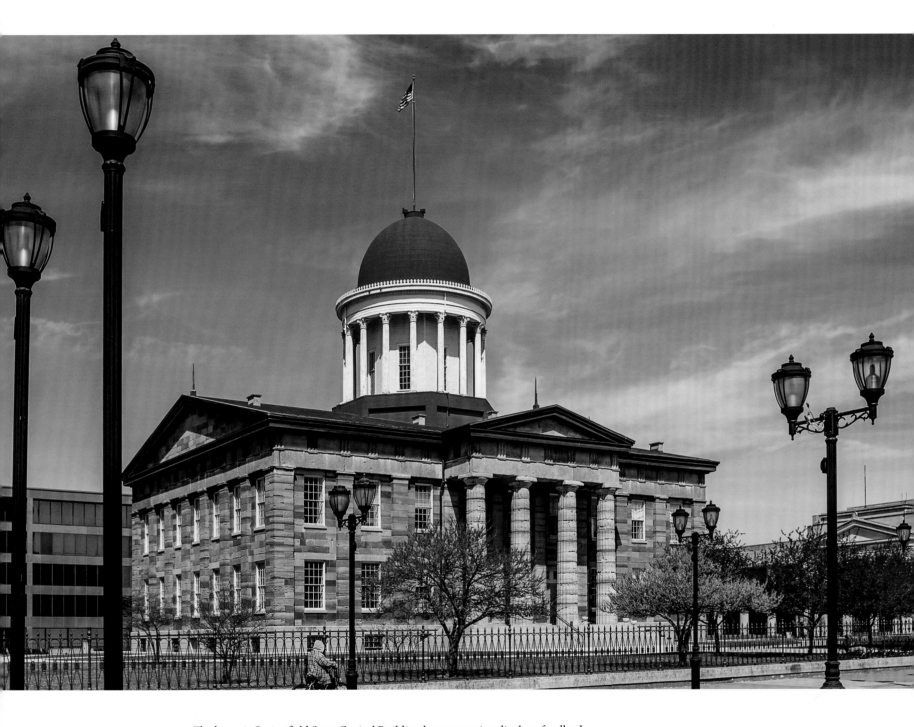

The historic Springfield State Capitol Building boasts a spring display of redbuds.

The fort at
Matthiessen
State Park.

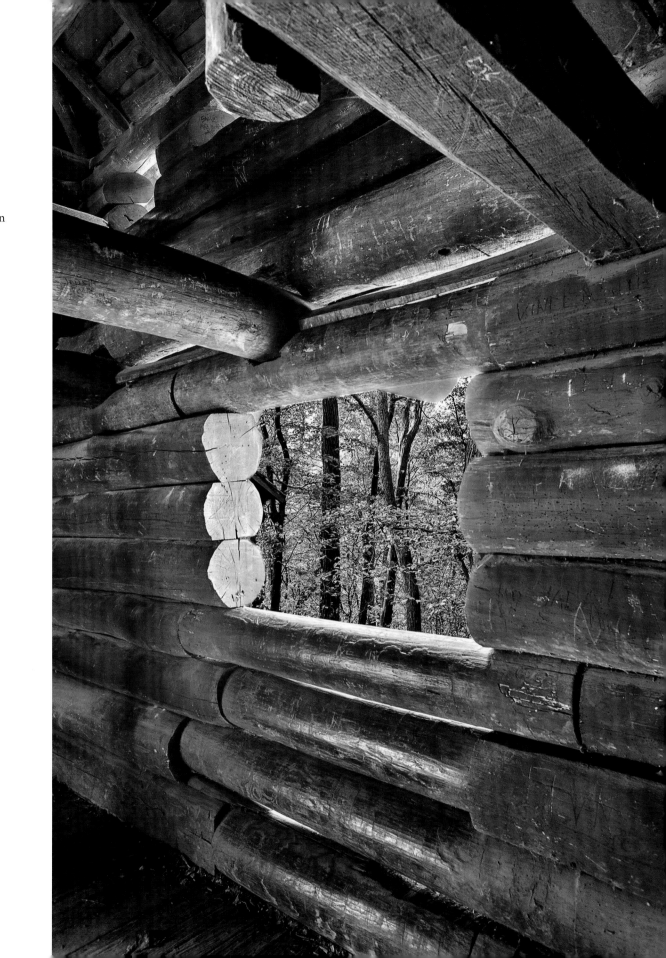

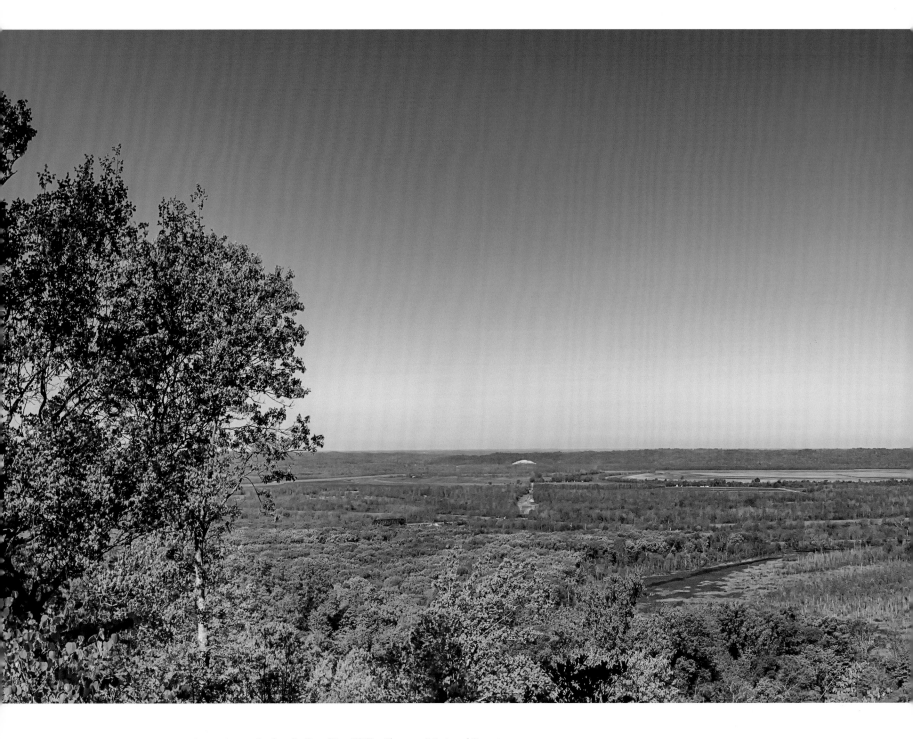

A scenic overlook at LaRue Pine Hills. *Shawnee National Forest*

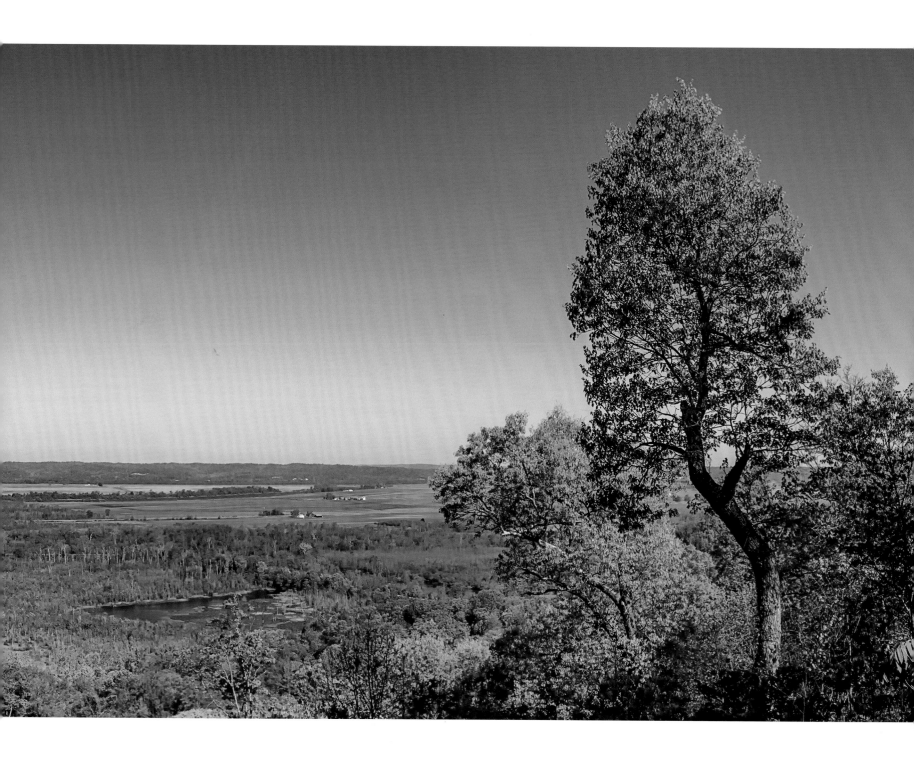

The Agricultural Crash Monument in Norway.

FACING Beginnings of autumn and the warning of winter. *Weldon Springs State Park*

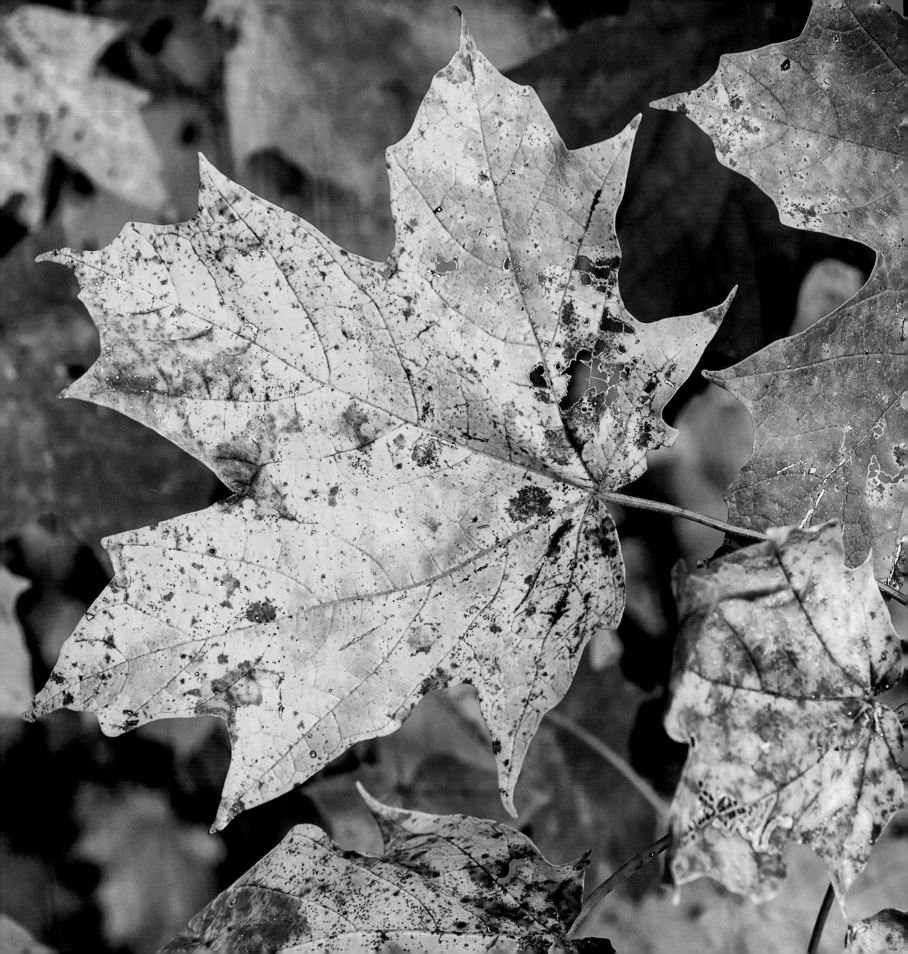

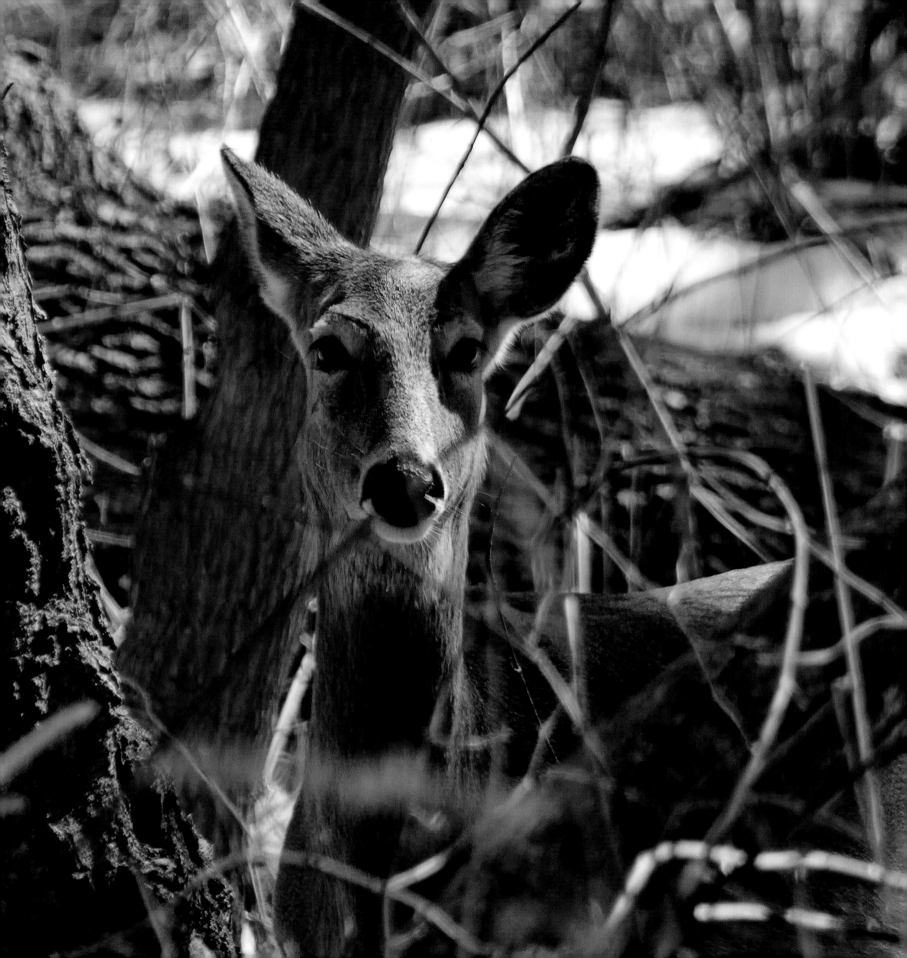

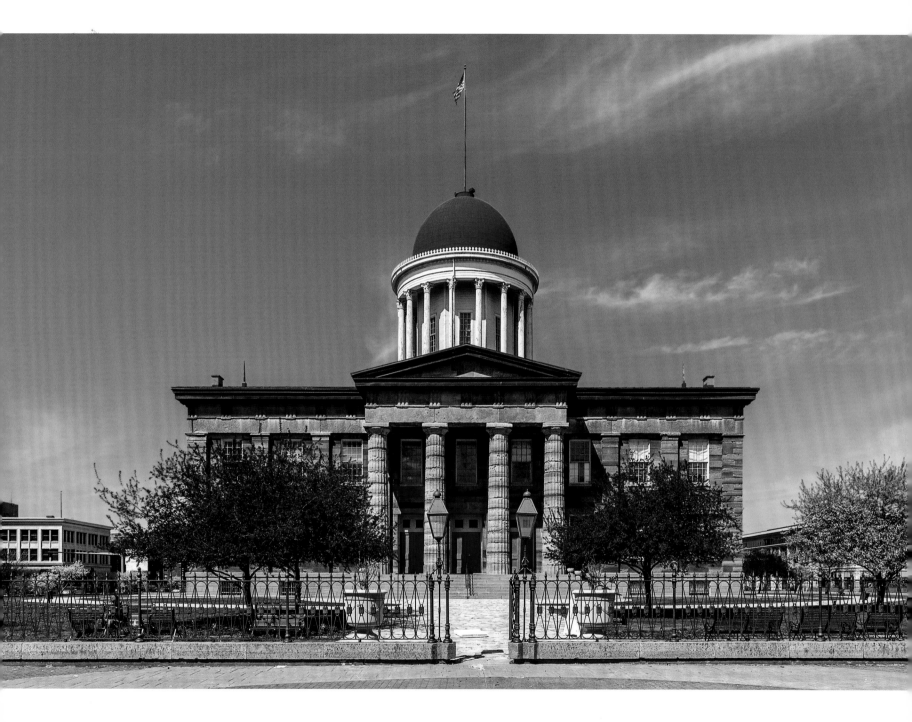

The historic Illinois State Capitol Building.

FACING A curious whitetail deer watches the photographers. *Adeline Jay State Park*

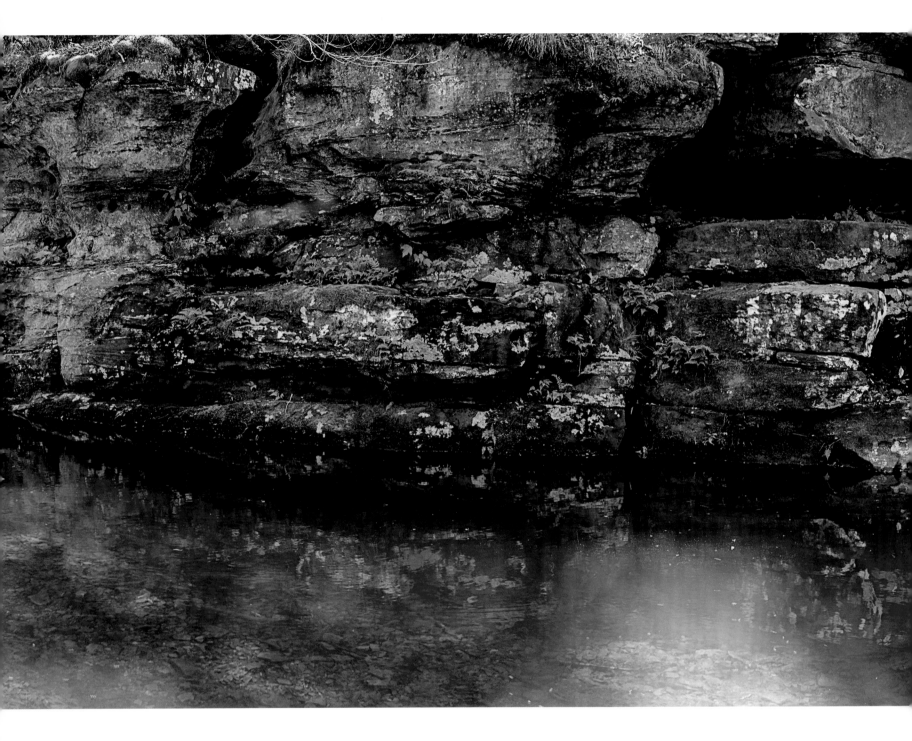

Turquoise water, rock, and sunlight at Bell Smith Springs Area.

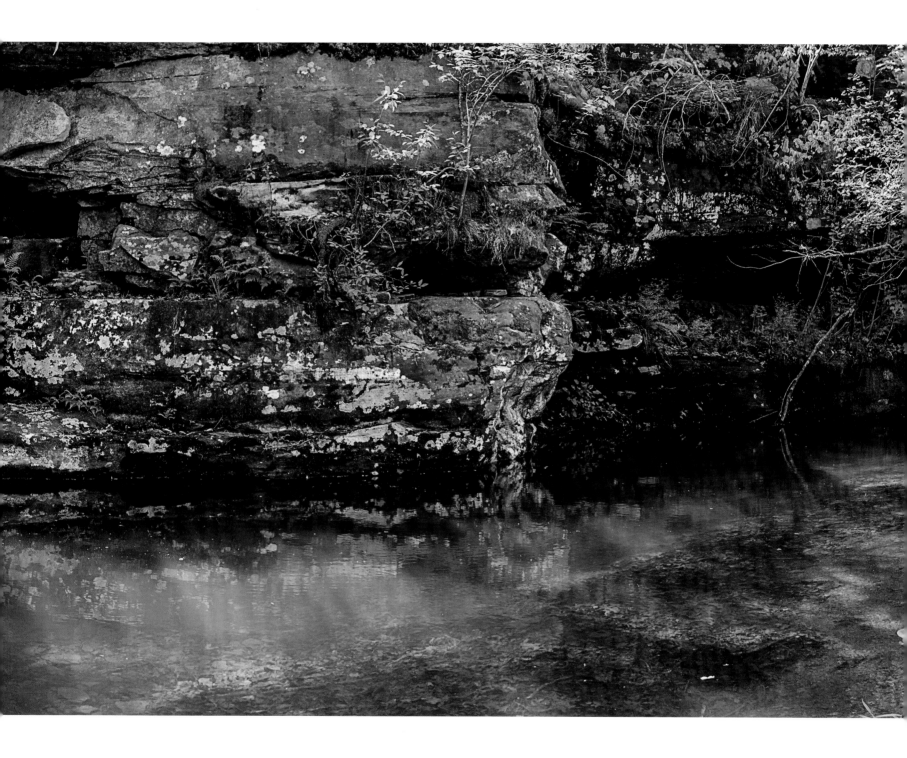

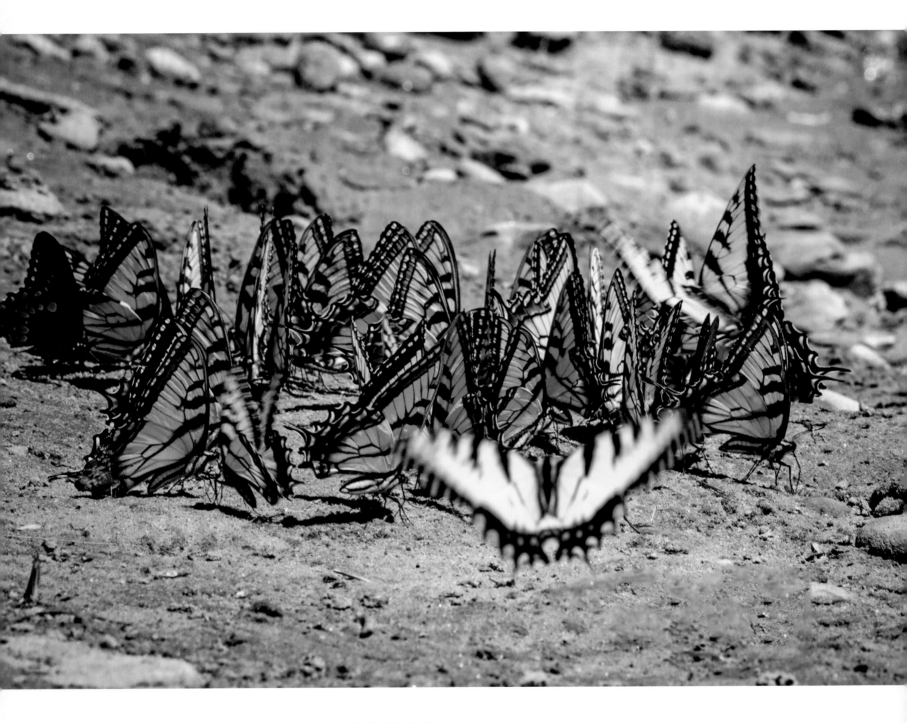

A butterfly swarm along the trail at Bell Smith Springs.

FACING Crab Orchard Wildlife Refuge is a natural haven for many species of birds, animals, and plants.

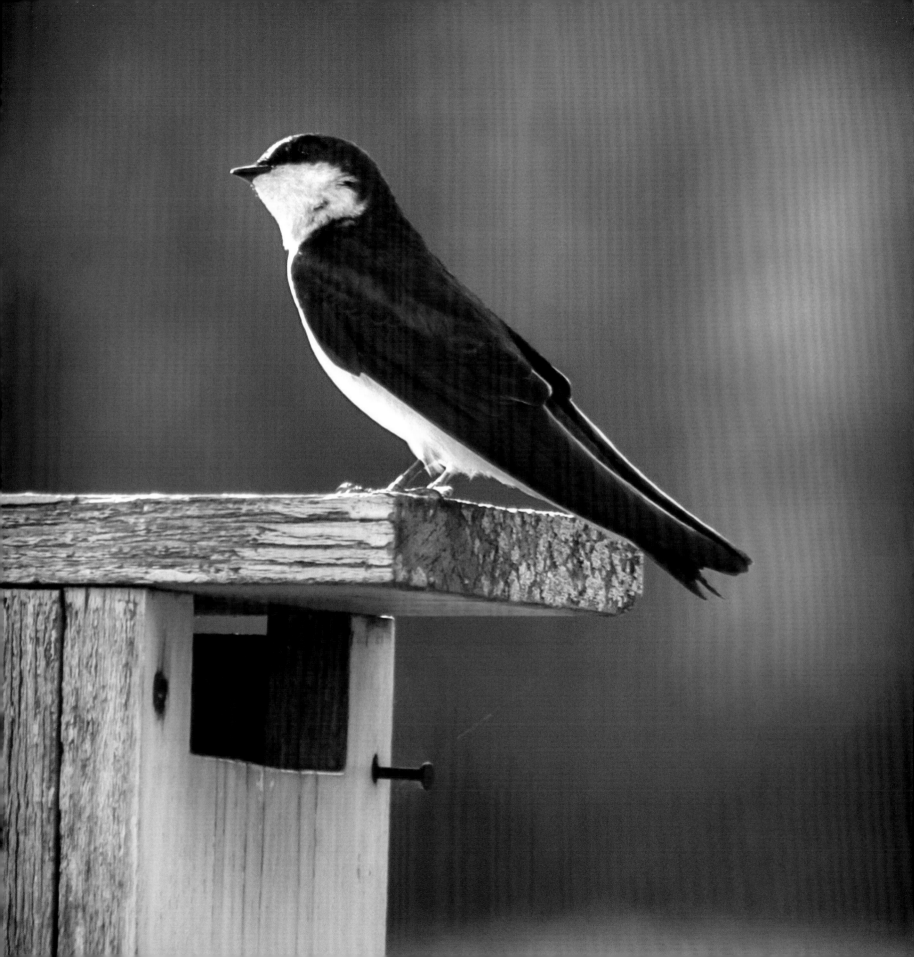

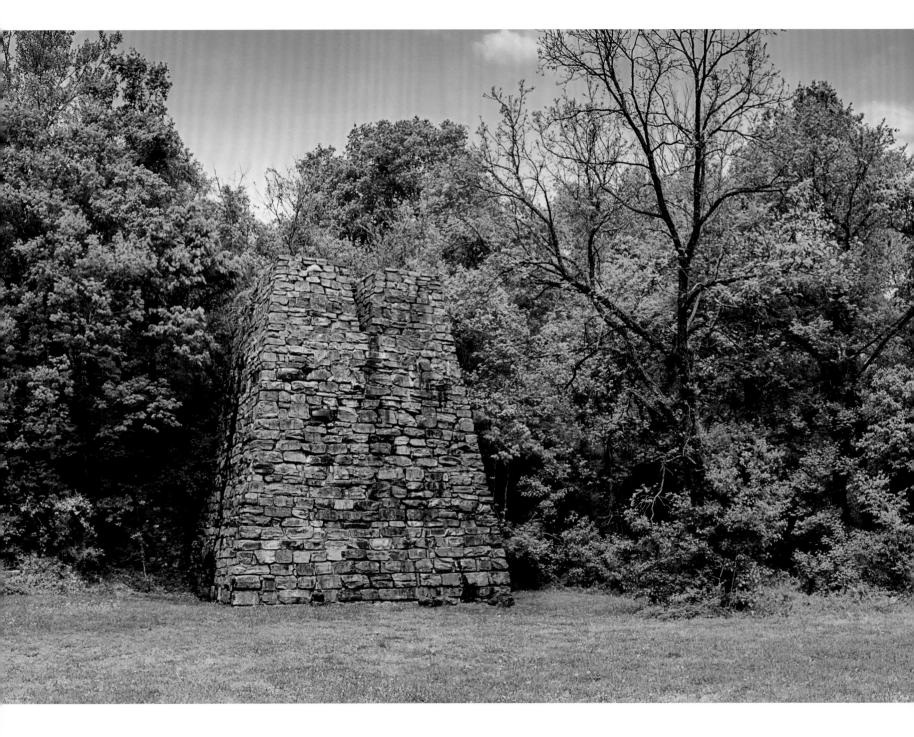

The historic Iron Furnace at Shawnee National Forest.

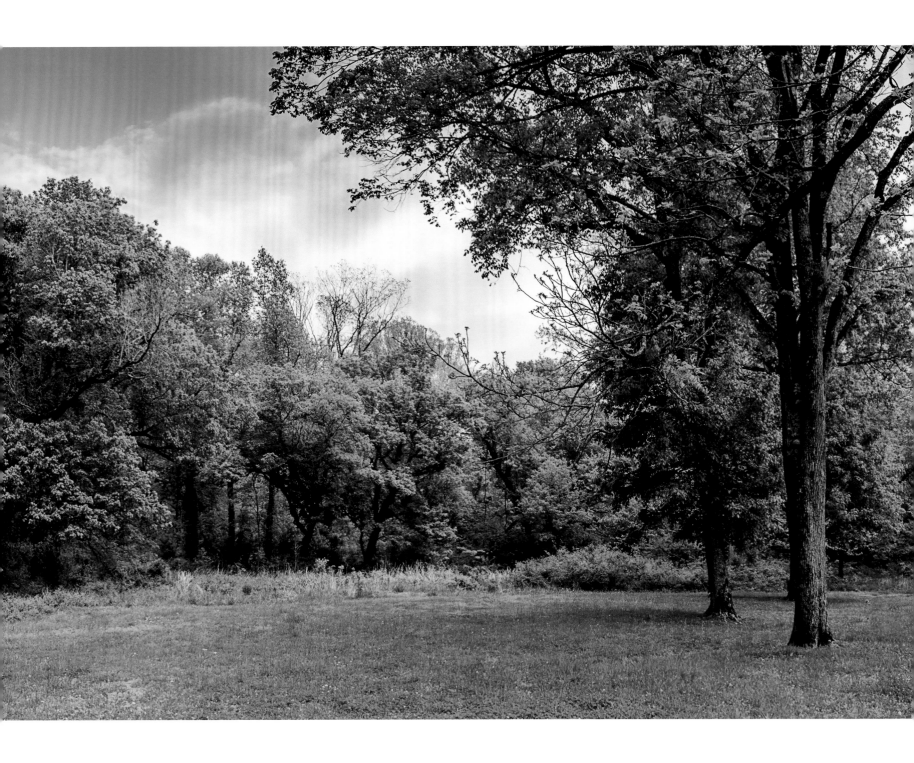

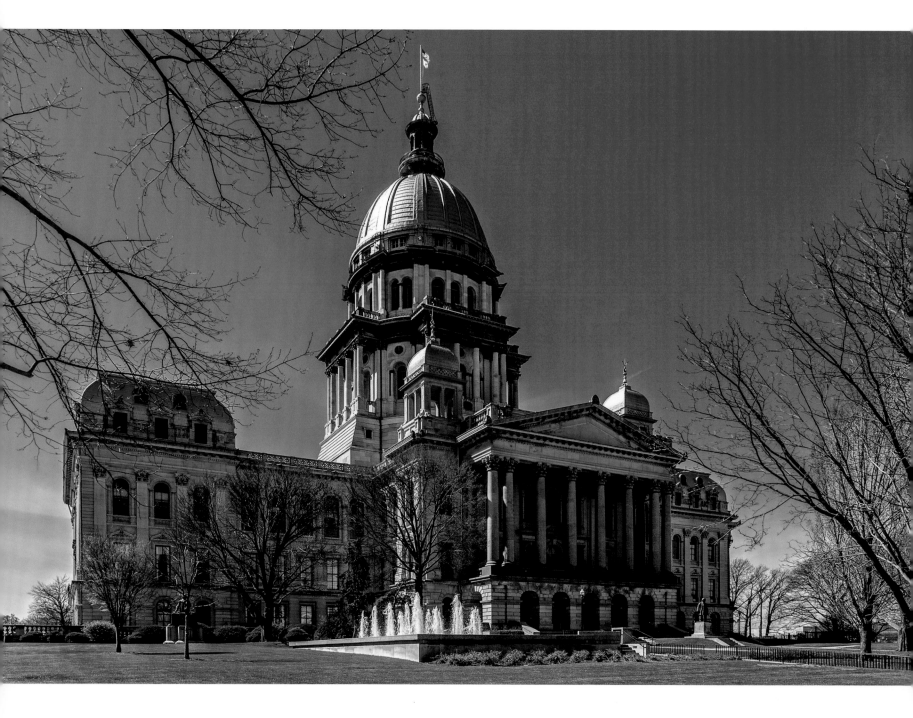

The Illinois State Capitol Building.

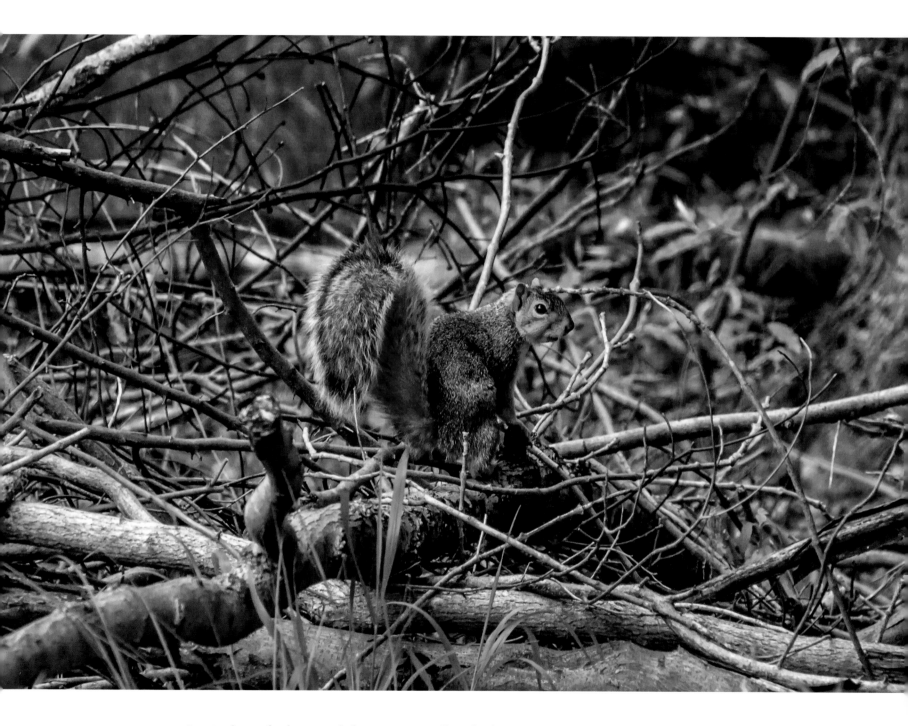

A squirrel poses for the camera before scampering off. *Rend Lake*

A modern covered bridge construction. *Captain Swift Covered Bridge*

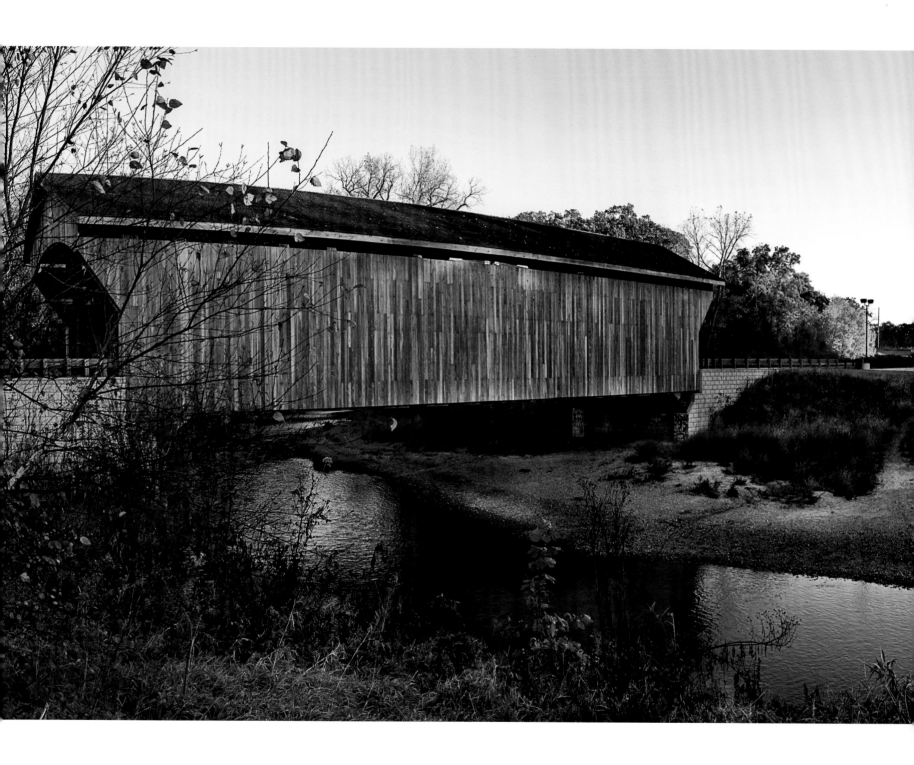

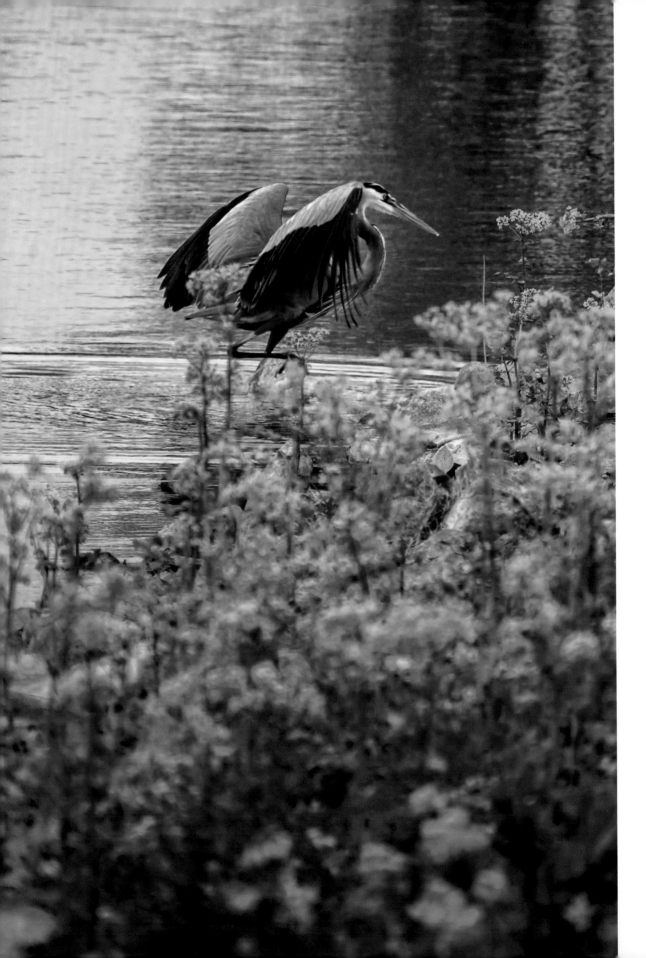

A blue heron
makes a
landing.
*Golconda
Marina*

FACING
A delicate
columbine
makes its
annual spring
appearance.
*Giant City
State Park*

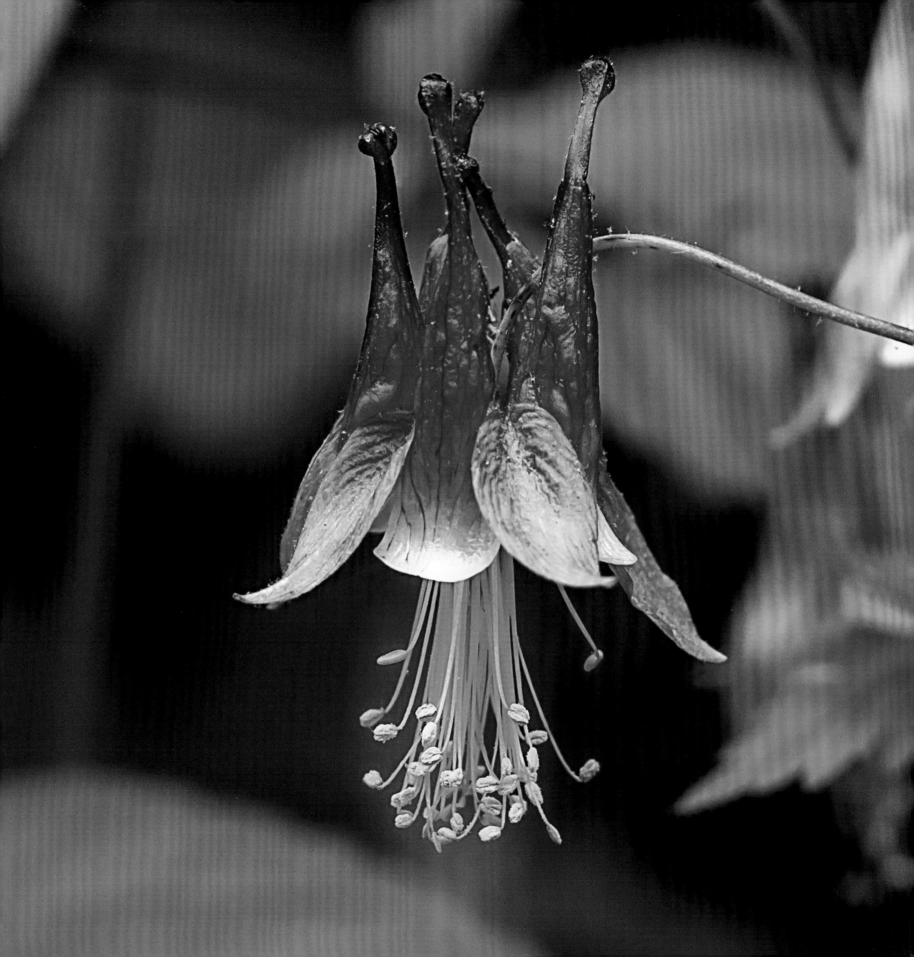

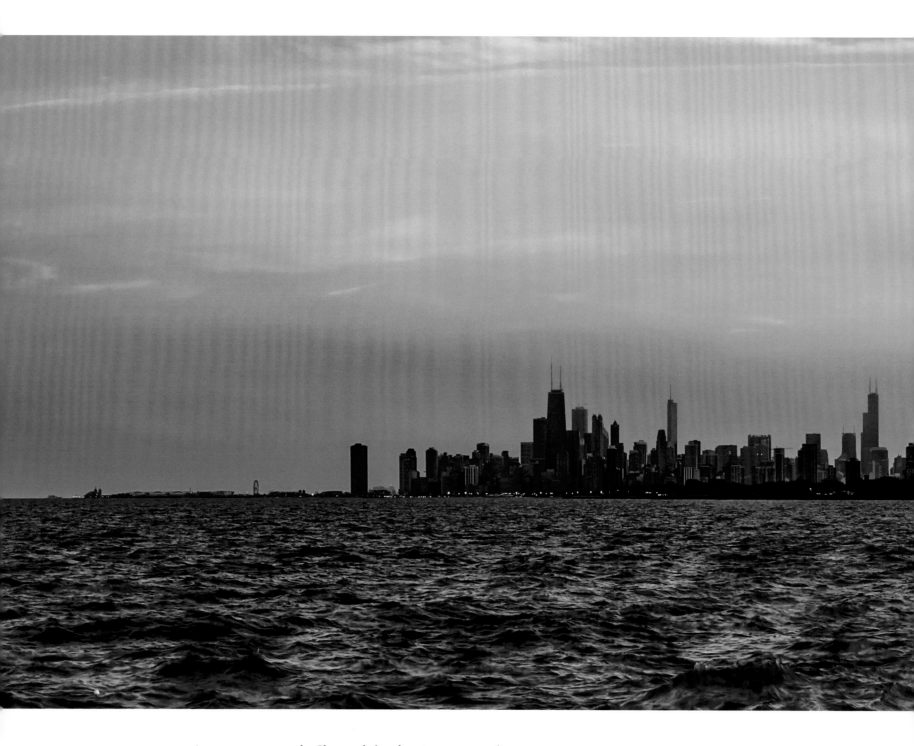

A serene sunset over the Chicago skyline from Montrose Beach.

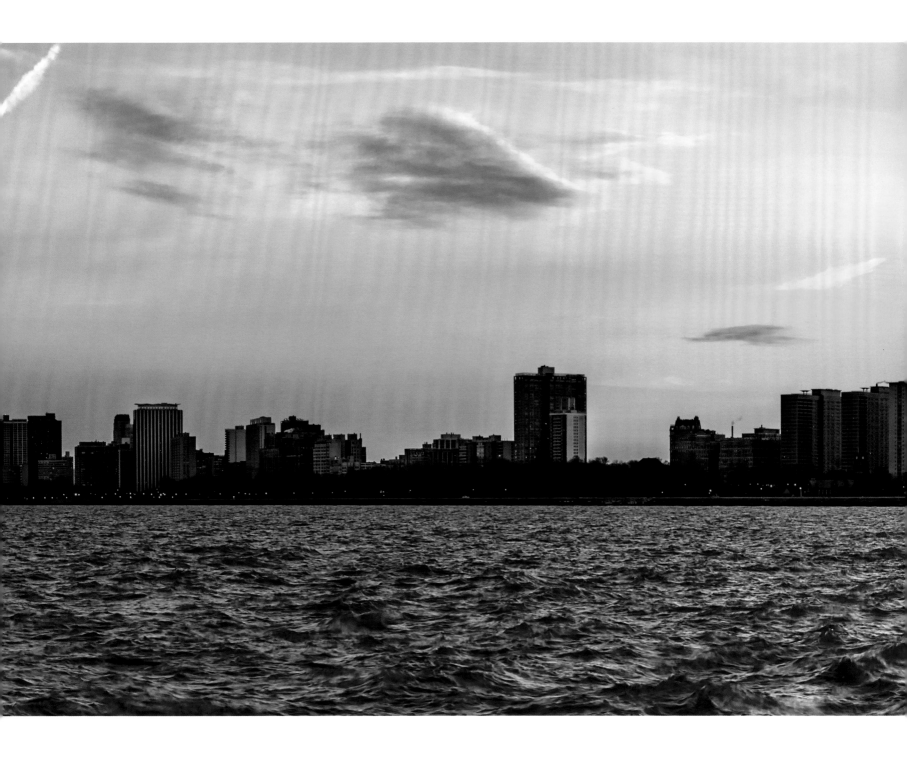

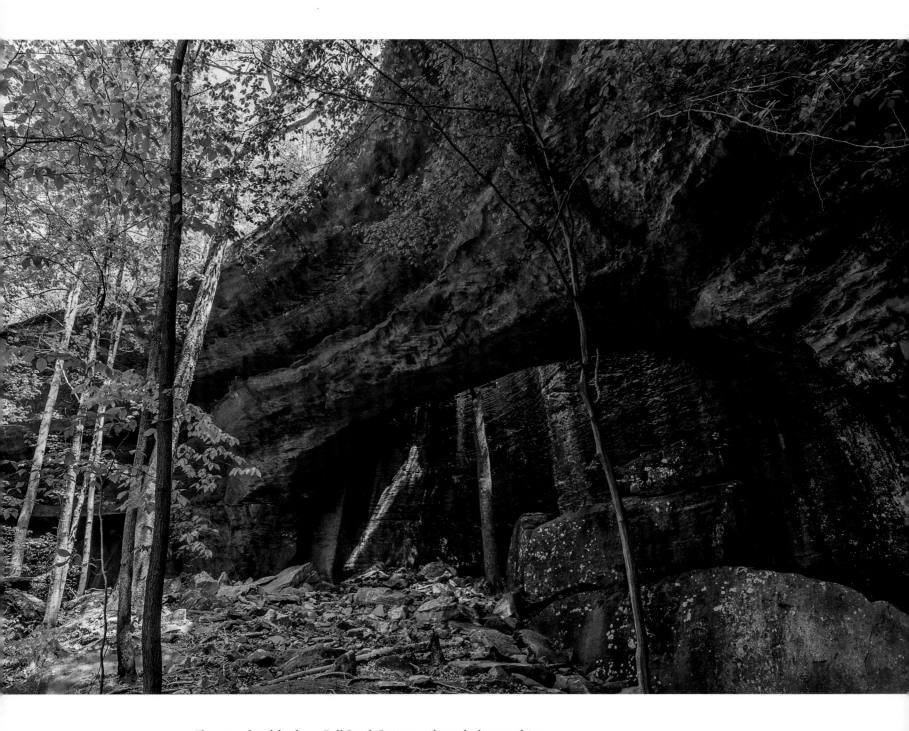

The natural rock bridge at Bell Smith Springs withstands the test of time.

FACING Morrison Covered Bridge is very open and modern.

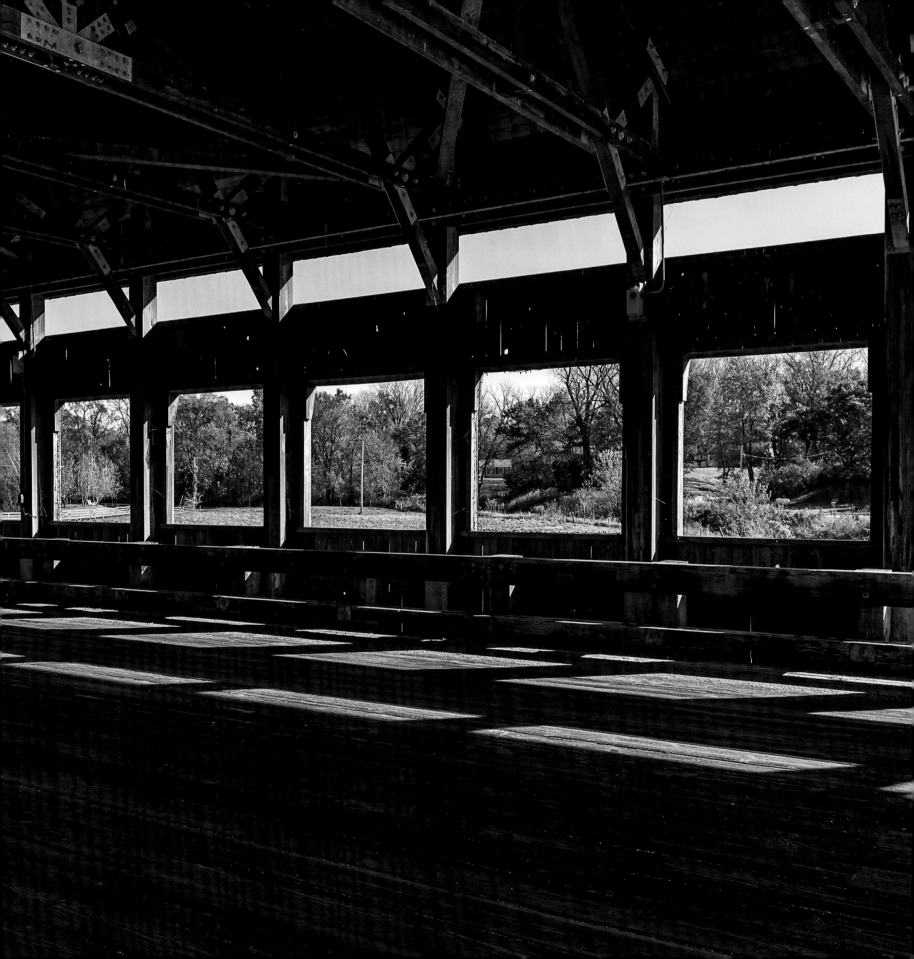

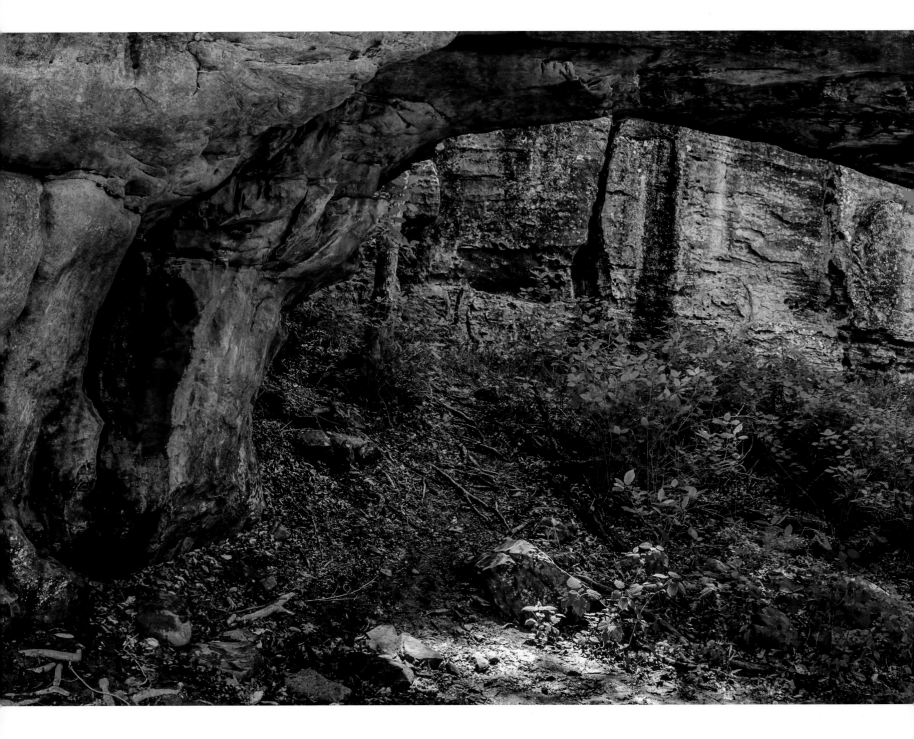

Pomona Natural Bridge from the bottom of the trail. *Shawnee National Forest*

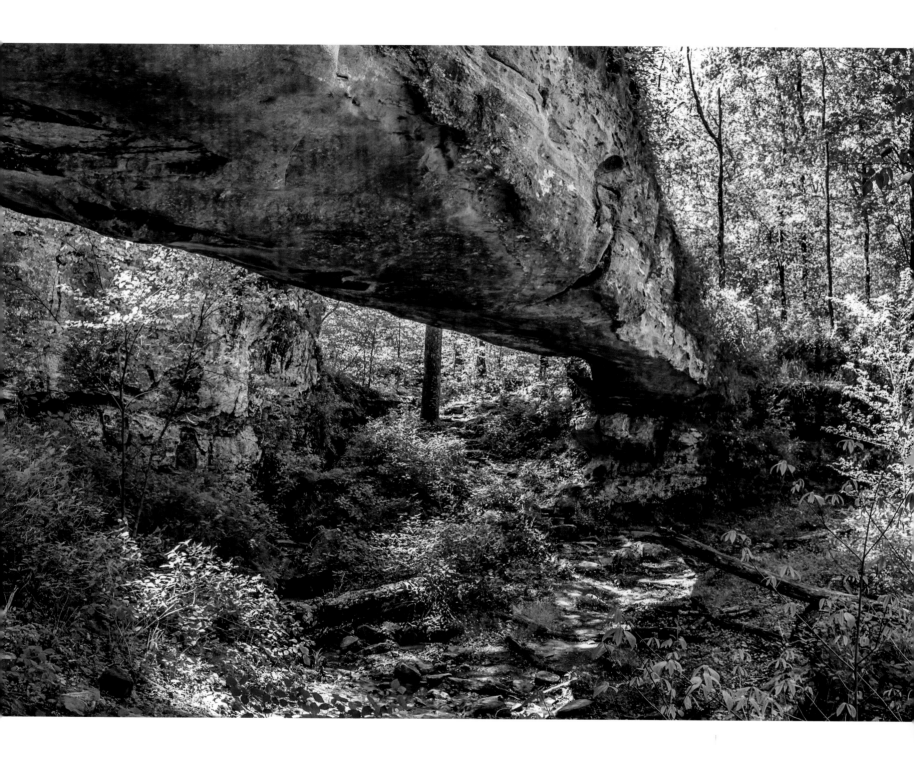

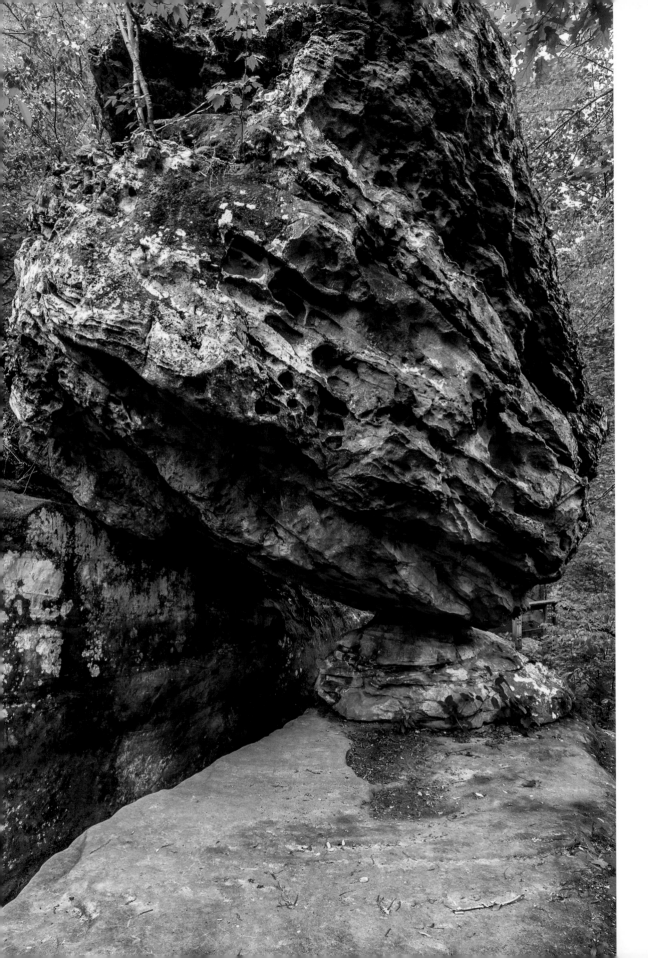

The trail
passes under
Balanced
Rock. *Giant
City State Park*

FACING
A look into the
past. *Forest
Glen Nature
Preserve*

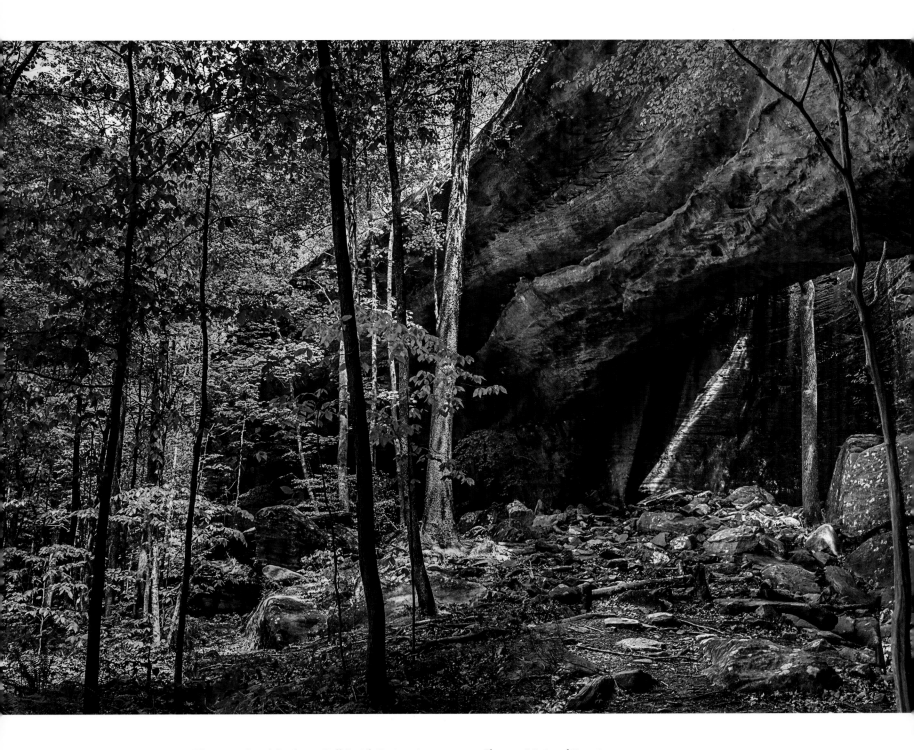

The natural rock bridge at Bell Smith Springs is a must-see. *Shawnee National Forest*

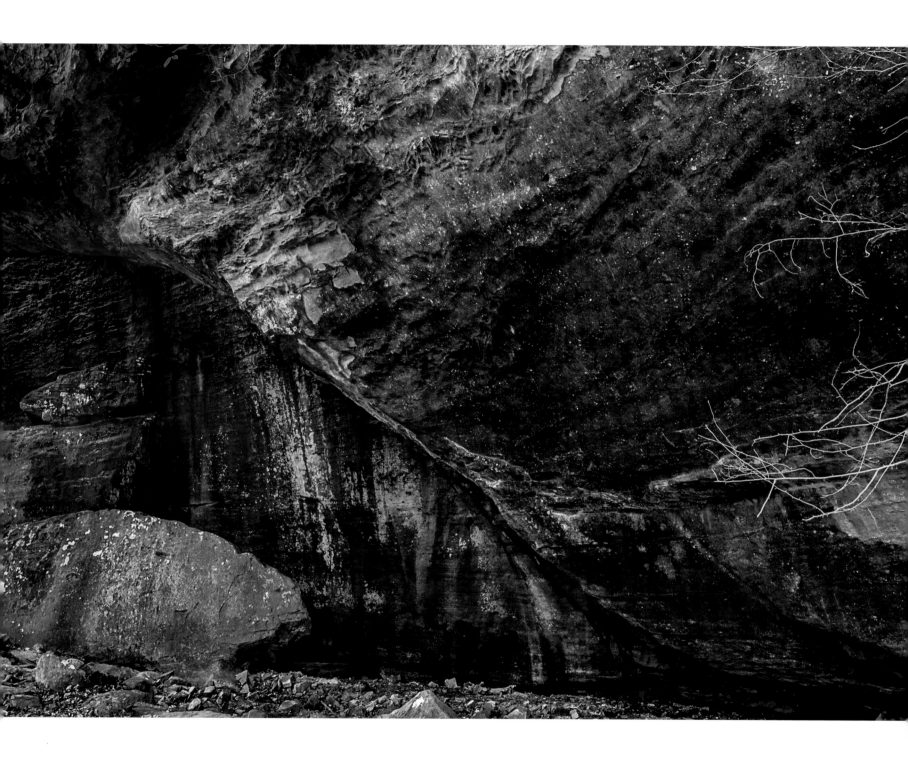

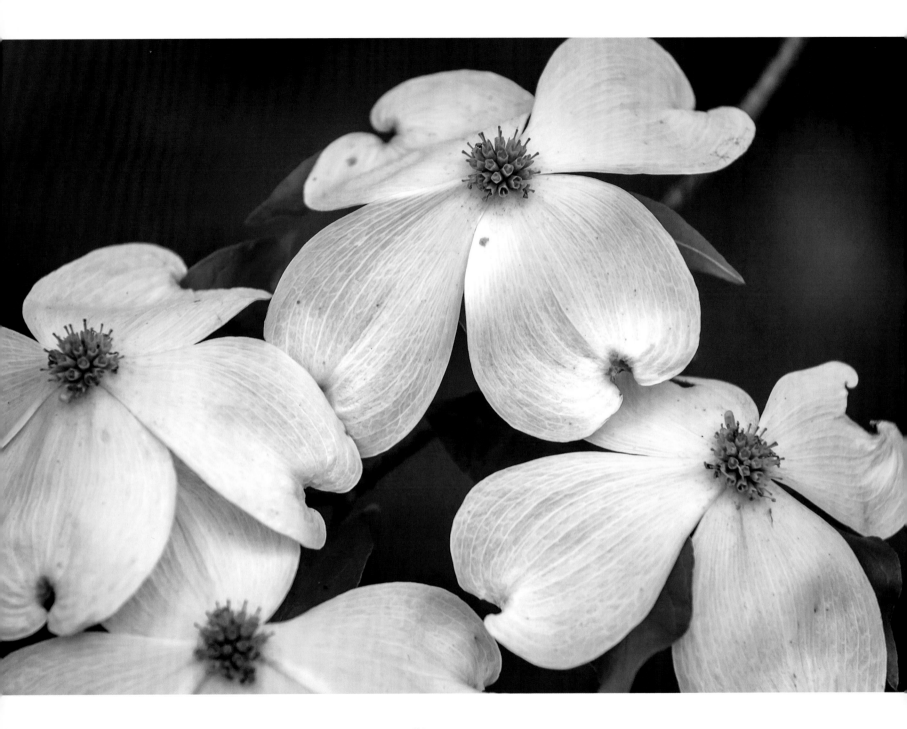

Majestic dogwoods close up. *Wayne Fitzgerrell State Recreation Area*

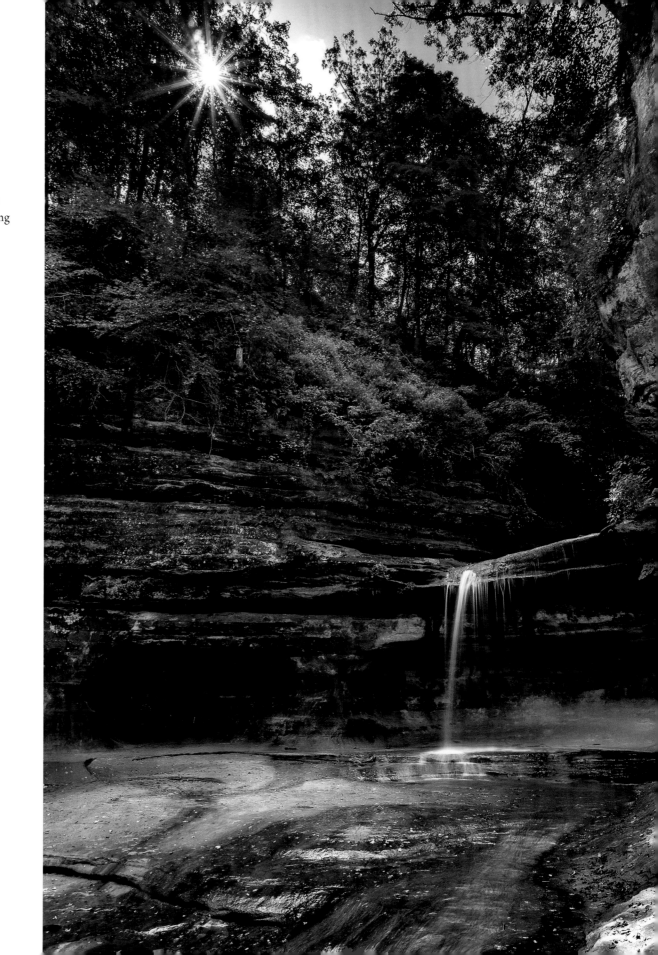

LaSalle Falls and the setting sun. *Starved Rock State Park*

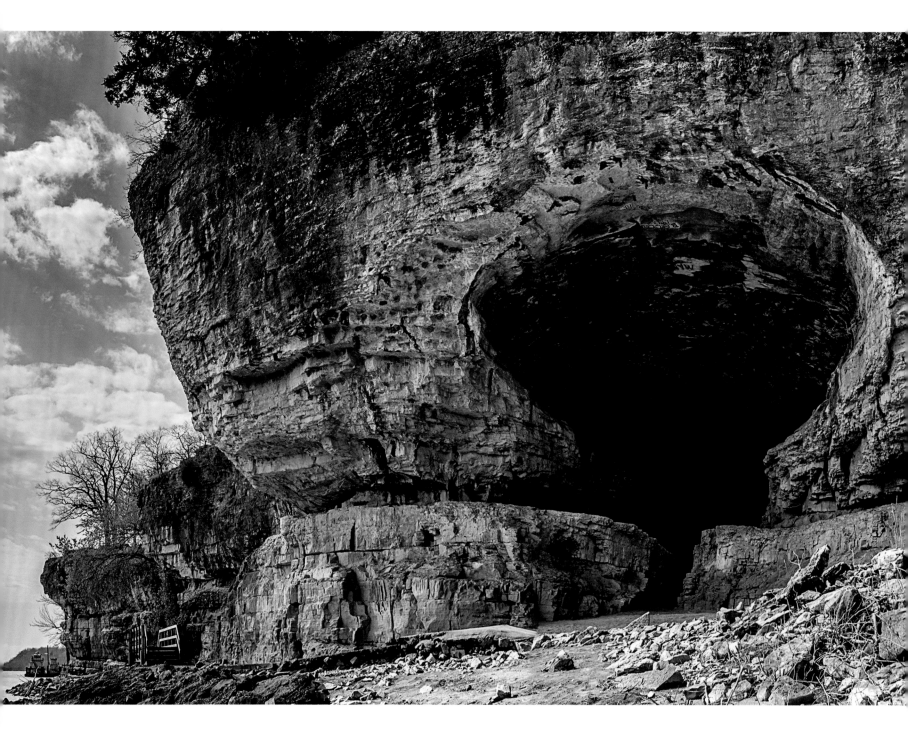

Cave-In-Rock looks out over the Ohio River.

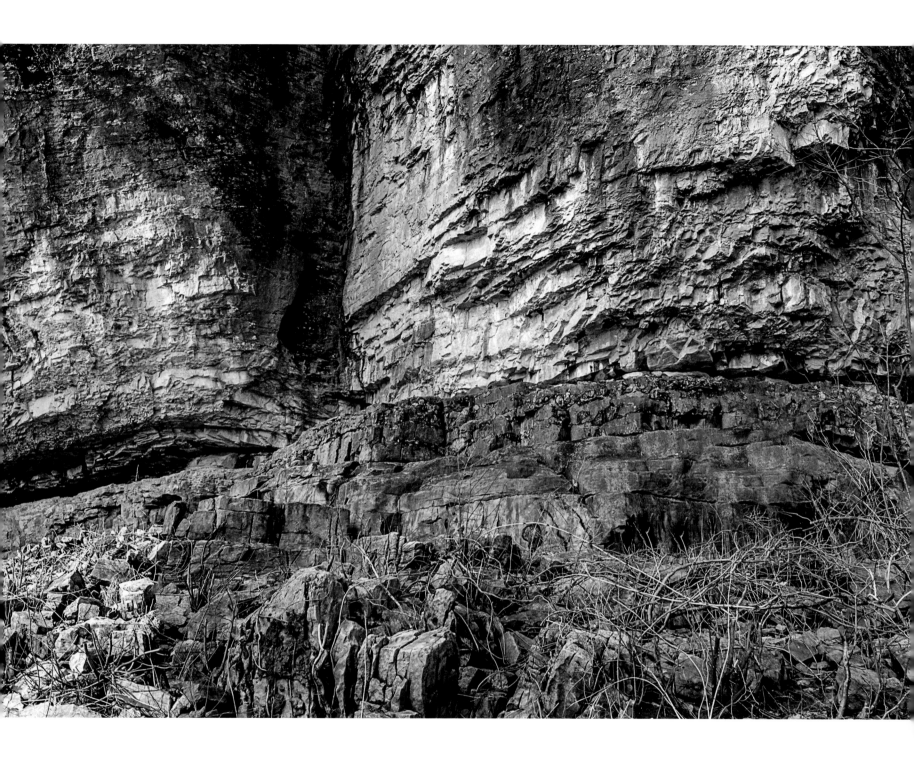

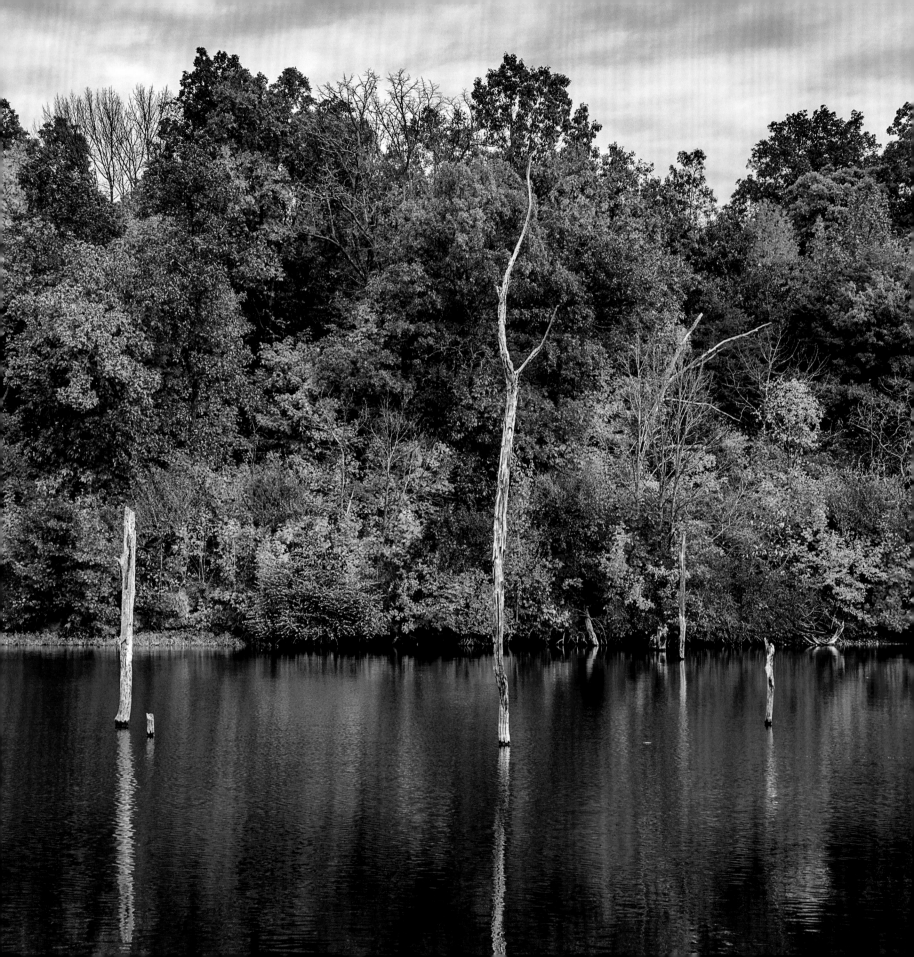

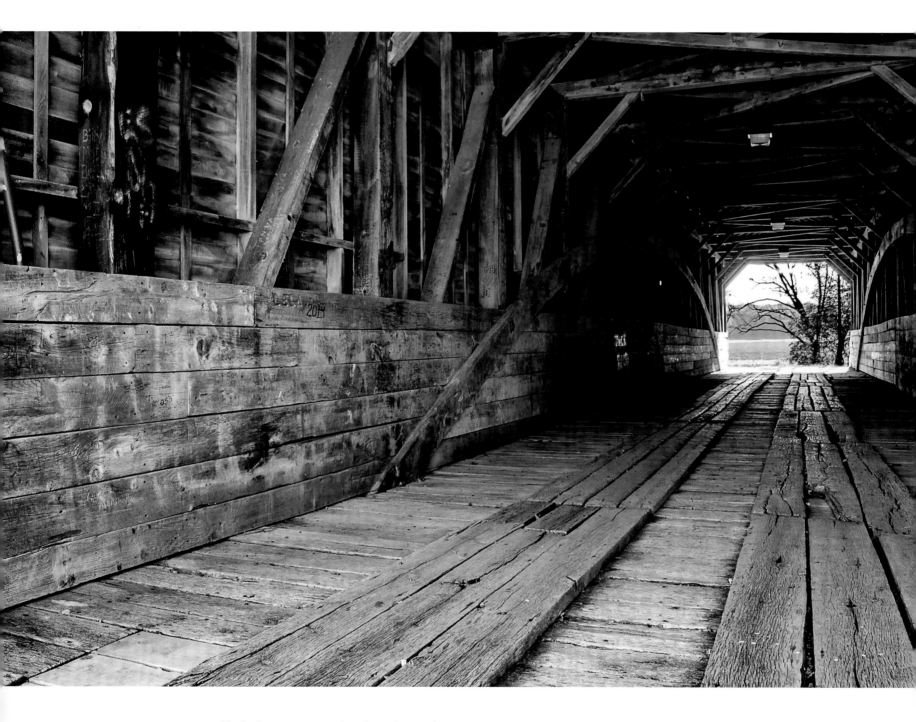

A world of color awaits us on the other side. *Henderson Recreation Area*

FACING Reflections of peak fall color. *Clinton State Recreation Area*

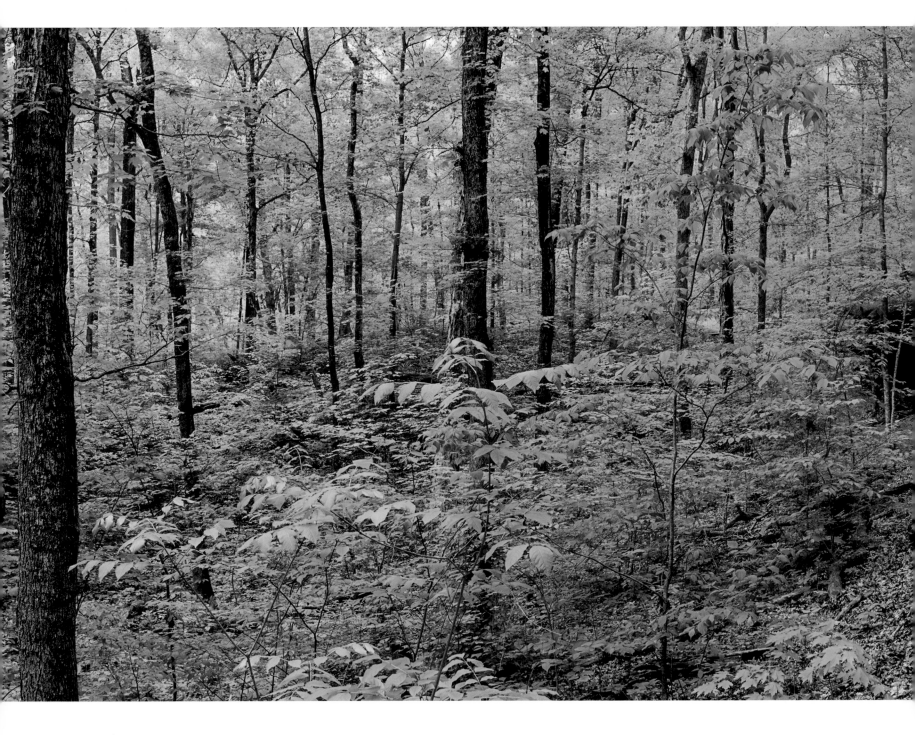

A relaxing trail takes you through Giant City State Park.

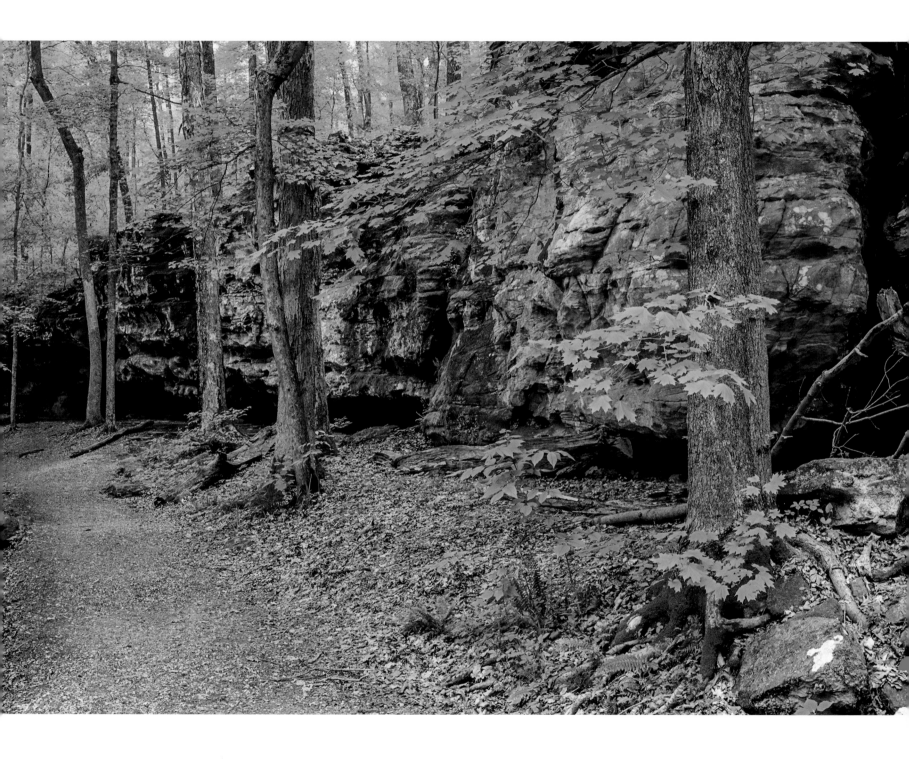

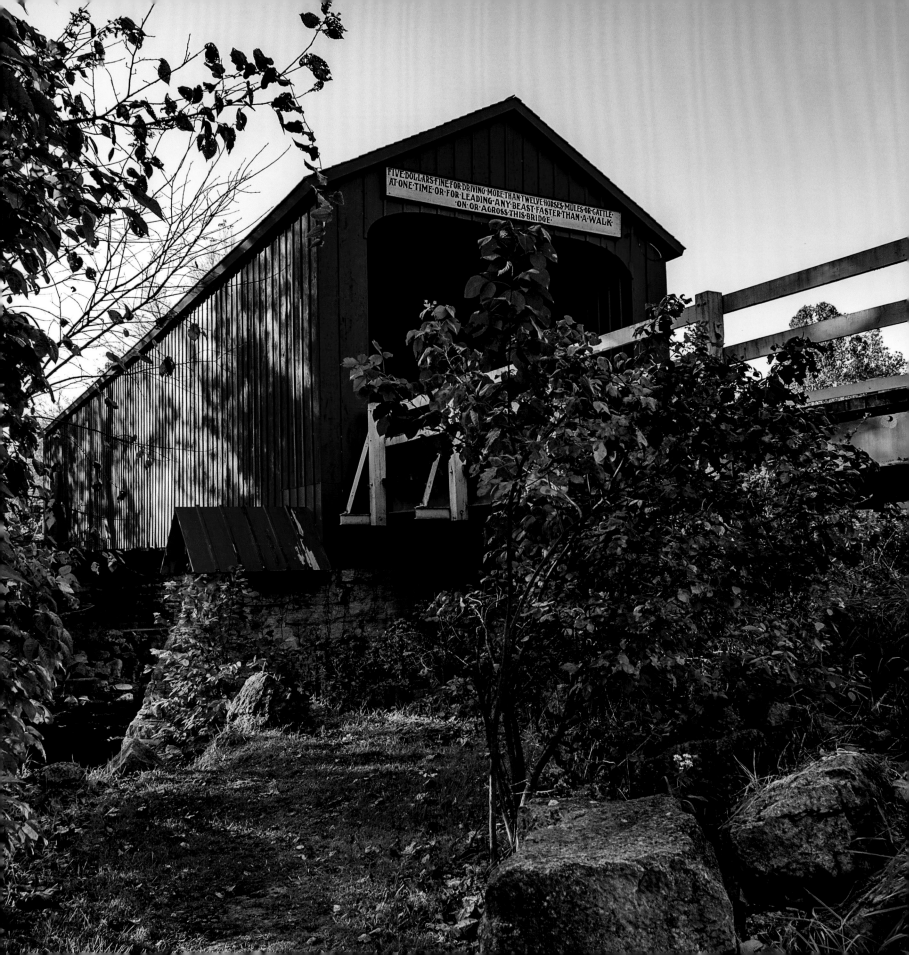

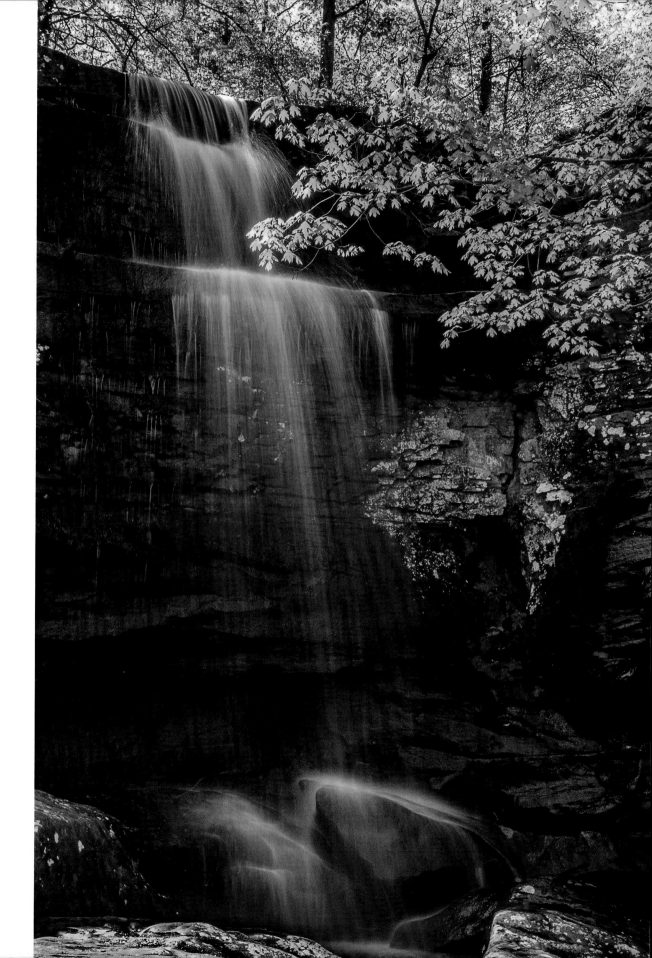

Mid-morning light shines upon Burden Falls. *Shawnee National Forest*

FACING

The historic Red Covered Bridge in Princeton.

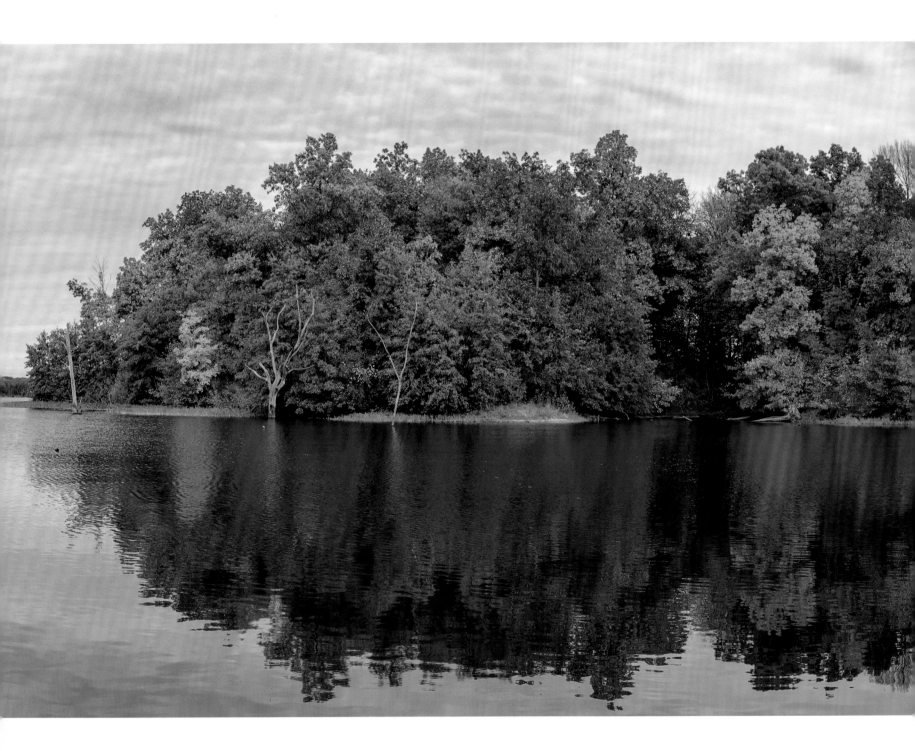

Fishermen enjoy the peak fall color while fishing. *Clinton Lake State Recreation Area*

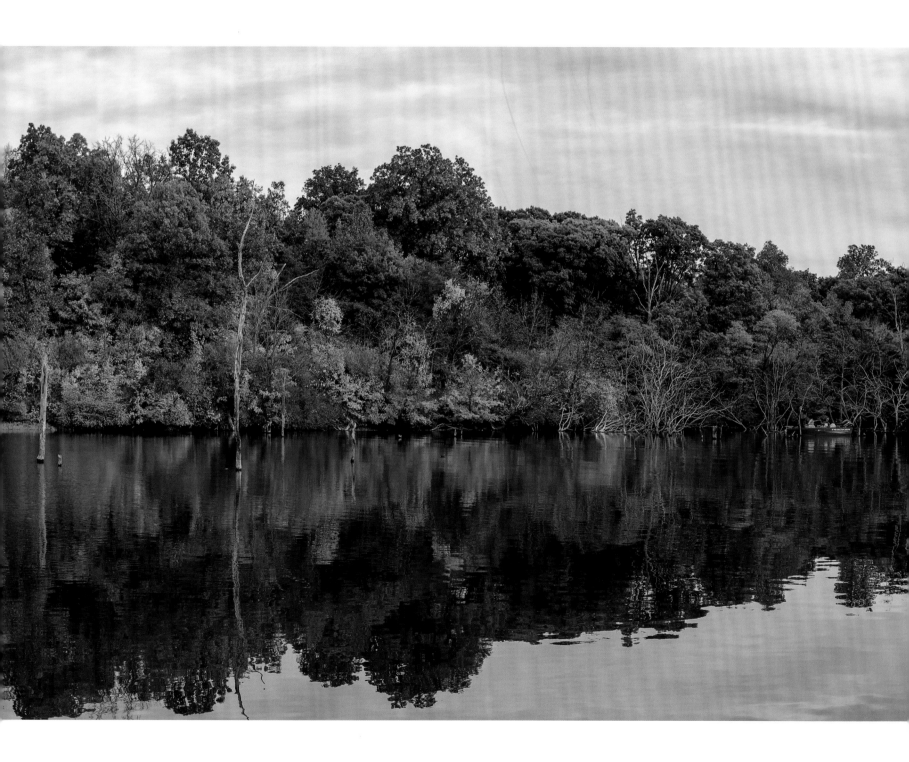

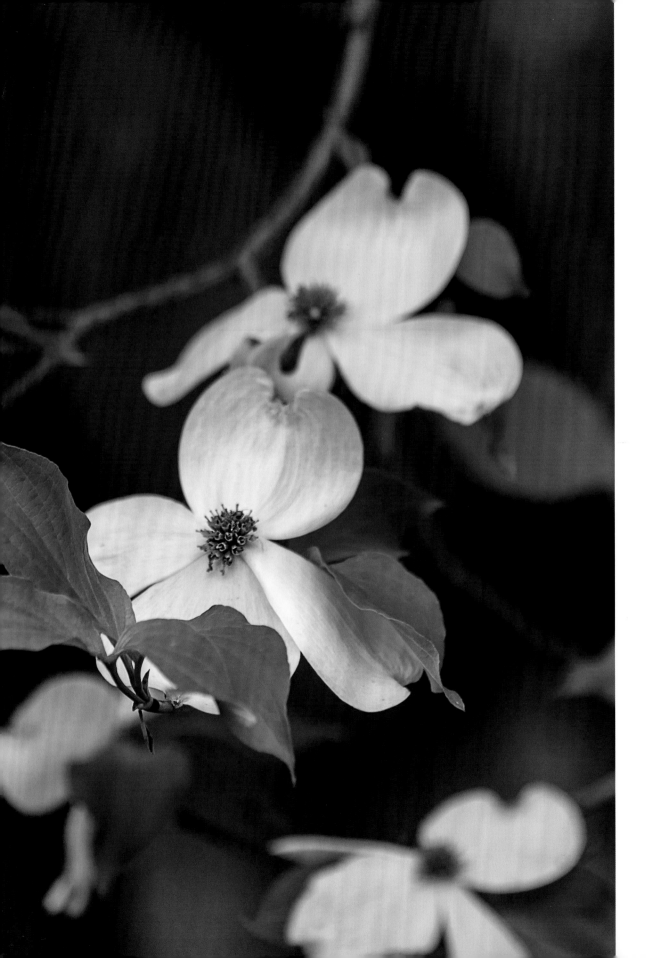

Dogwoods
signal late
spring. *Rend
Lake*

The Illinois
State Capitol
Building.

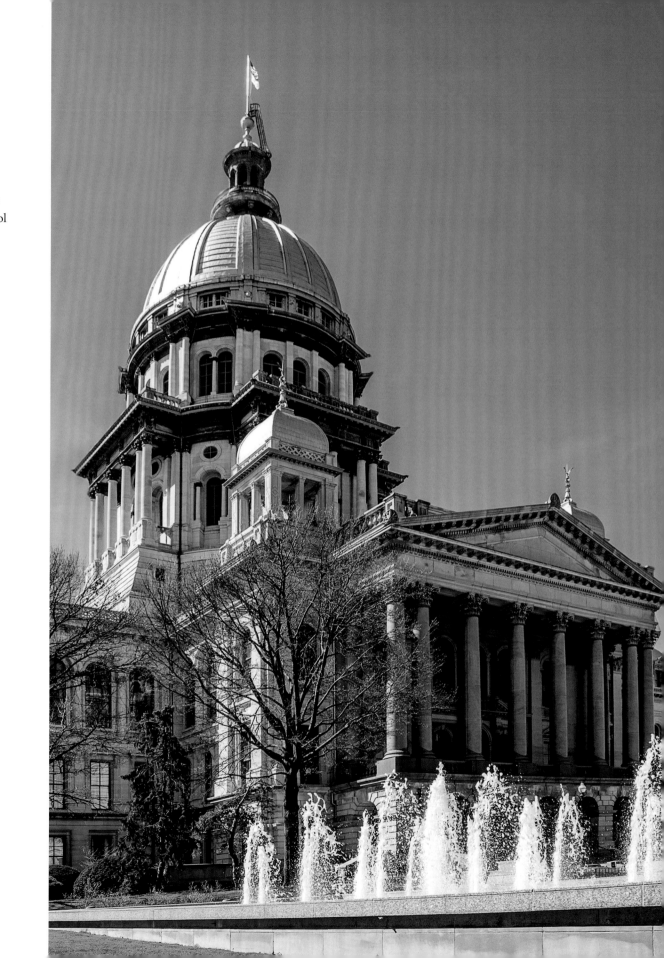

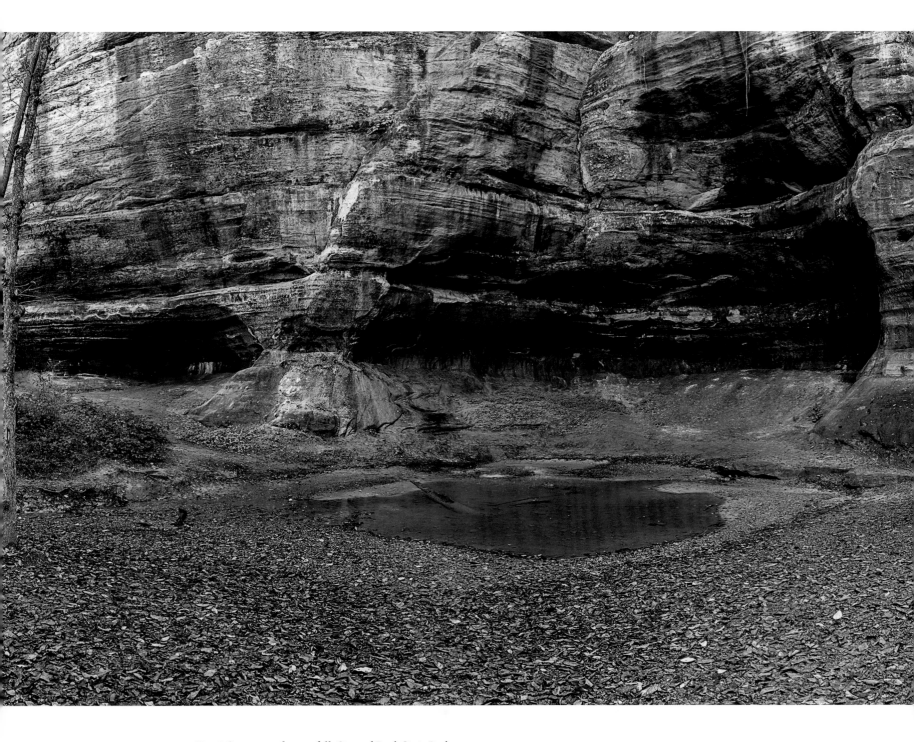

Tonti Canyon and waterfall. *Starved Rock State Park*

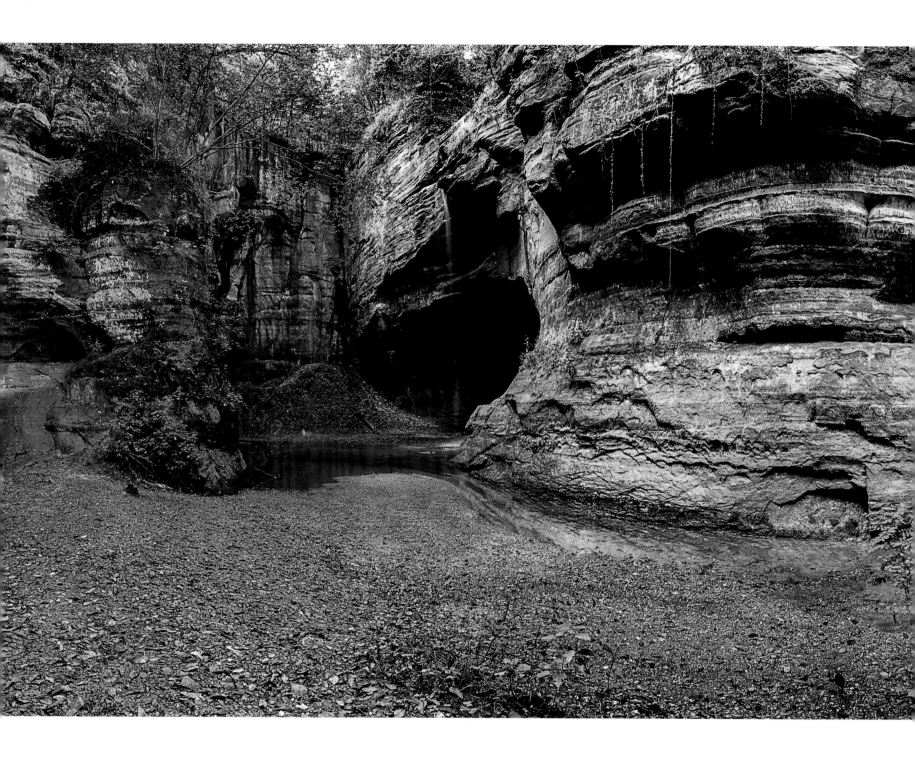

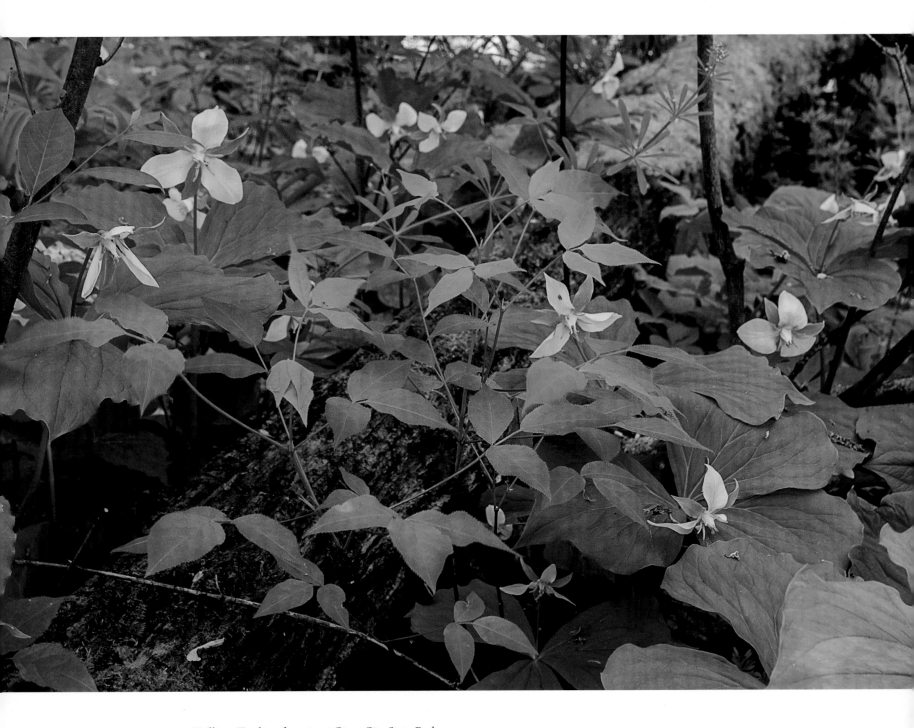

Trillium Trail is a favorite at Giant City State Park.

FACING Abstract patterns in the rocks. *Garden of the Gods*

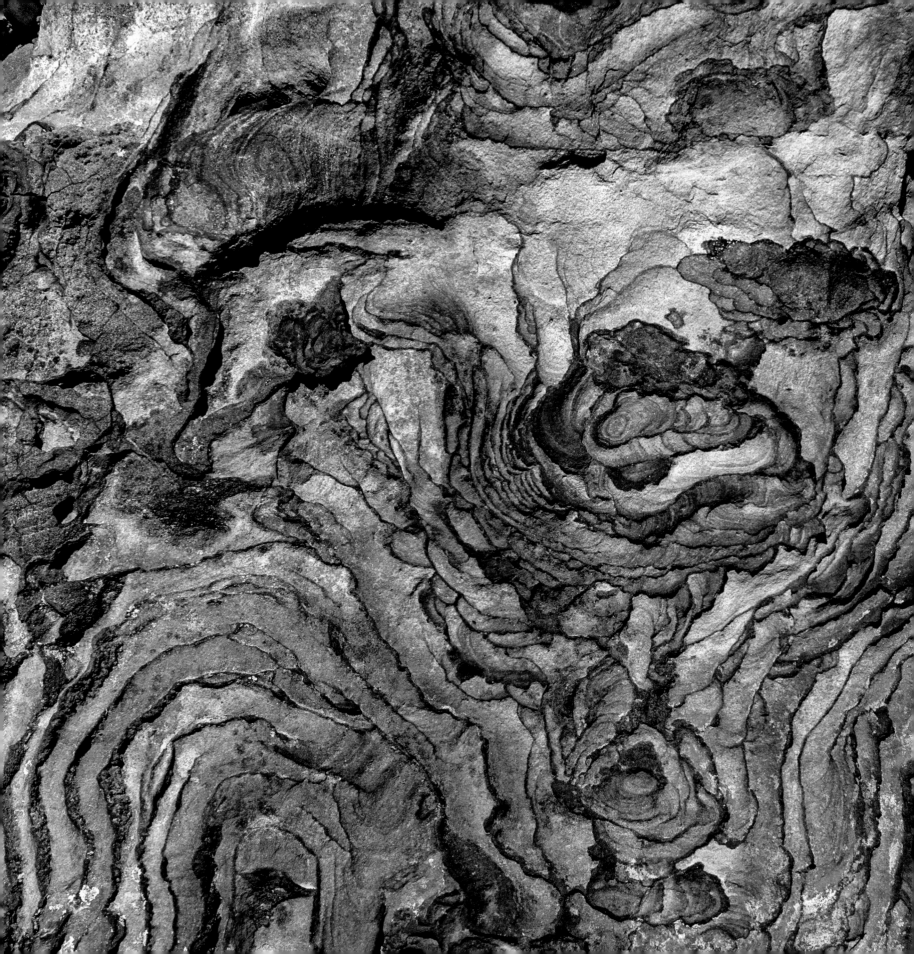

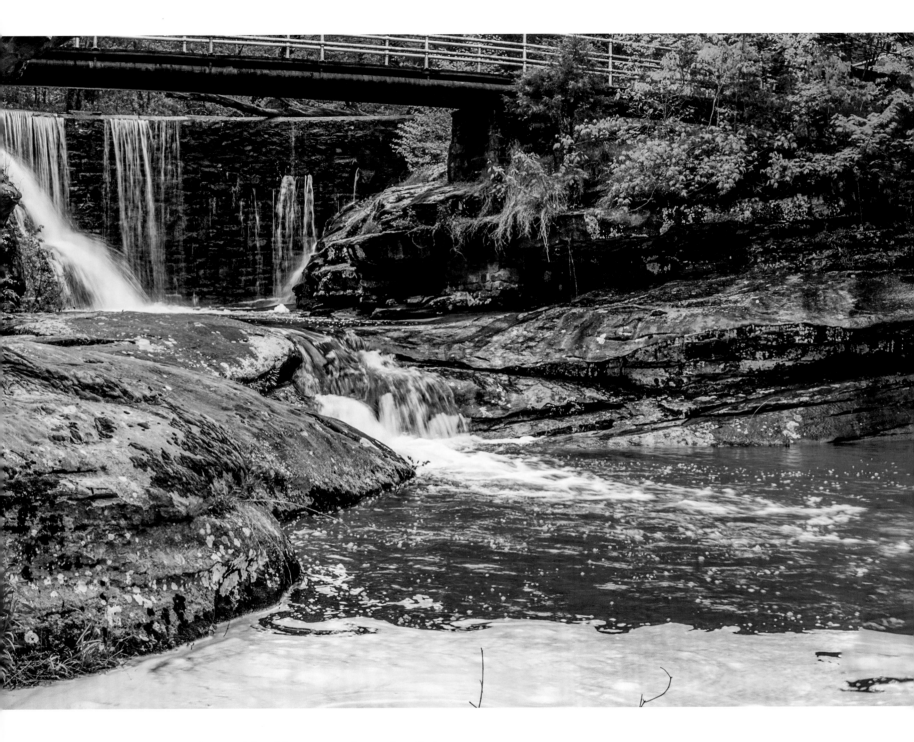

The waterfall and dam at Dixon Springs State Park.

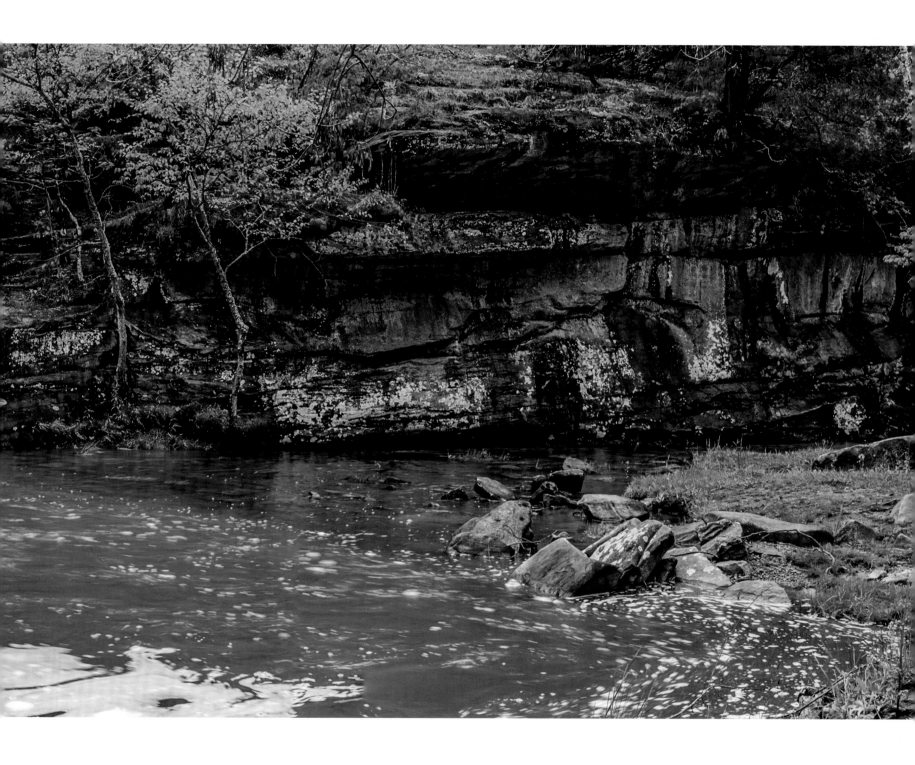

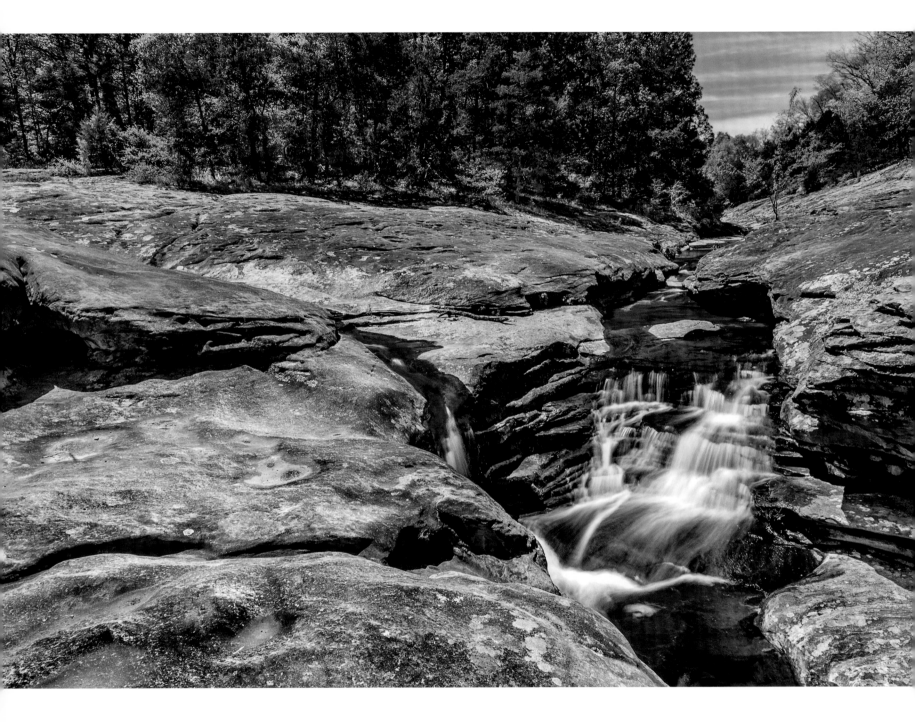

A midday waterfall on the Grist Mill Trail. *Bell Smith Springs*

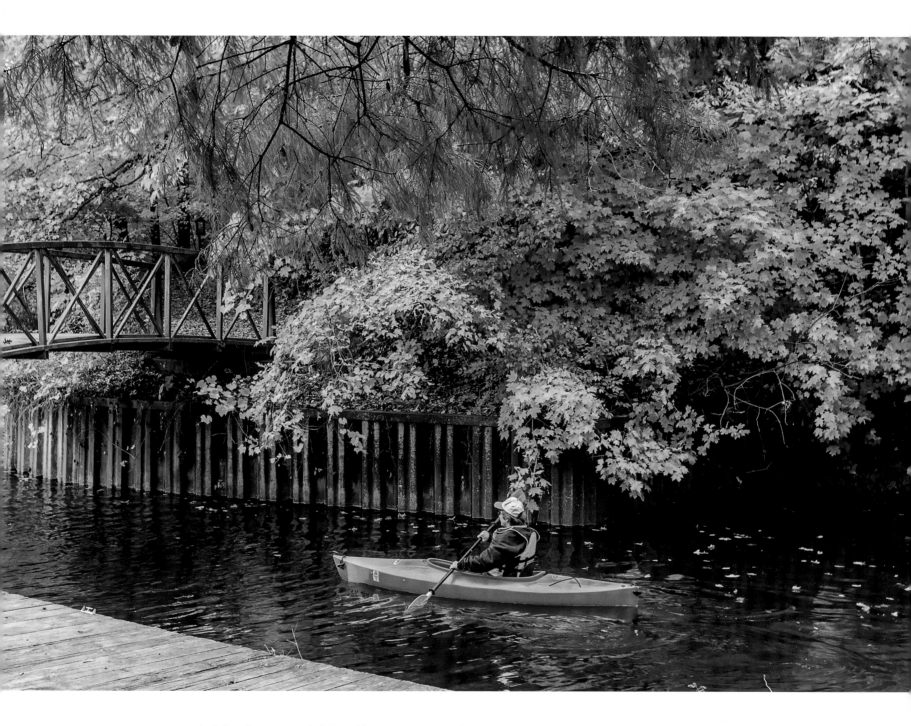

A little kayak time in early fall. *Weldon Springs State Park*

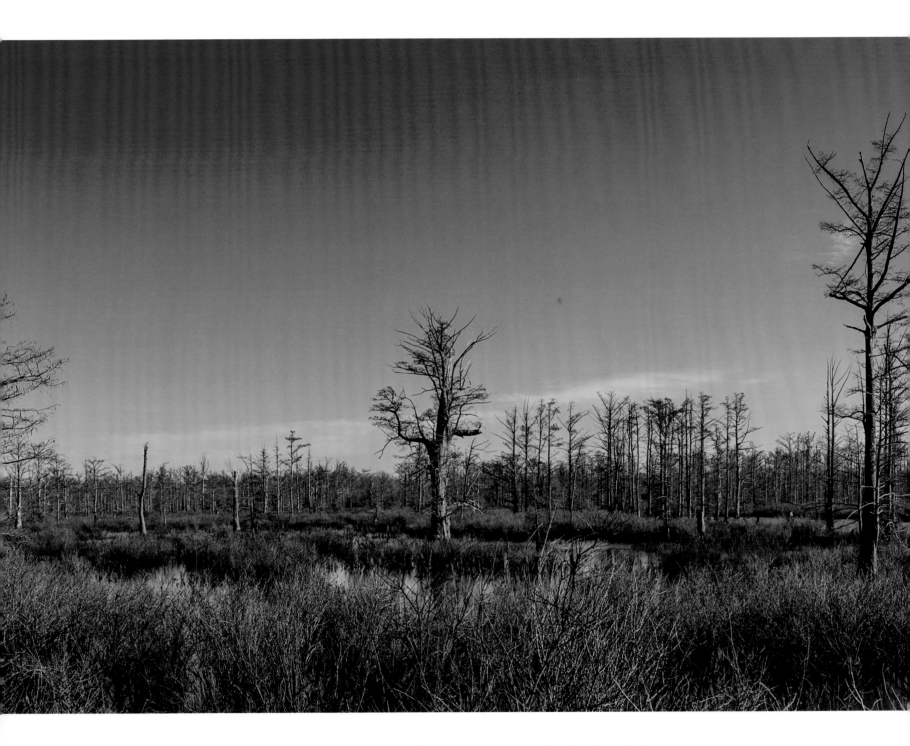

More than 1000 years old and having a circumference measuring more than forty feet at the base,
this cypress is crowned the State Champion Cypress tree.

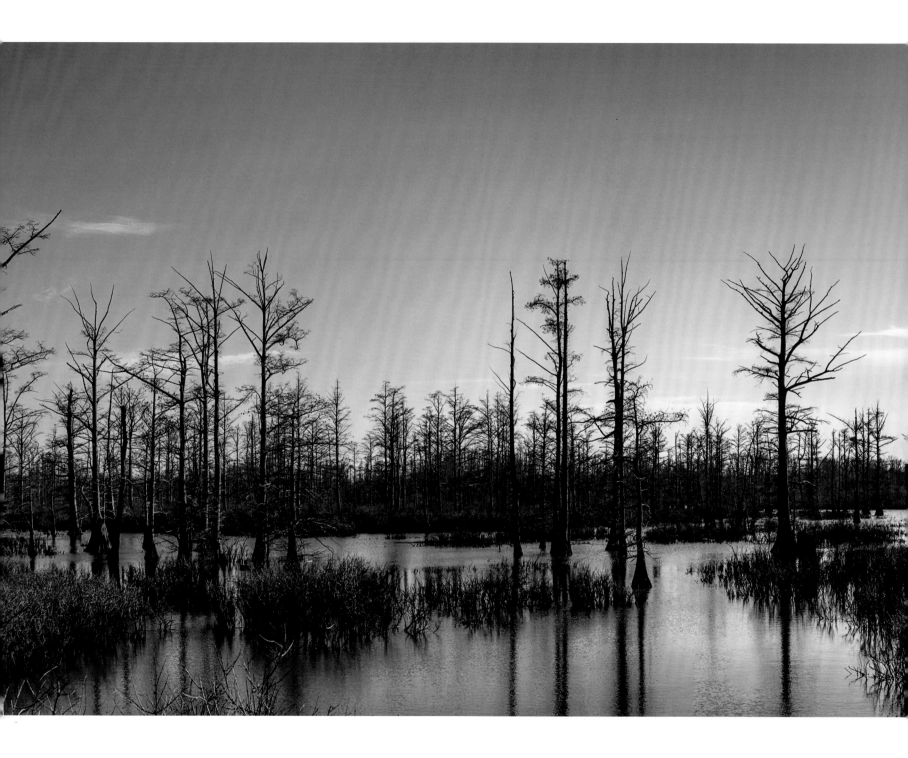

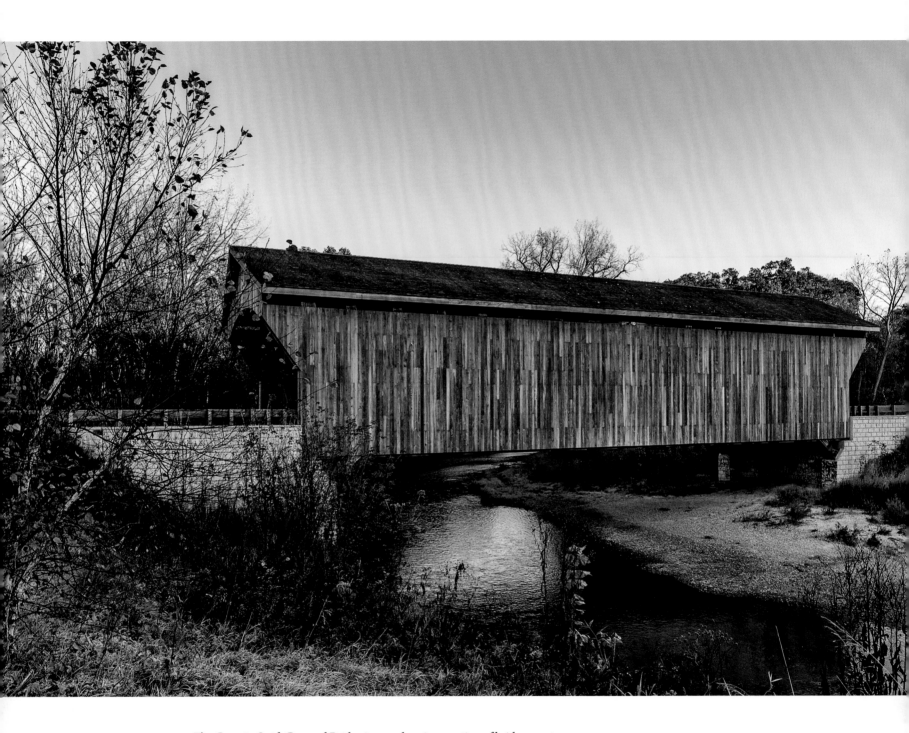

The Captain Swift Covered Bridge is a modern incarnation of bridges past.

FACING A light winter leaves a touch of snow along the beach of Lake Michigan.

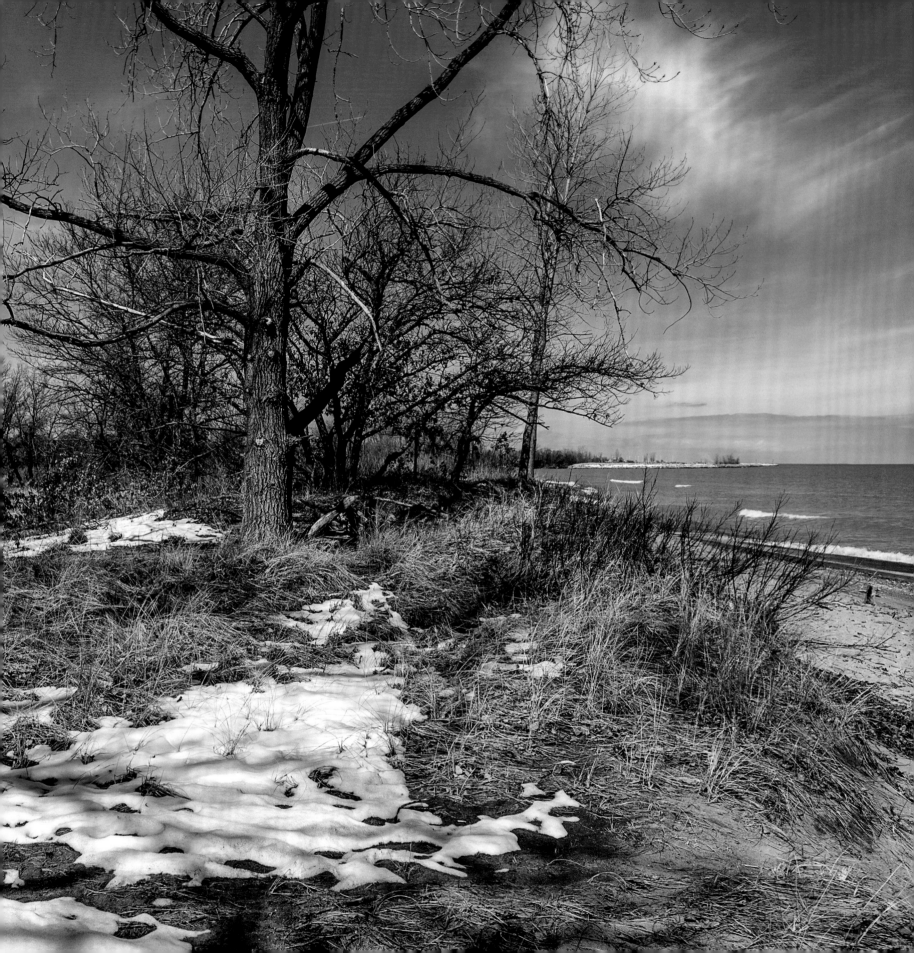

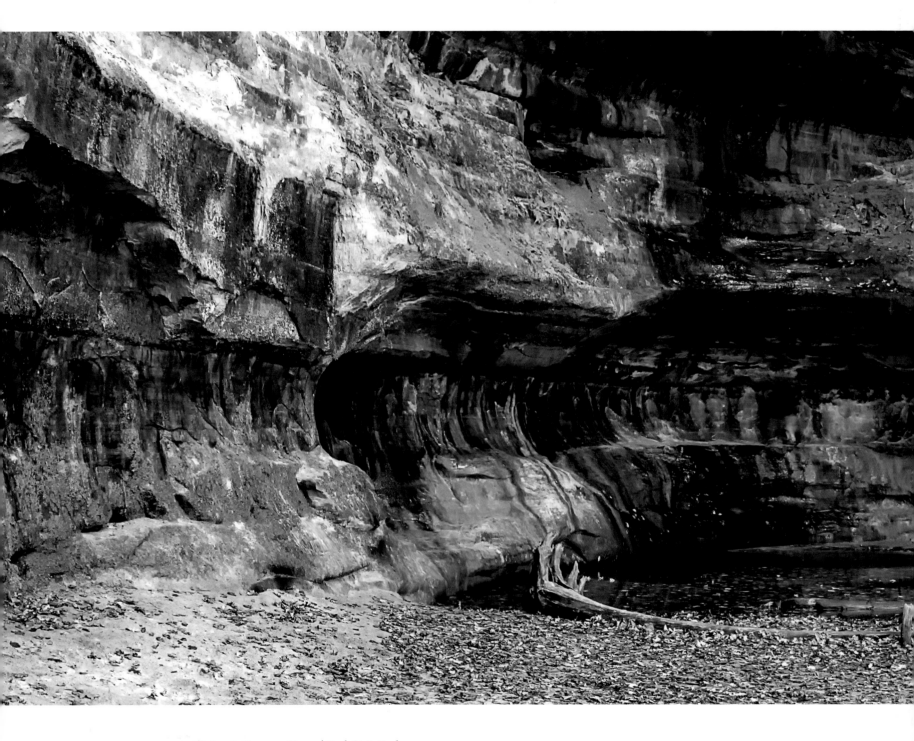

St. Louis Canyon. *Starved Rock State Park*

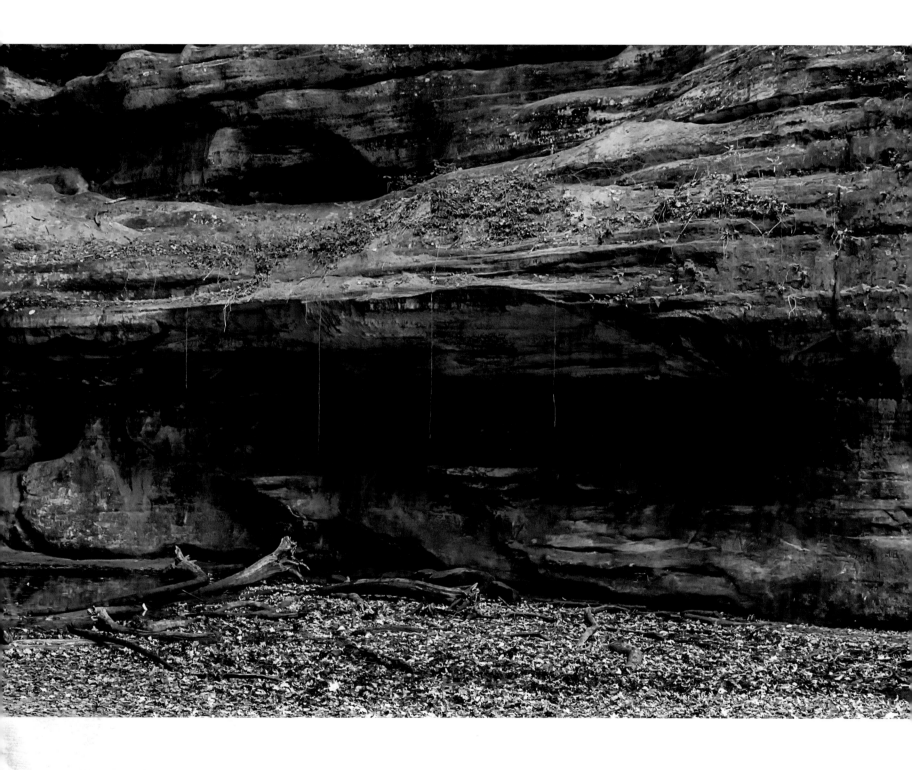

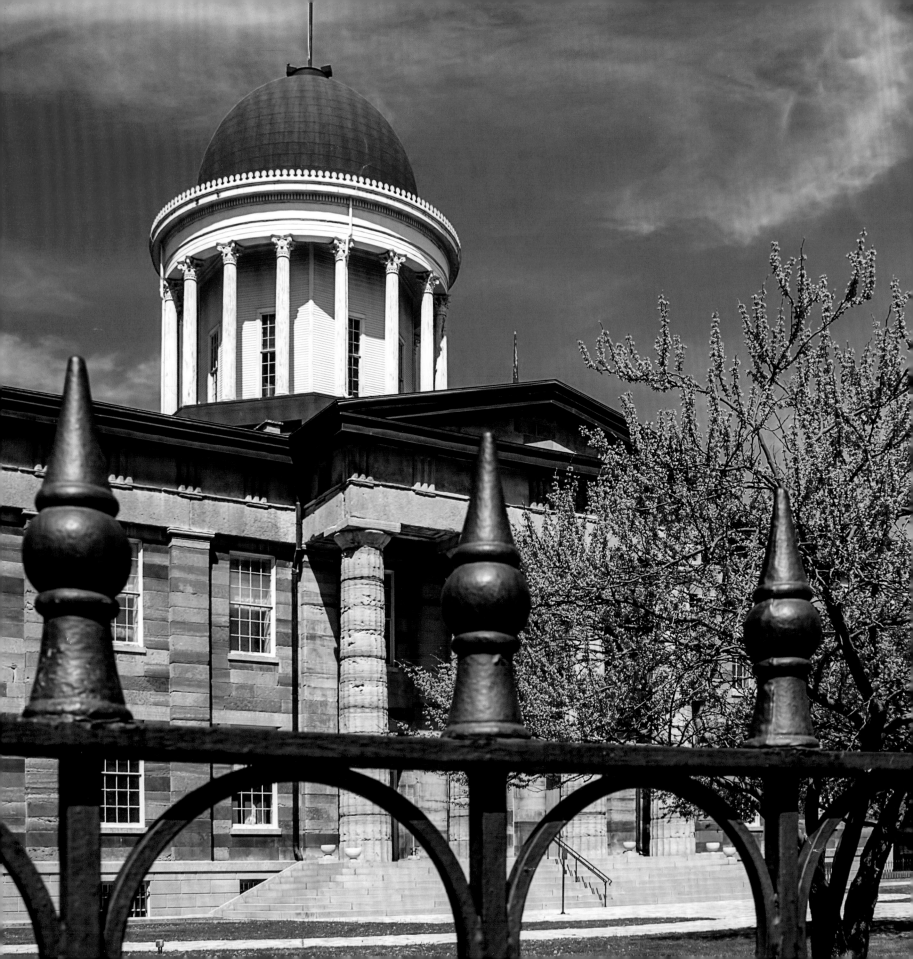

Teepees at
Forest Glen
Nature Preserve
provide an
authentic Indian
experience.

FACING
The historic
State Capitol
Building and
flowering
redbuds.

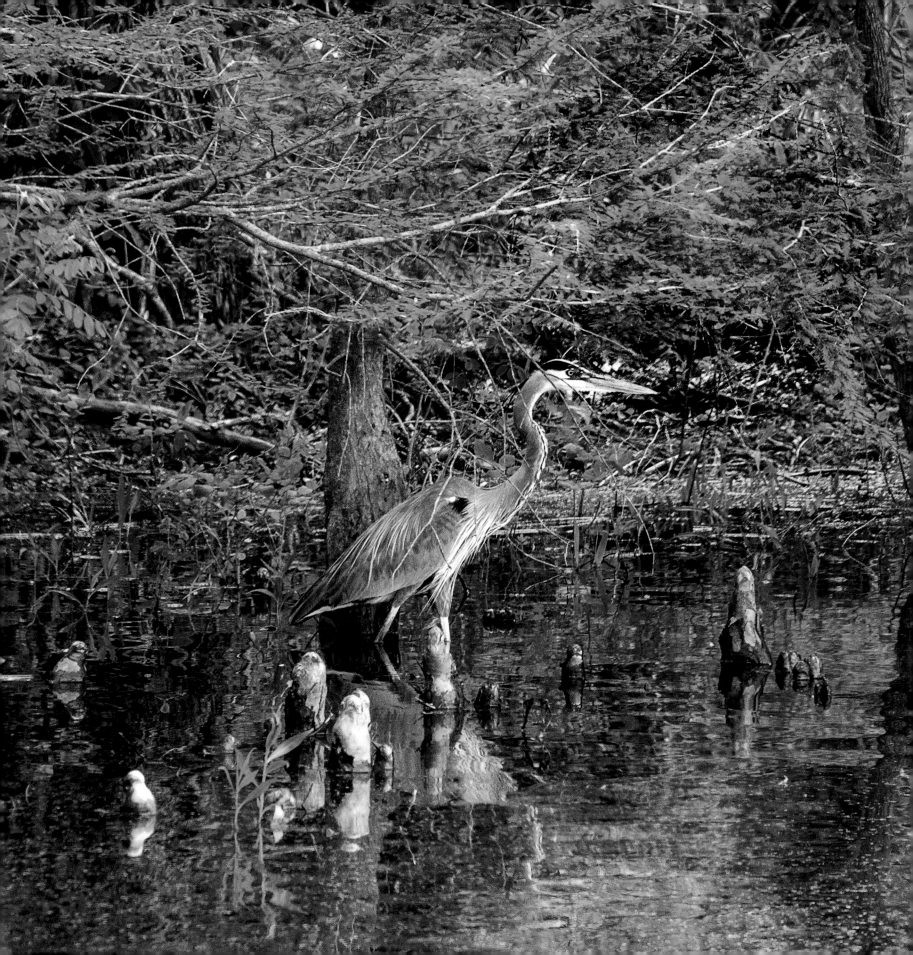

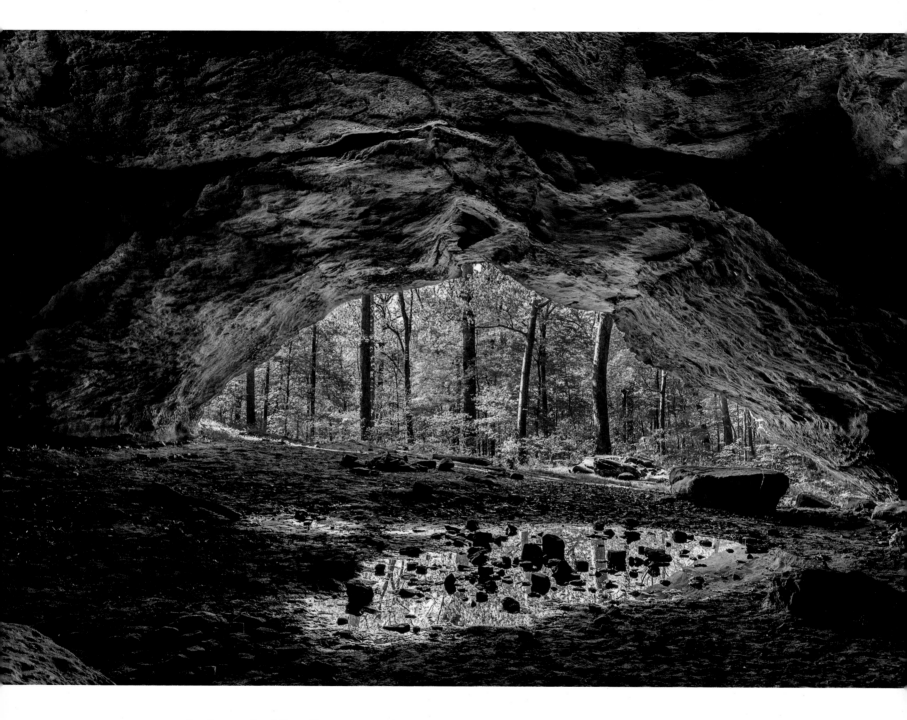

Inside out at Sand Cave. *Shawnee National Forest*

FACING A natural fisherman, a blue heron watches for something to eat. *Crab Orchard Wildlife Refuge*

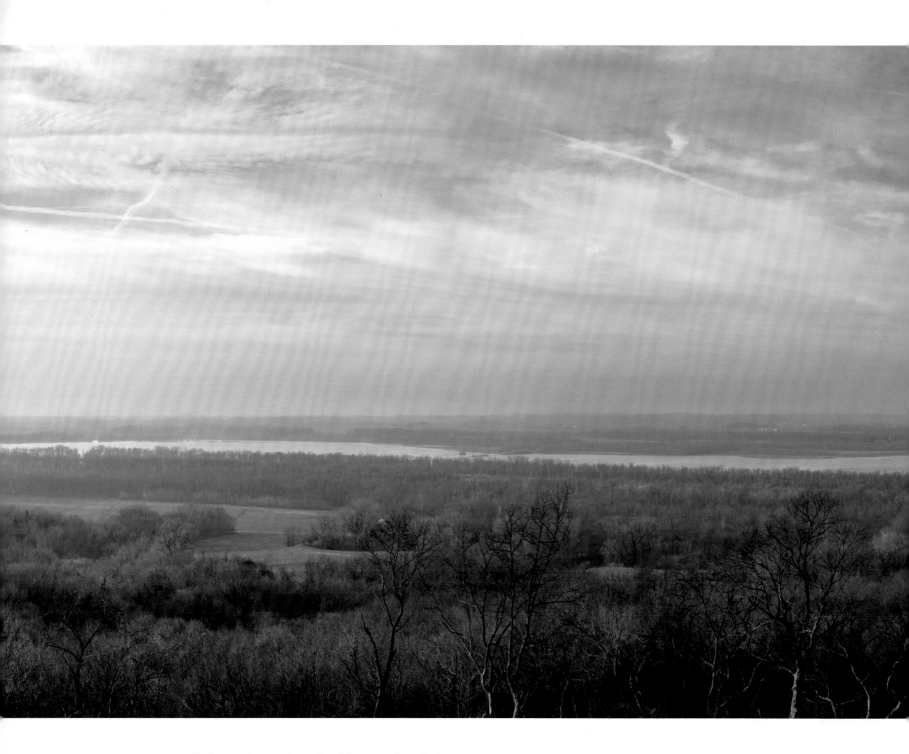

Early morning sunrise at Pere Marquette State Park.

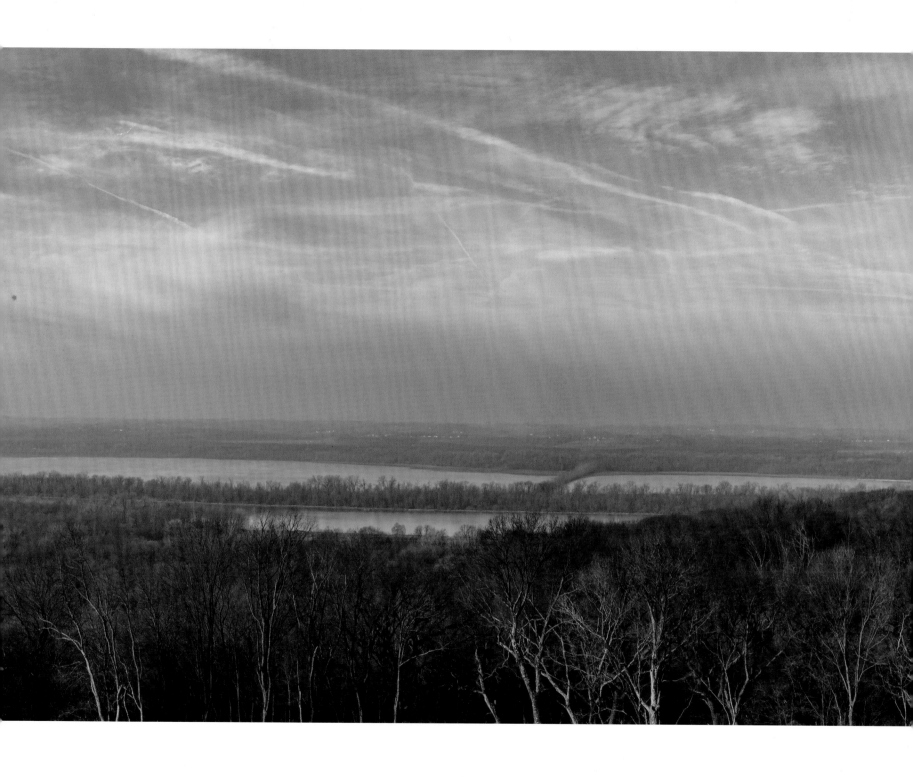

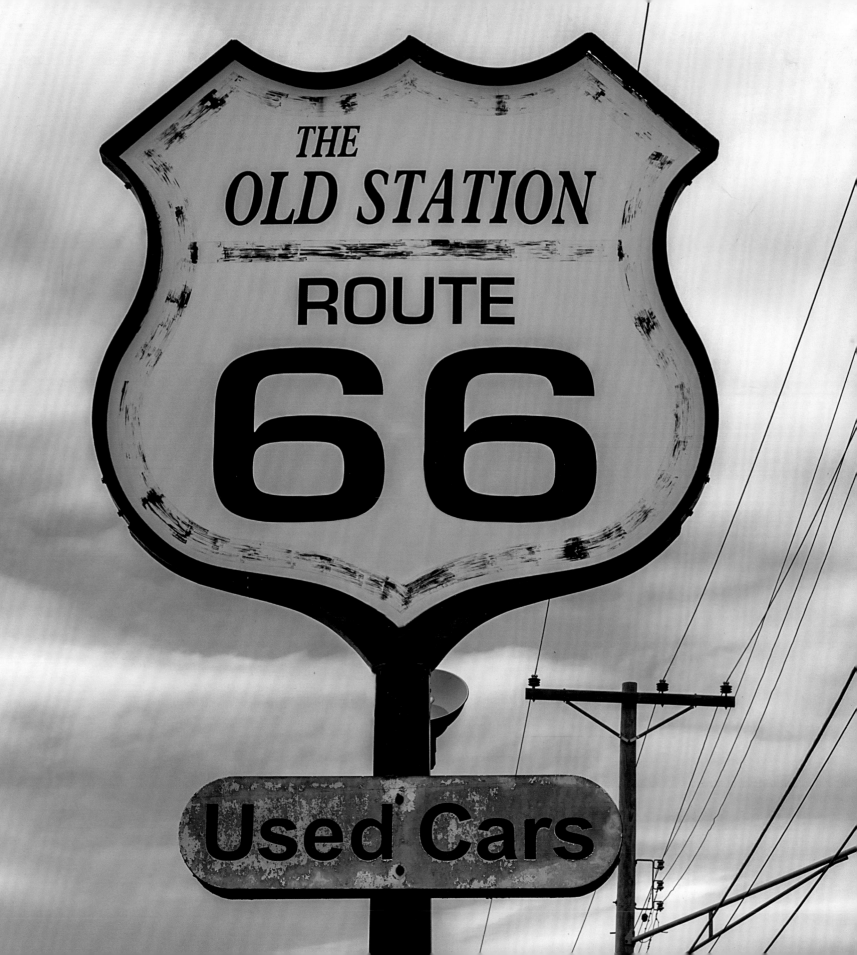

Dogwoods'
white blooms
are a stark
contrast to the
surrounding
forest.

FACING
The Old
Station along
Route 66 in
Williamsville.

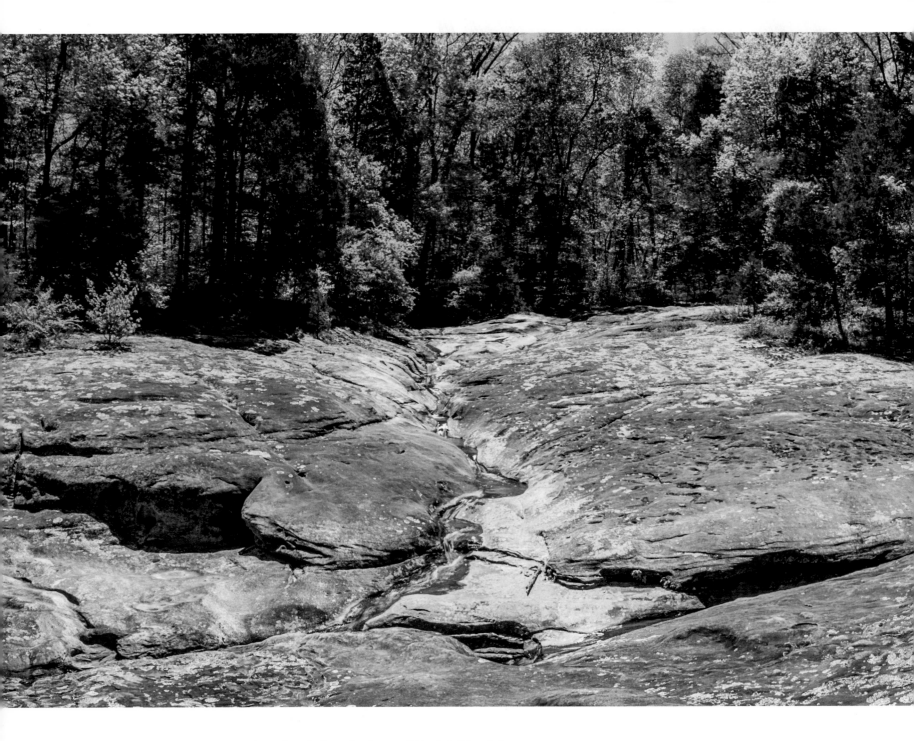

Water cuts through rock along the Grist Mill Trail. *Bell Smith Springs*

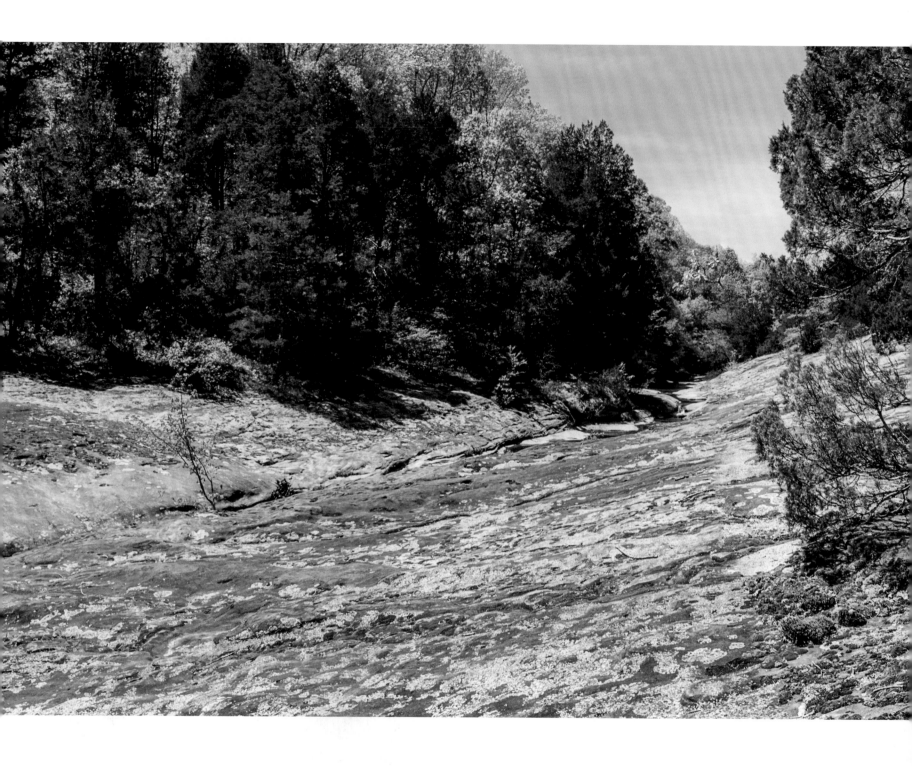

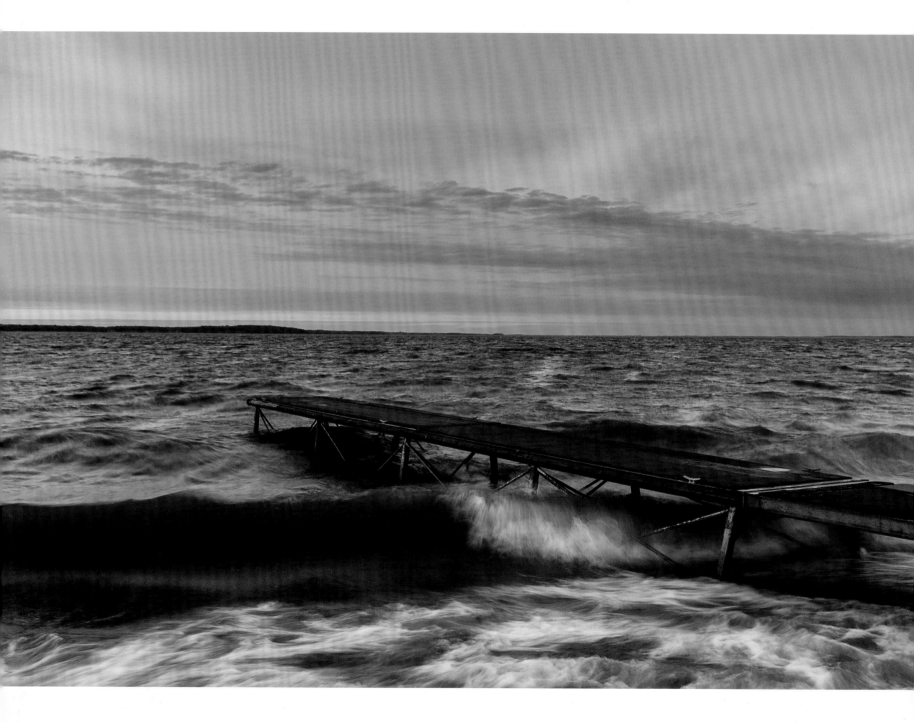

Evening breakers rolling in. *Carlyle Lake*

FACING A fiery sunset at day's end. *Crab Orchard Wildlife Refuge*

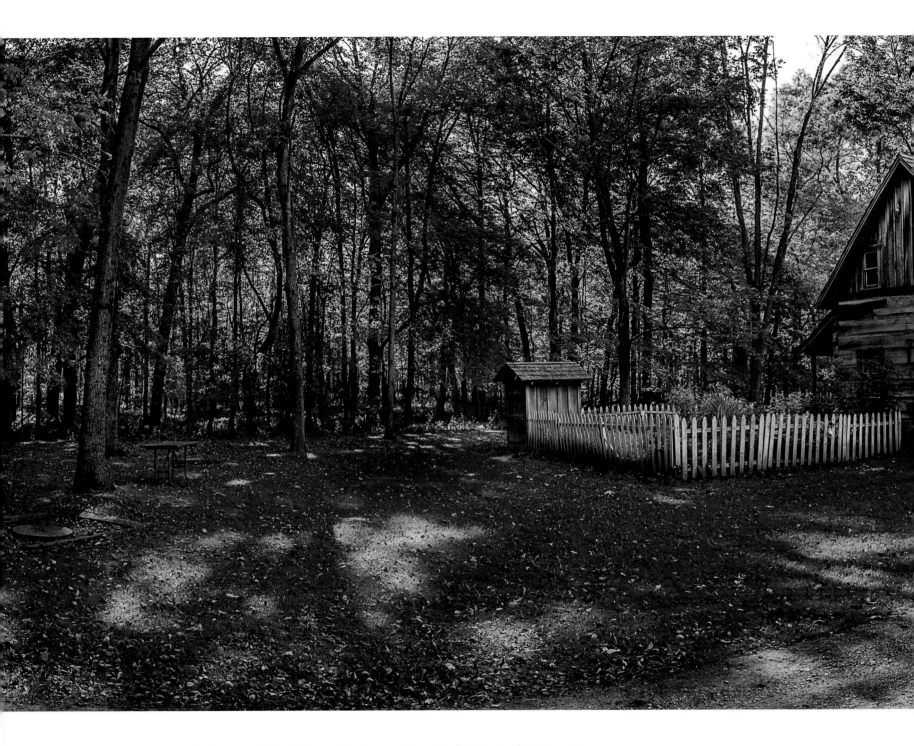

Enjoy a peaceful walk through the Pioneer Homestead at Forest Glen Nature Preserve.

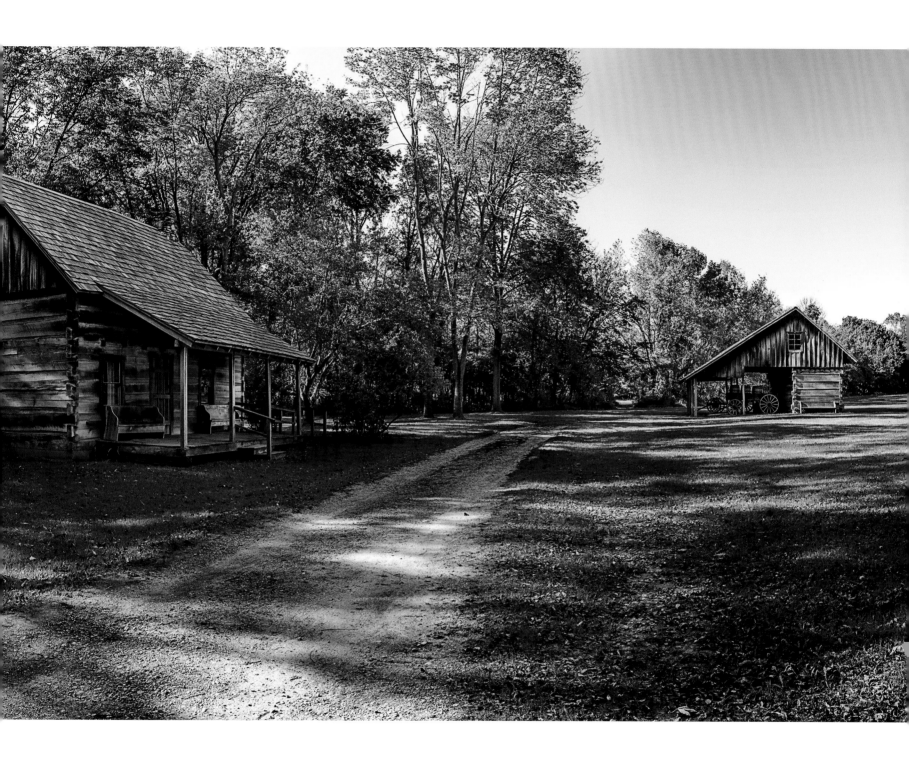

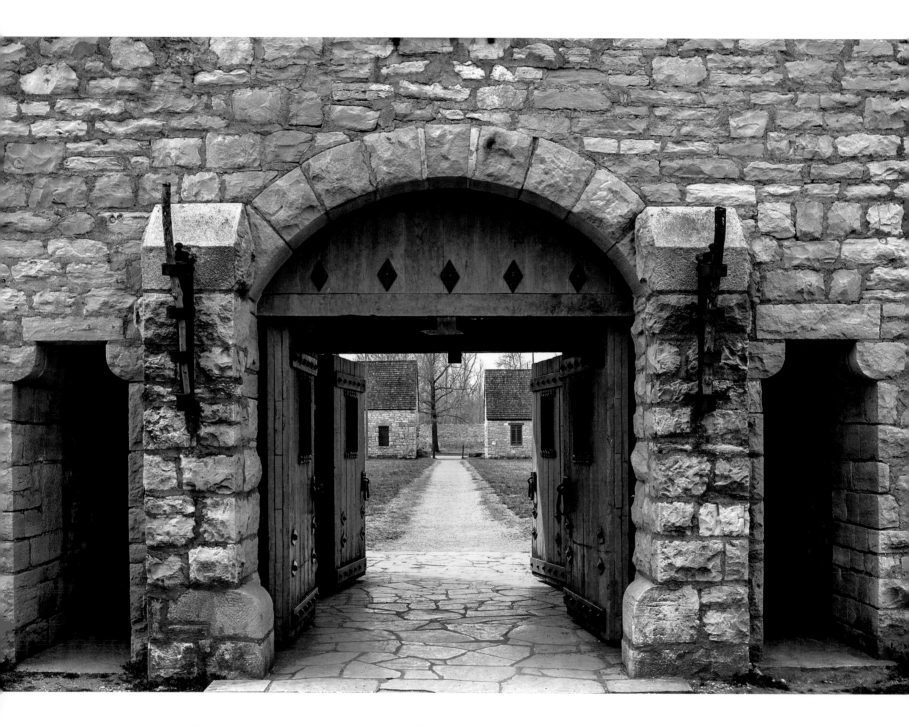

Everyone is welcome. *Fort De Chartres State Historic Site*

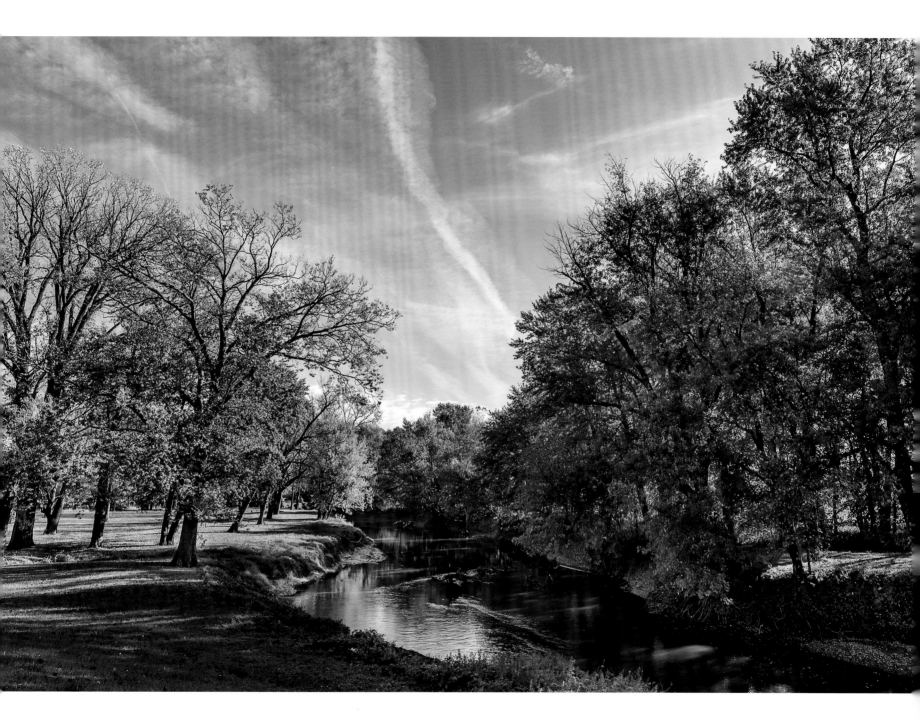

A very peaceful morning. *Henderson Recreation Area*

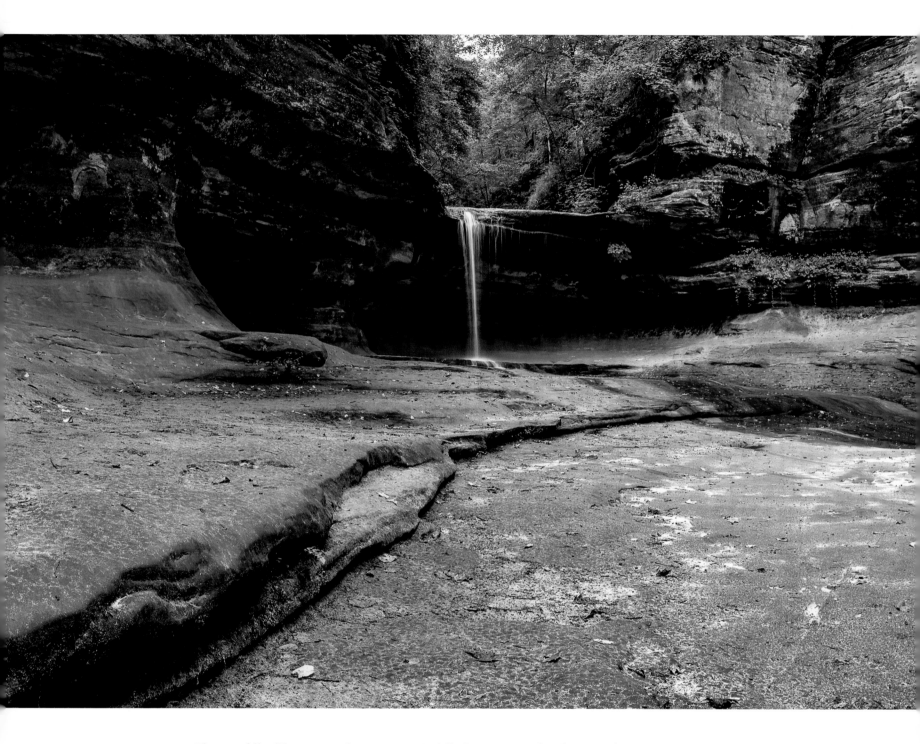

The waterfall still lingers on in late summer in LaSalle Canyon. *Starved Rock State Park*

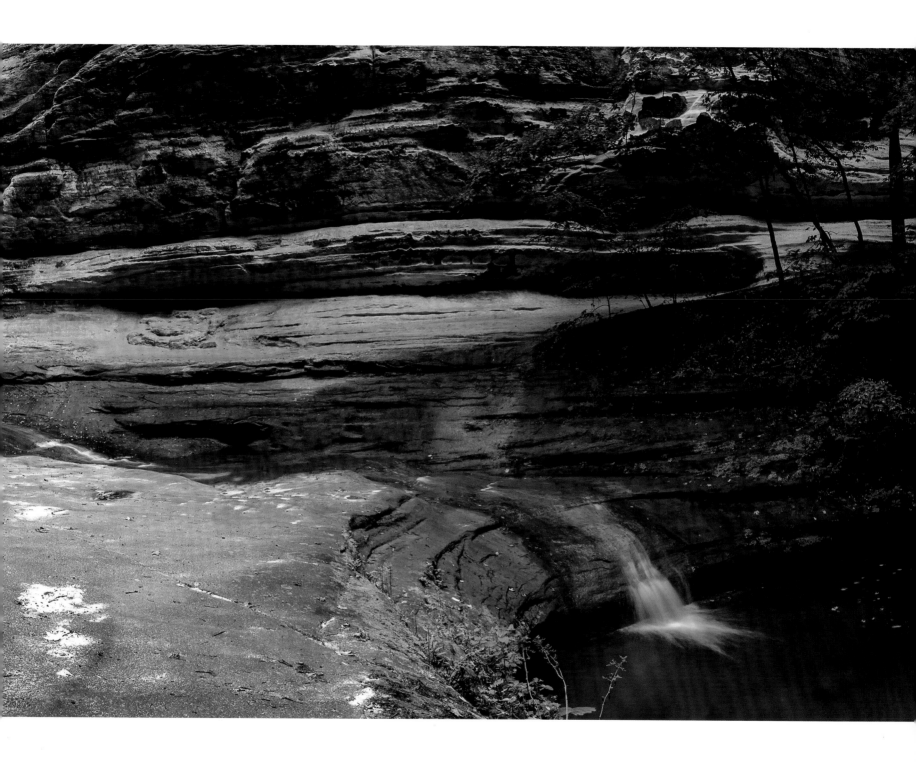

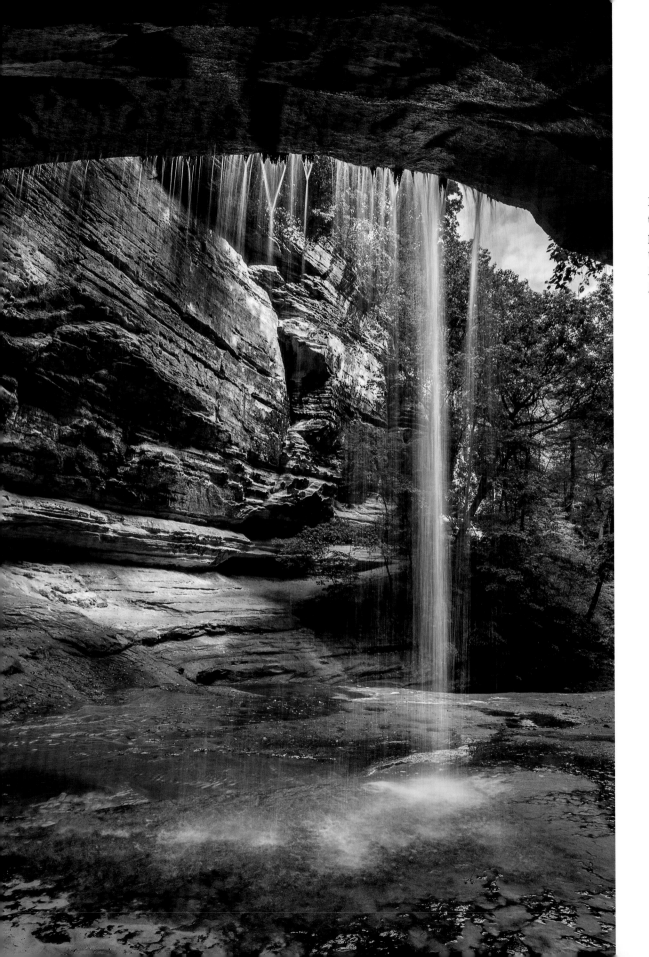

Be careful not to get wet when passing under the falls. *LaSalle Falls, Starved Rock State Park*

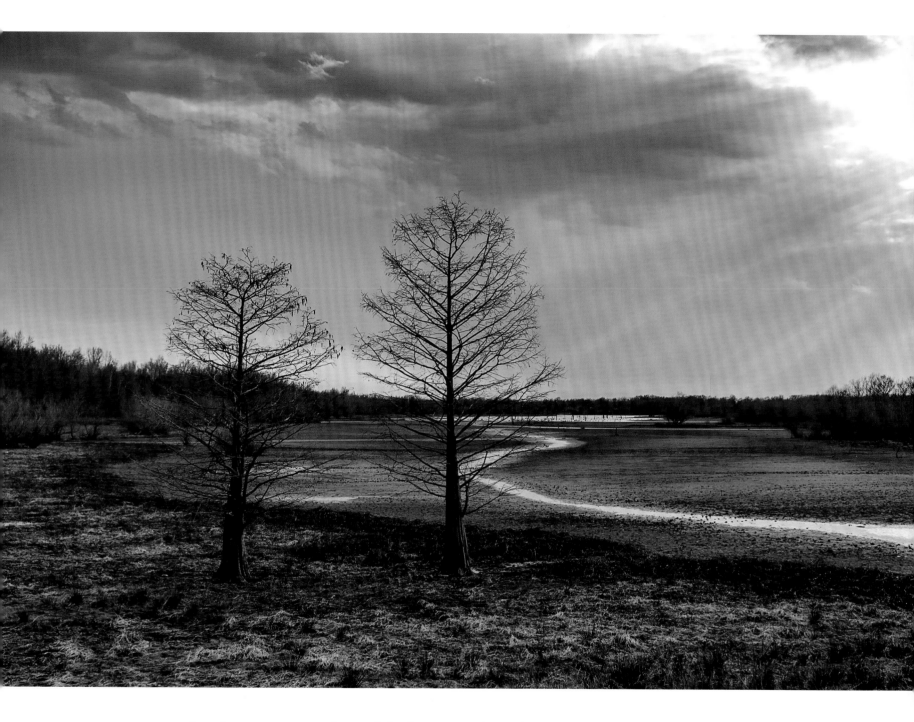

Late afternoon sunrays cast dramatic light after a storm. *Lake Carlyle*

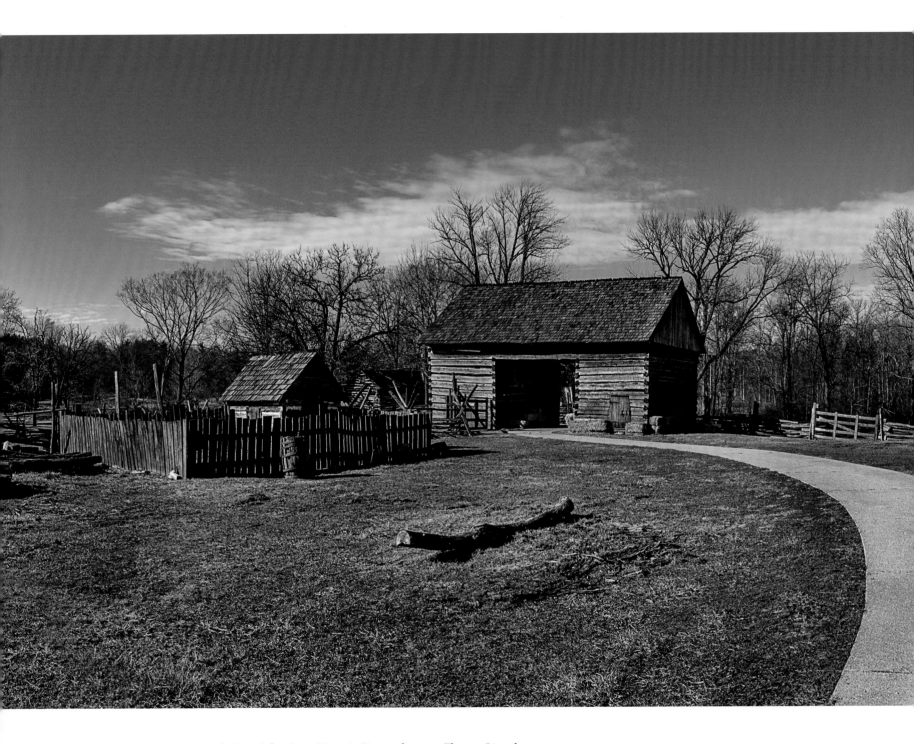

Lincoln Log Cabin State Historic Site was home to Thomas Lincoln.

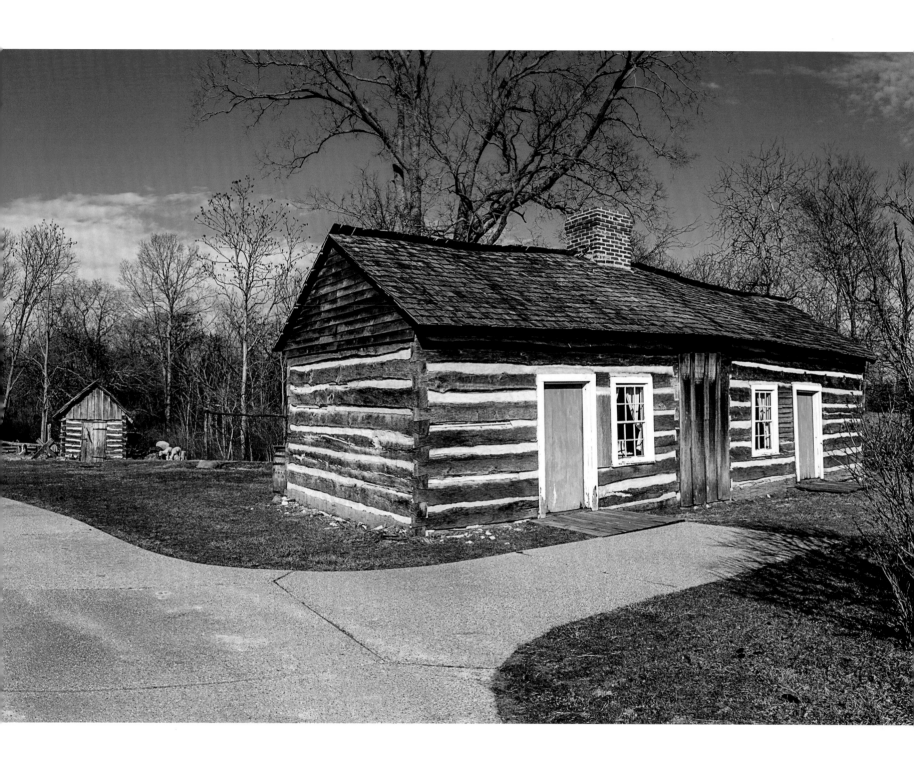

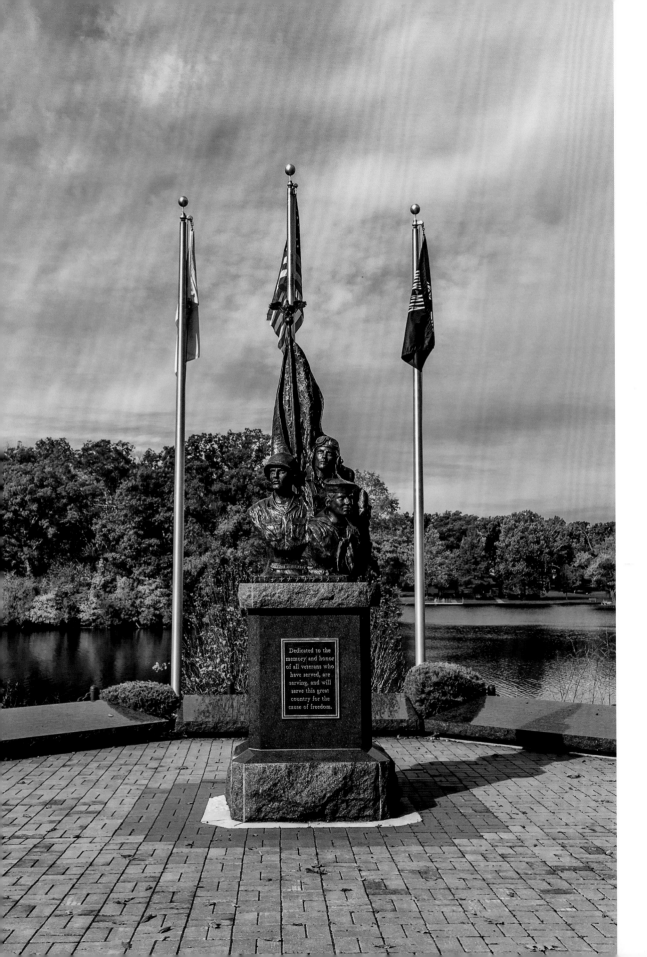

A statue
honoring our
many veterans.
*Weldon Springs
State Park*

FACING
An overlook
from the Bell
Smith Grist
Mill Trail.

Dedicated to the
memory and honor
of all veterans who
have served, are
serving, and will
serve this great
country for the
cause of freedom.

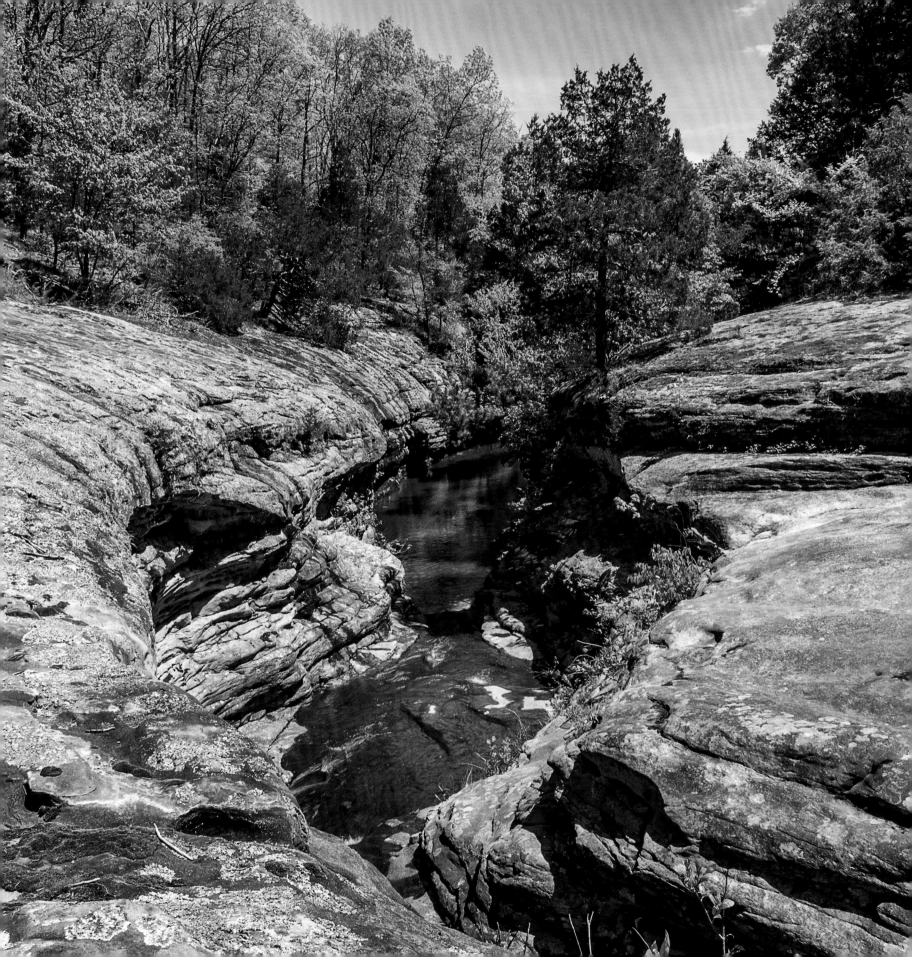

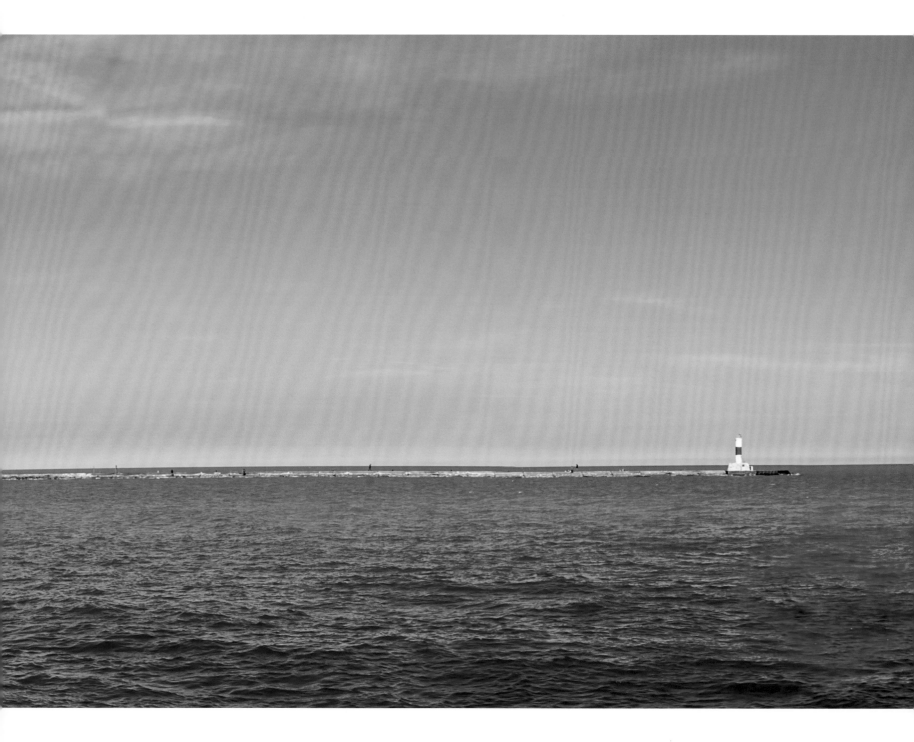

The Waukegan Harbor Lighthouse stands watch over Lake Michigan.

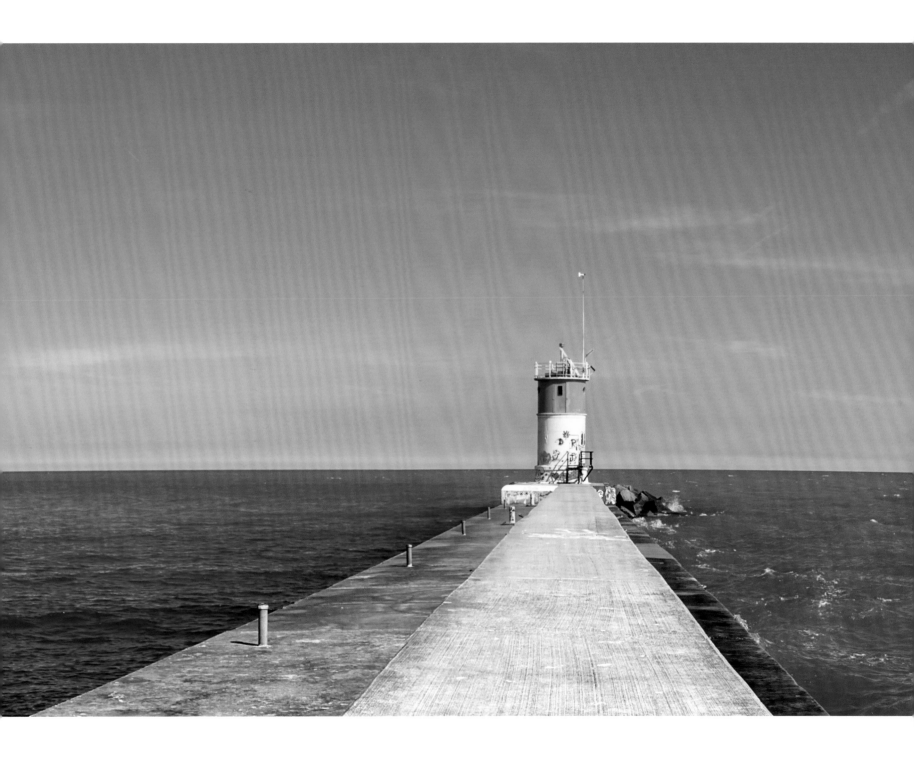

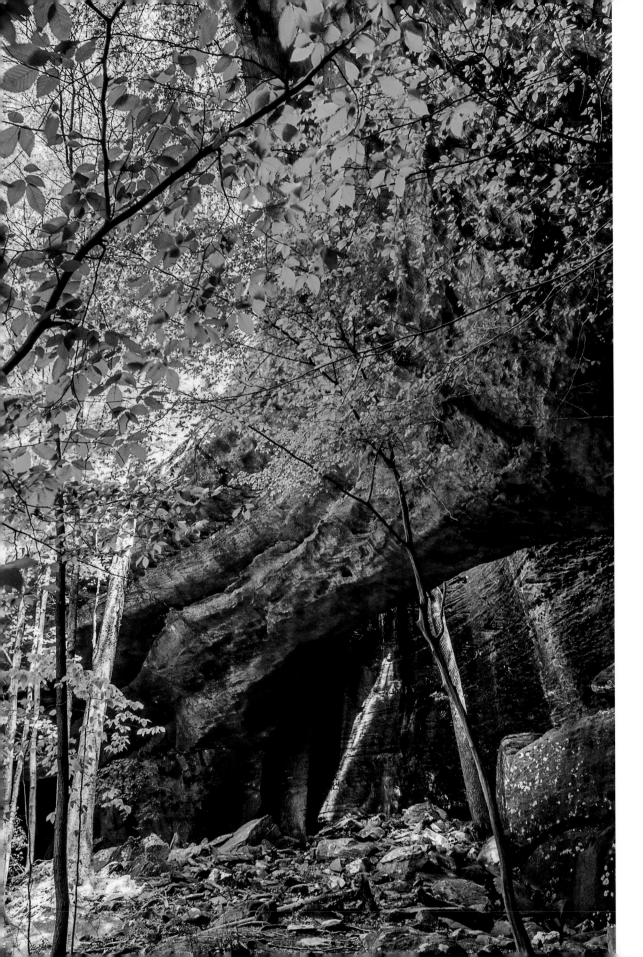

It's well worth the effort, but one has to cross the water to see Bell Smith Springs natural rock bridge.

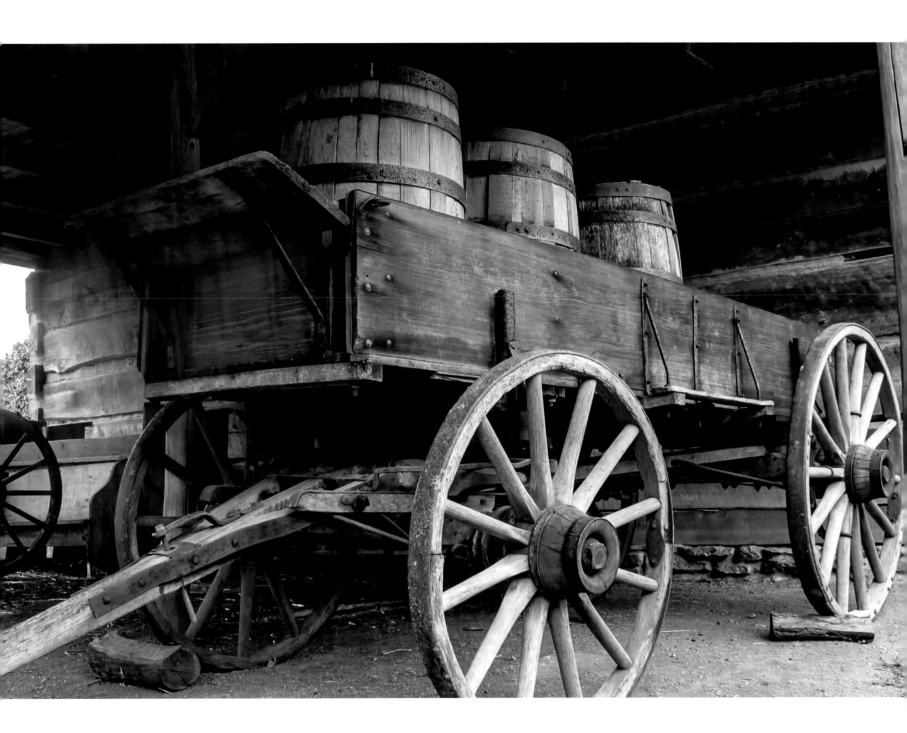

A primitive wagon ready to move merchandise. *Forest Glen Nature Preserve*

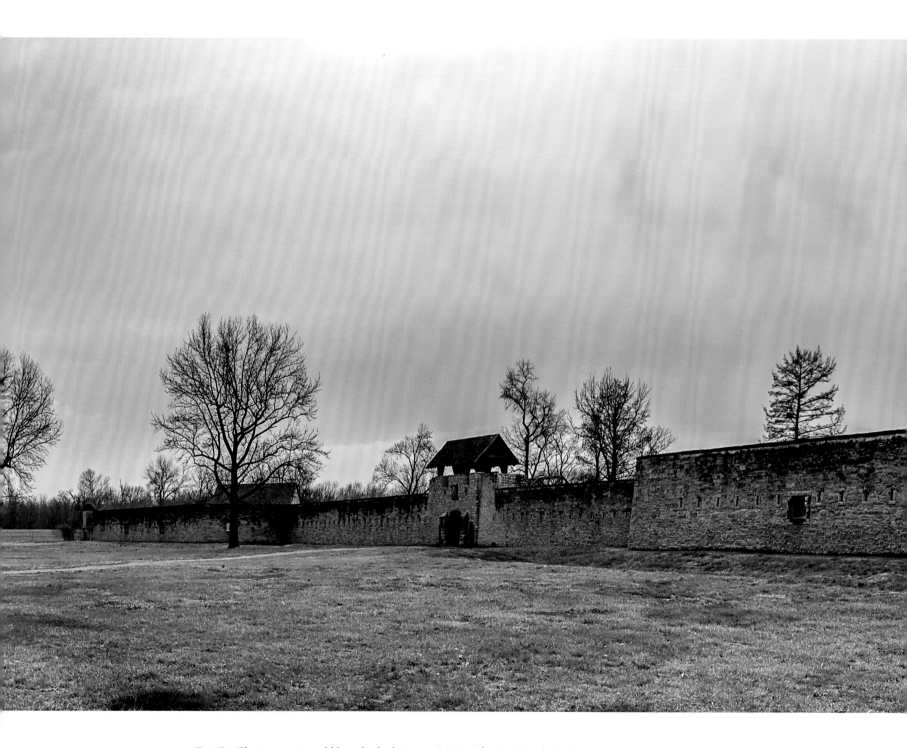

Fort De Chartres as it would have looked in 1753. *Fort De Chartres State Historic Site*

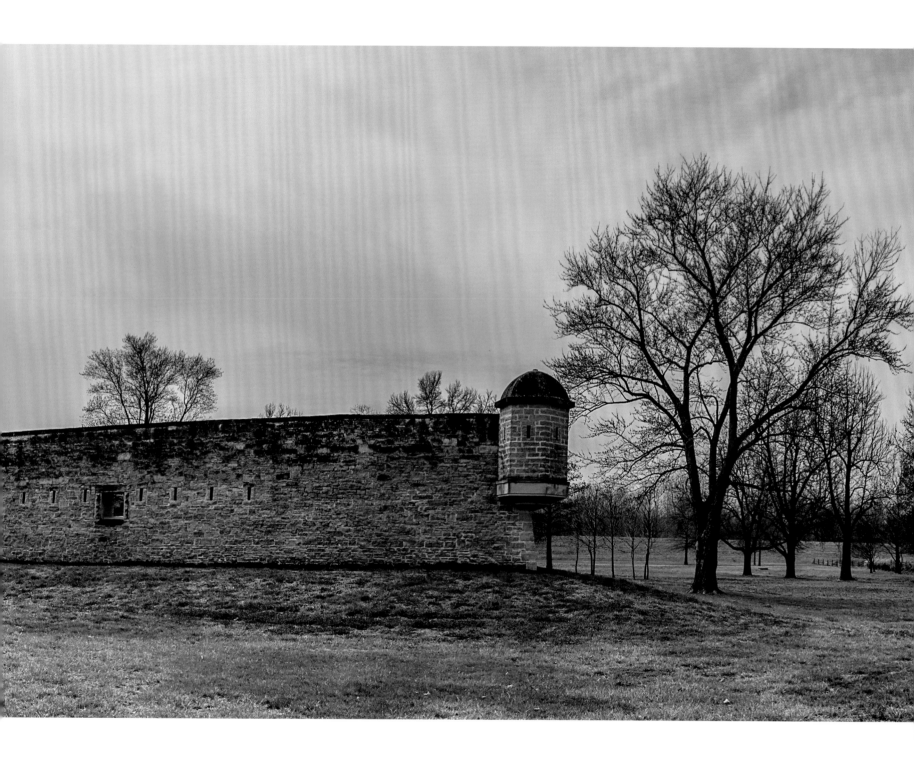

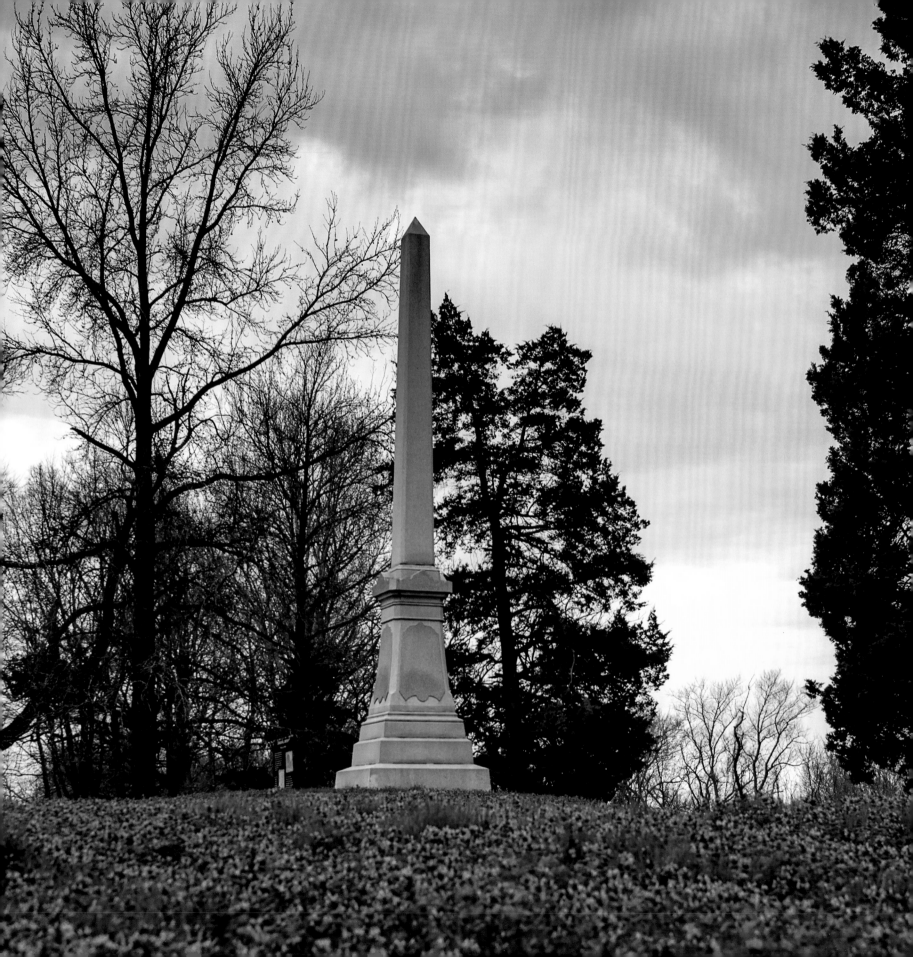

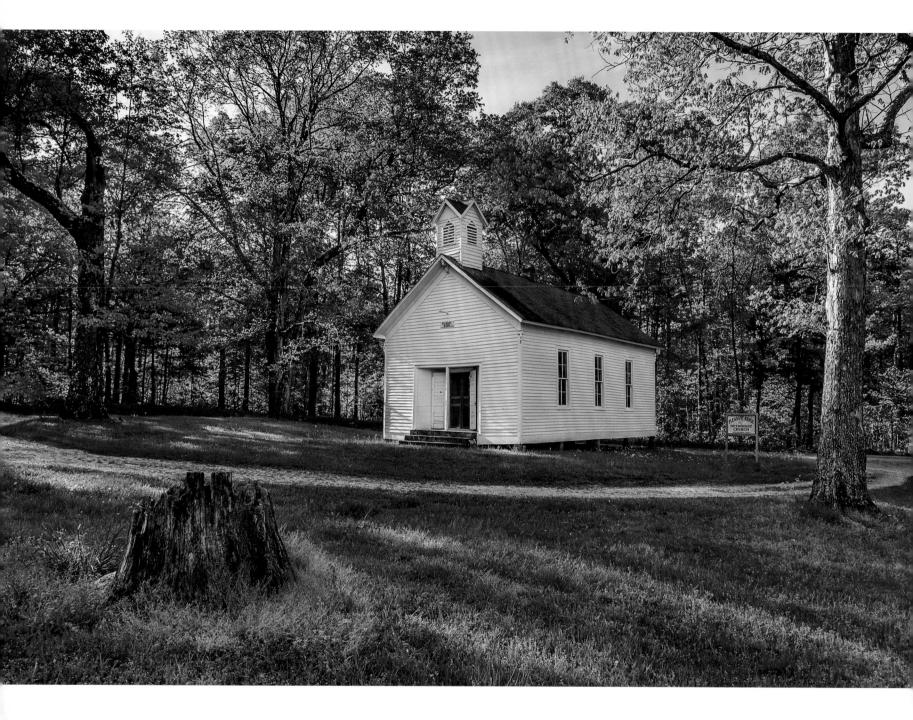

Historic Pleasant Ridge Church nestled in the Shawnee National Forest.

FACING A lone monument marks where Fort Kaskaskia once stood. *Fort Kaskaskia State Historic Site*

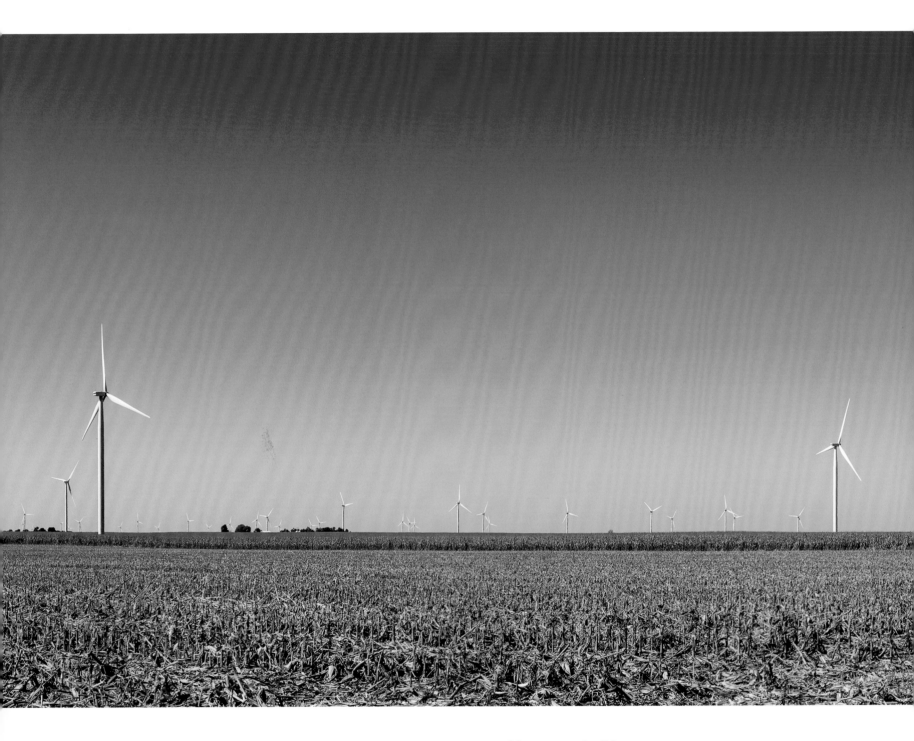

When traveling through Illinois, you are sure to encounter one of the many windmill farms.

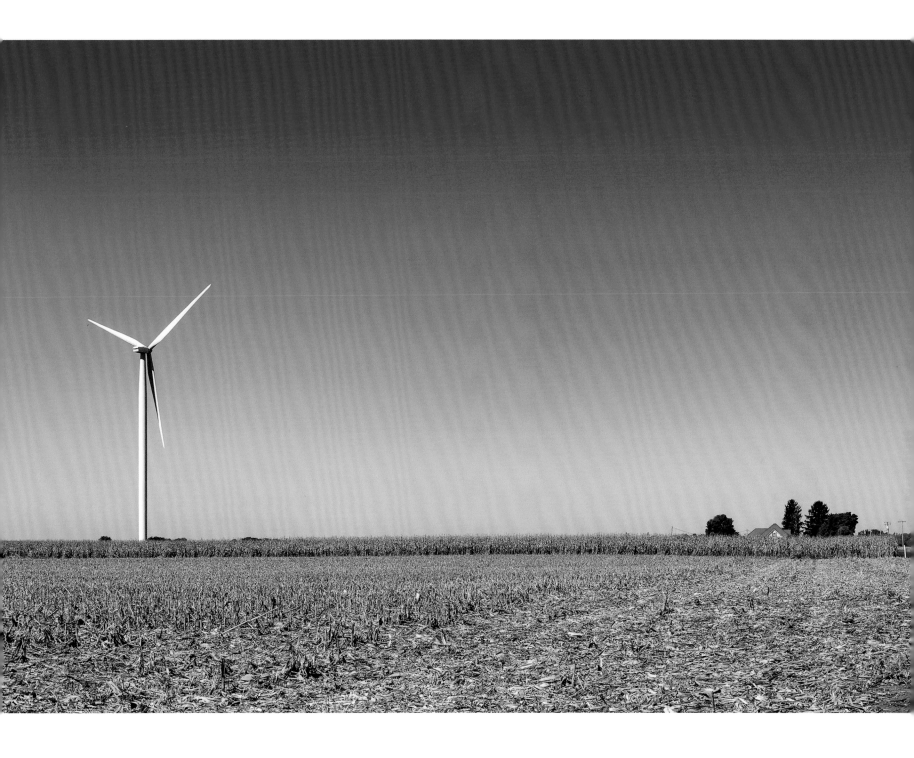

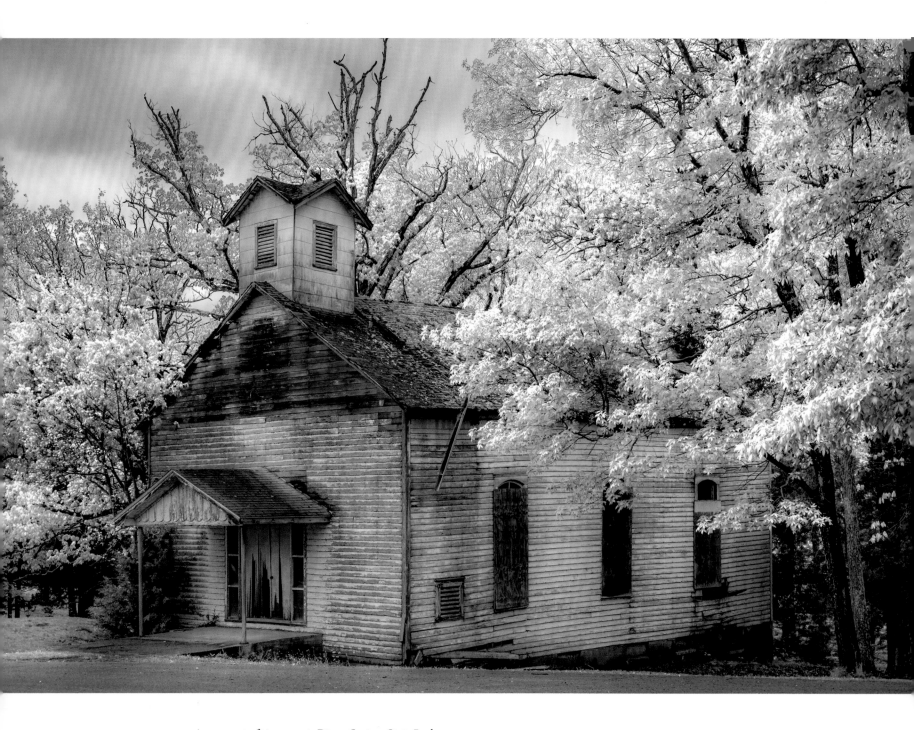

A remnant of times past. *Dixon Springs State Park*

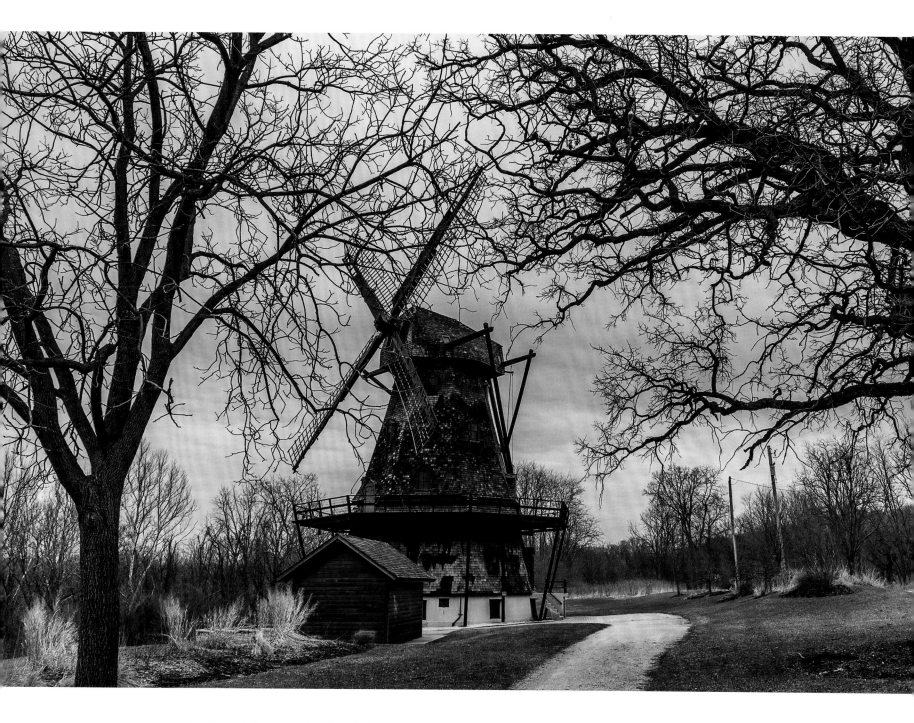

A mid-1800's Dutch windmill nestled in Geneva. *Fabyan Park*

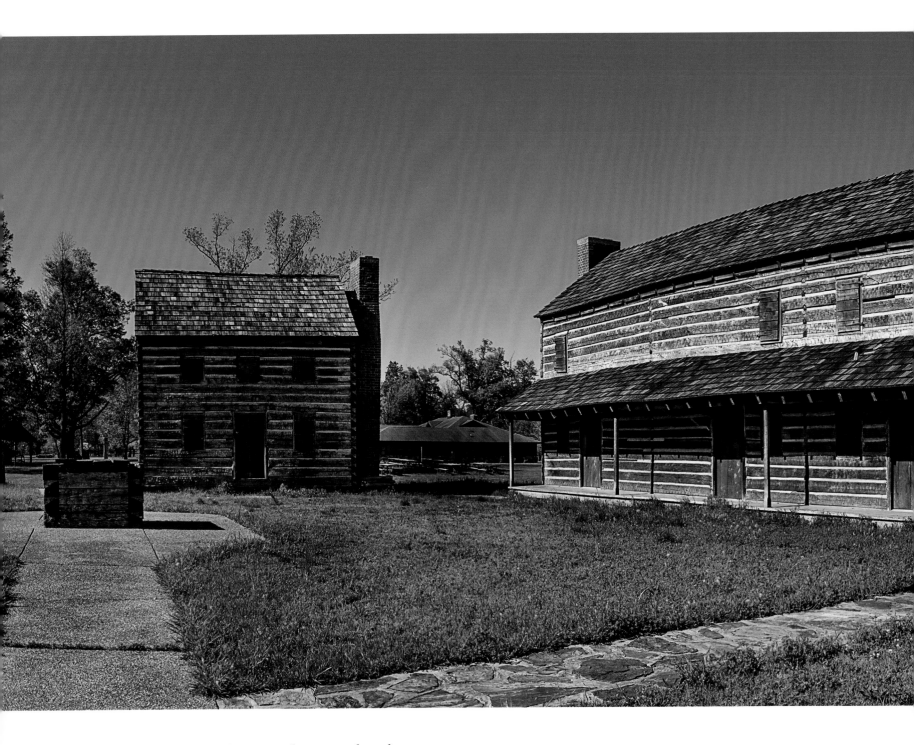

Fort Massac general quarters and guard towers.

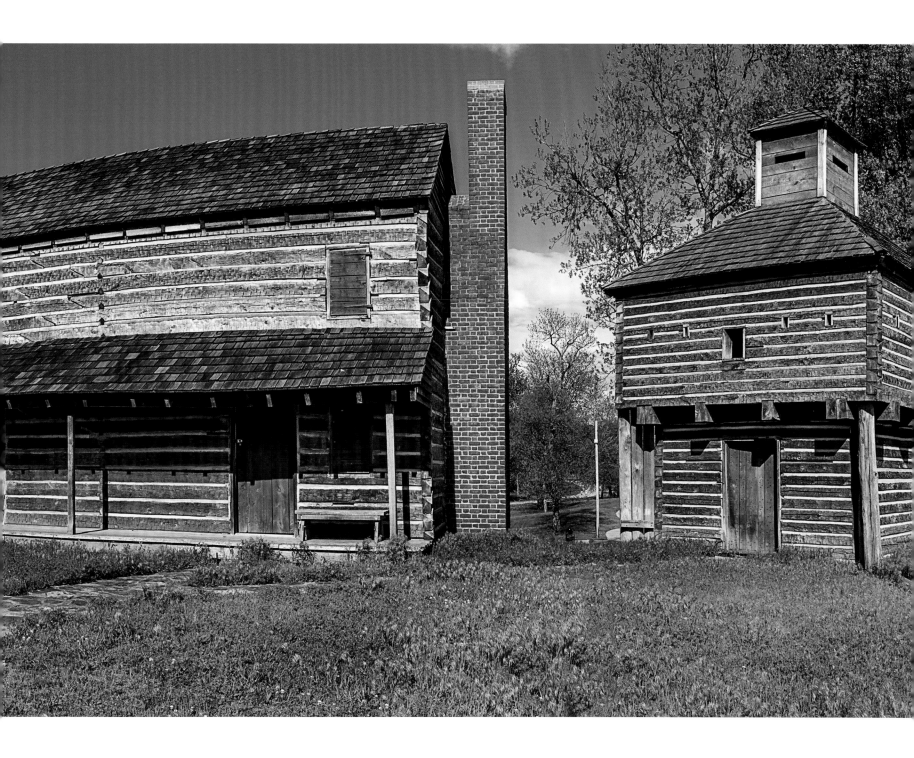

After the winter thaw. *Chain O' Lakes State Park*

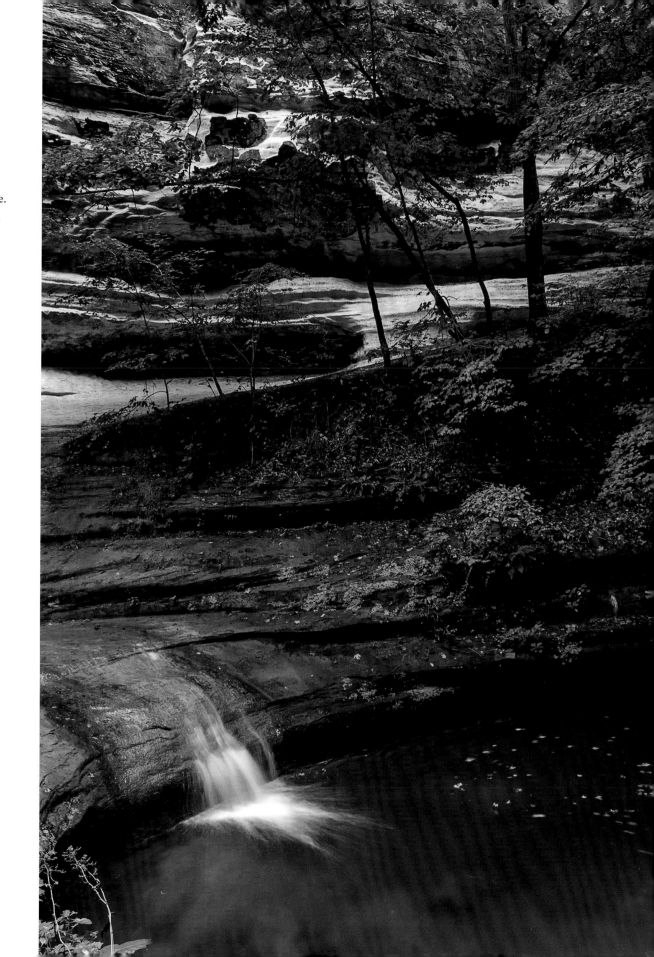

A gentle cascade.
LaSalle Canyon,
Starved Rock
State Park

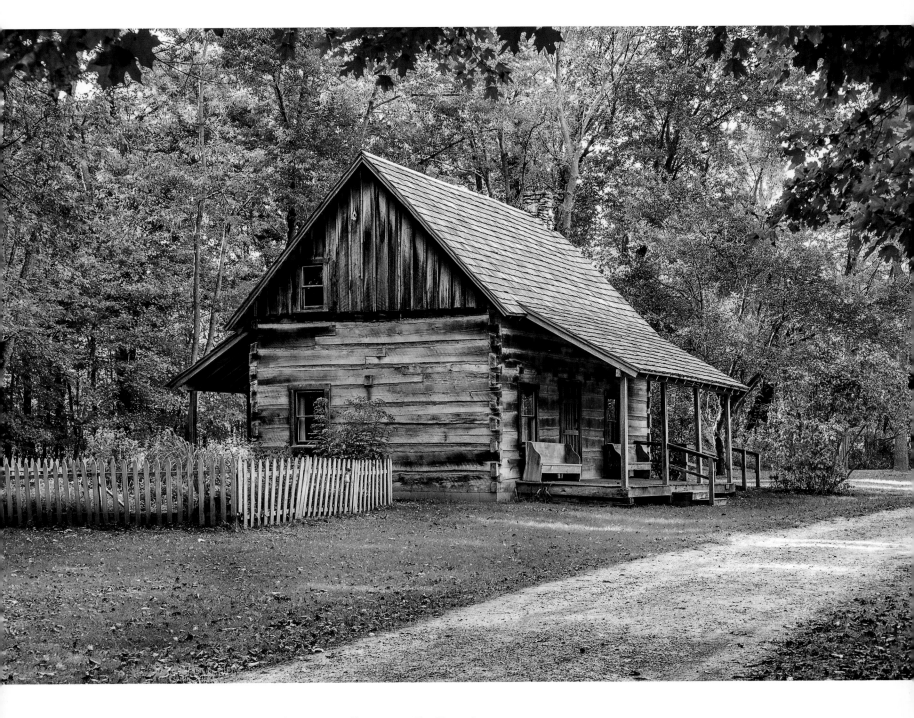

A replica cabin in the Pioneer Village. *Forest Glen Nature Preserve*

FACING A view from the top of the border wall. *Fort De Chartres State Historic Site*

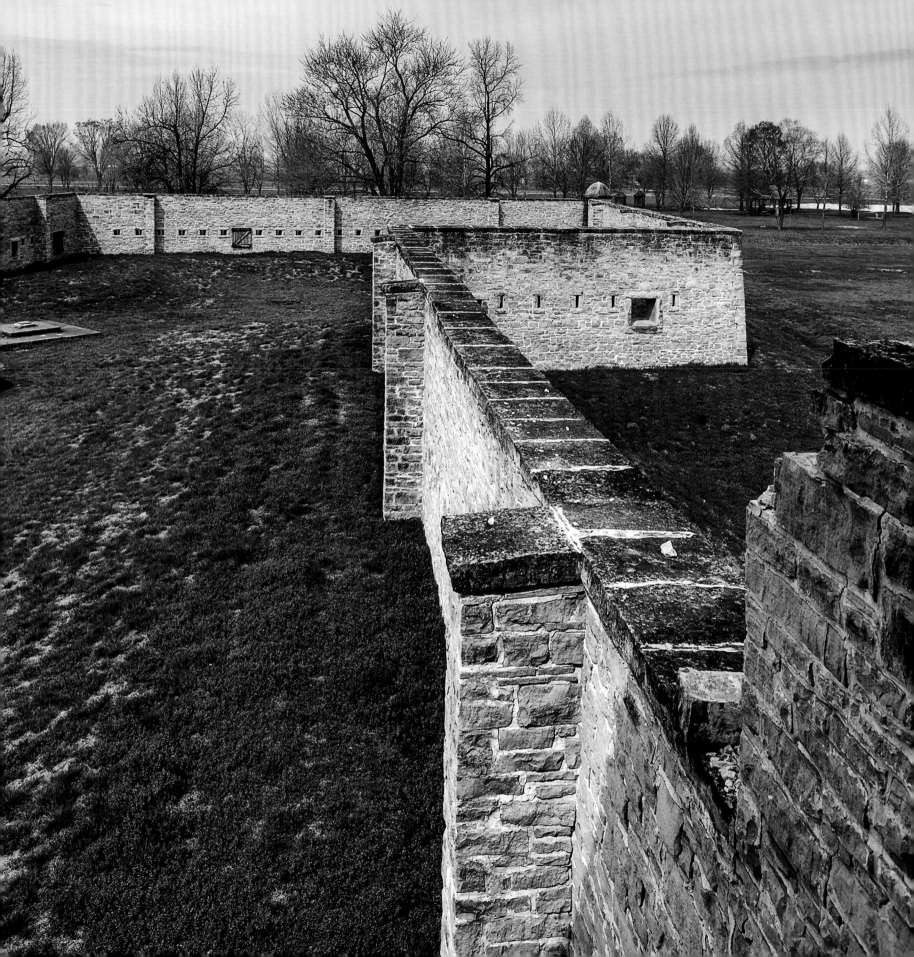

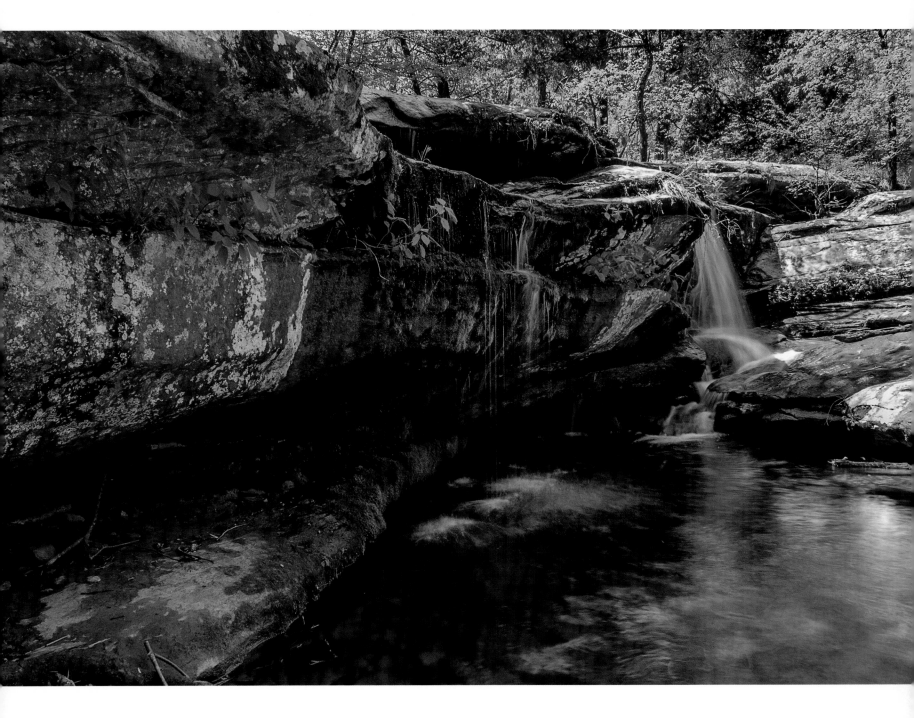

The Upper Falls at Burden Falls. *Shawnee National Forest*

FACING A barn in disrepair somewhere along the Cache River wilderness backroads.

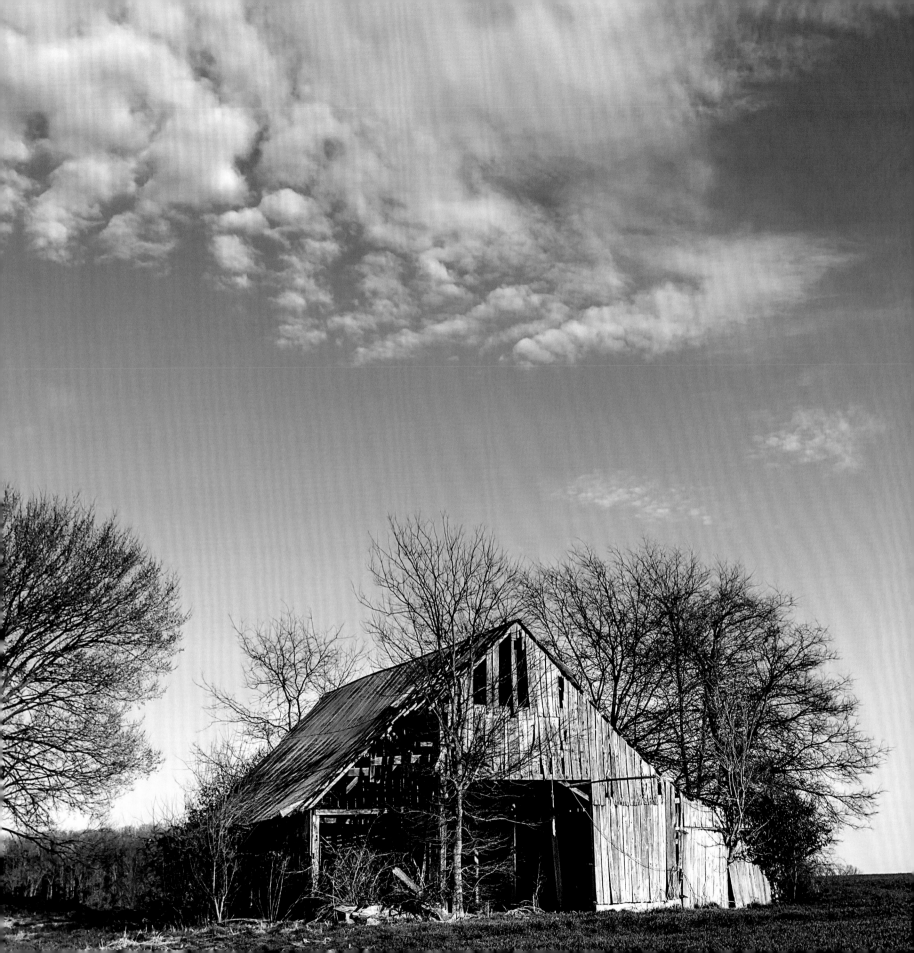

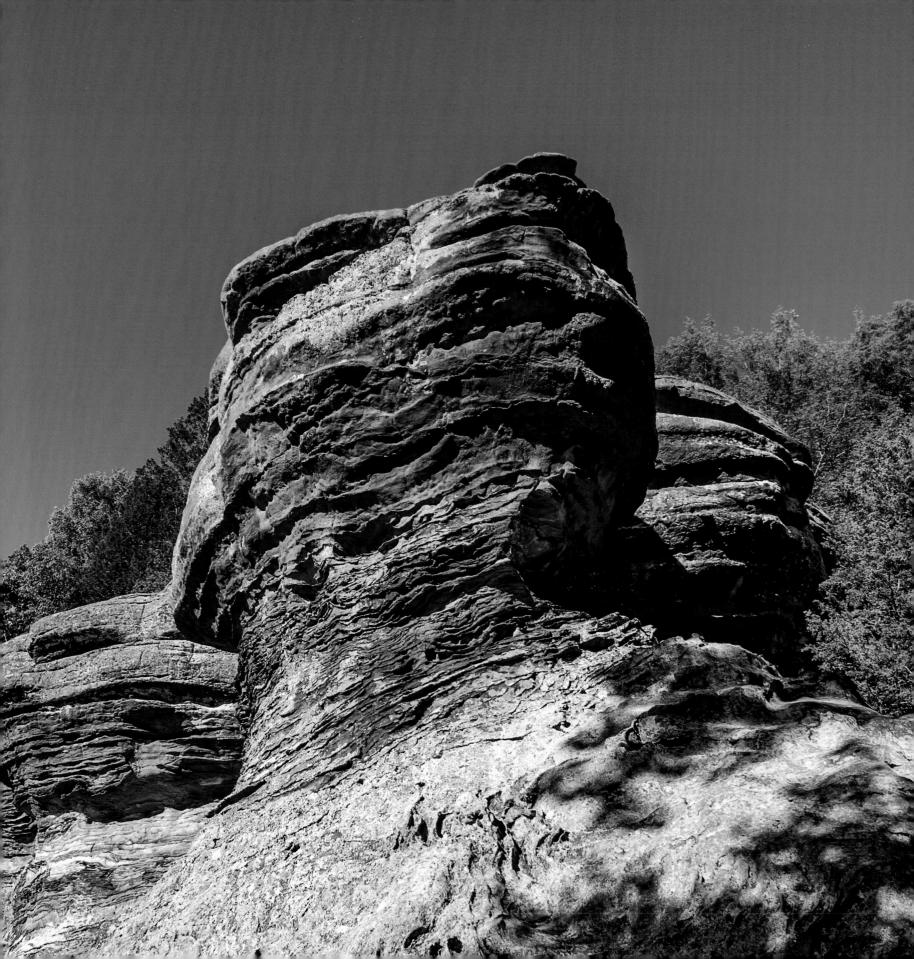

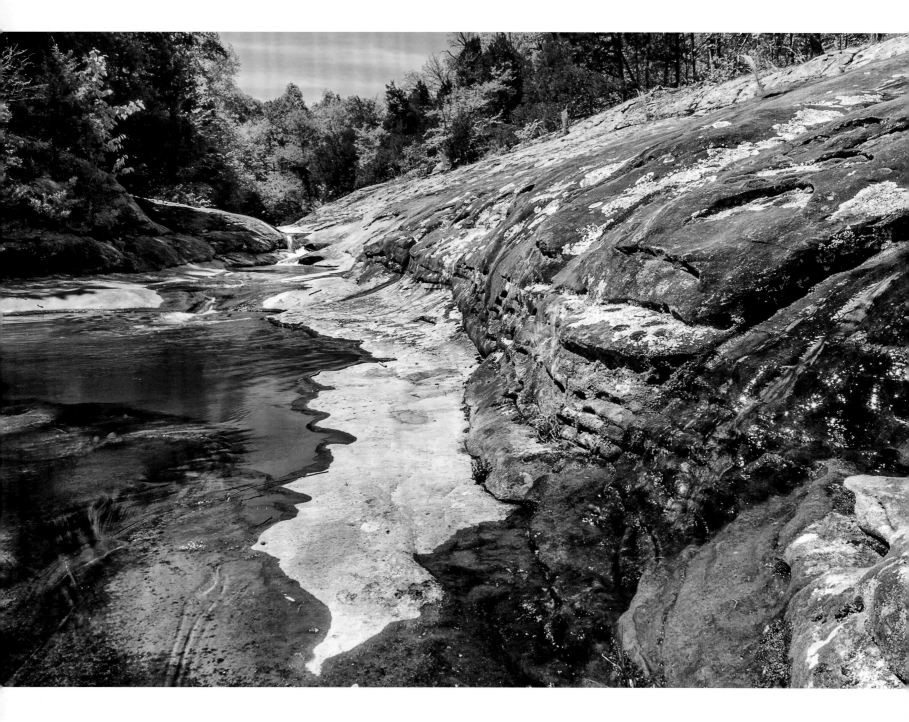

A scenic view along the Grist Mill Trail. *Bell Smith Springs*

FACING Standing tall. *Garden of the Gods*

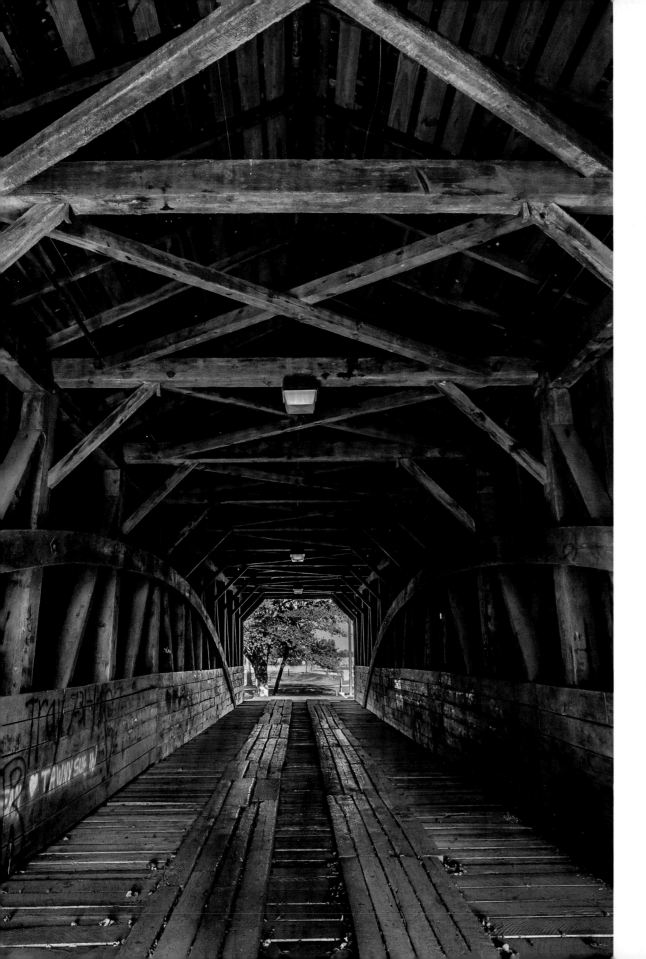

A throwback
to yesteryears.
*Henderson
Recreation Area
Covered Bridge*

FACING
The Waukegan
Harbor
Lighthouse has
kept boaters safe
for many years.

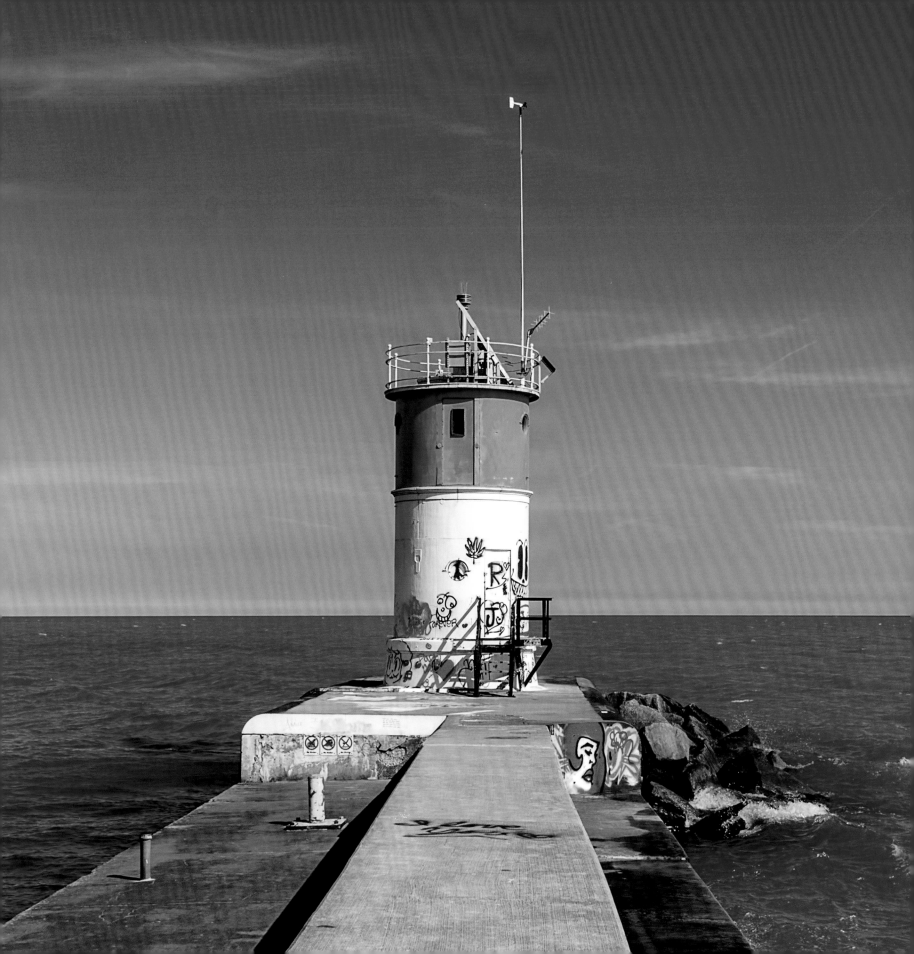

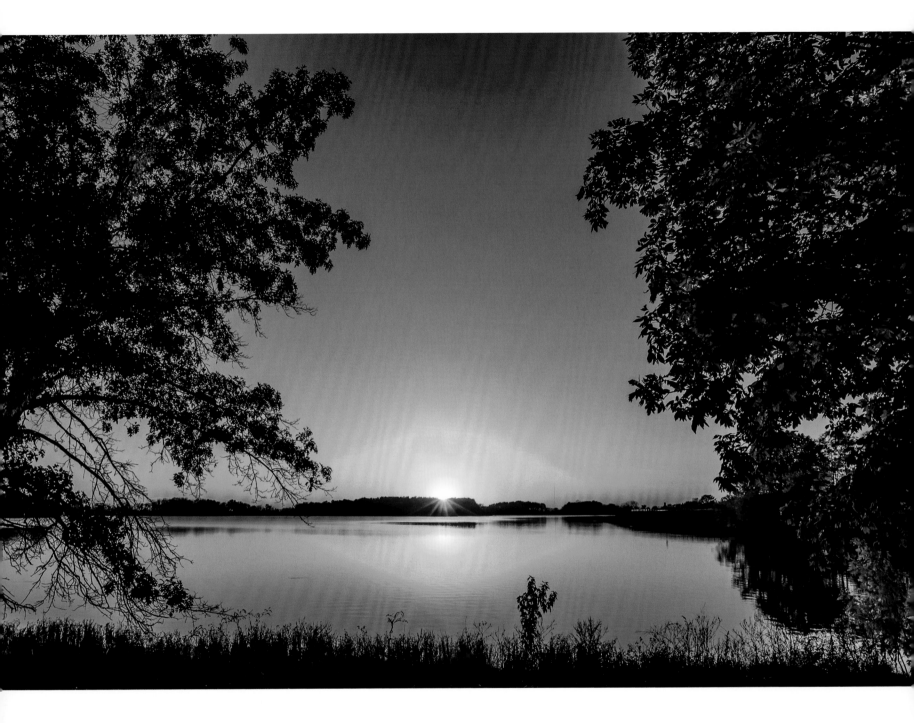

A perfect sunset on Sangchris Lake.

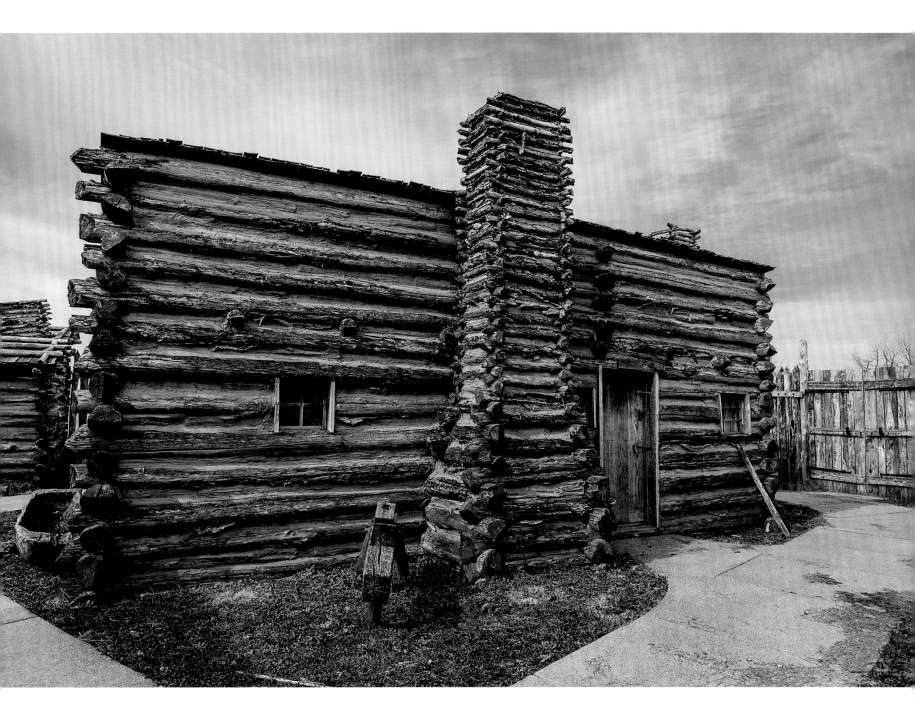

Lewis and Clark State Historic Site.

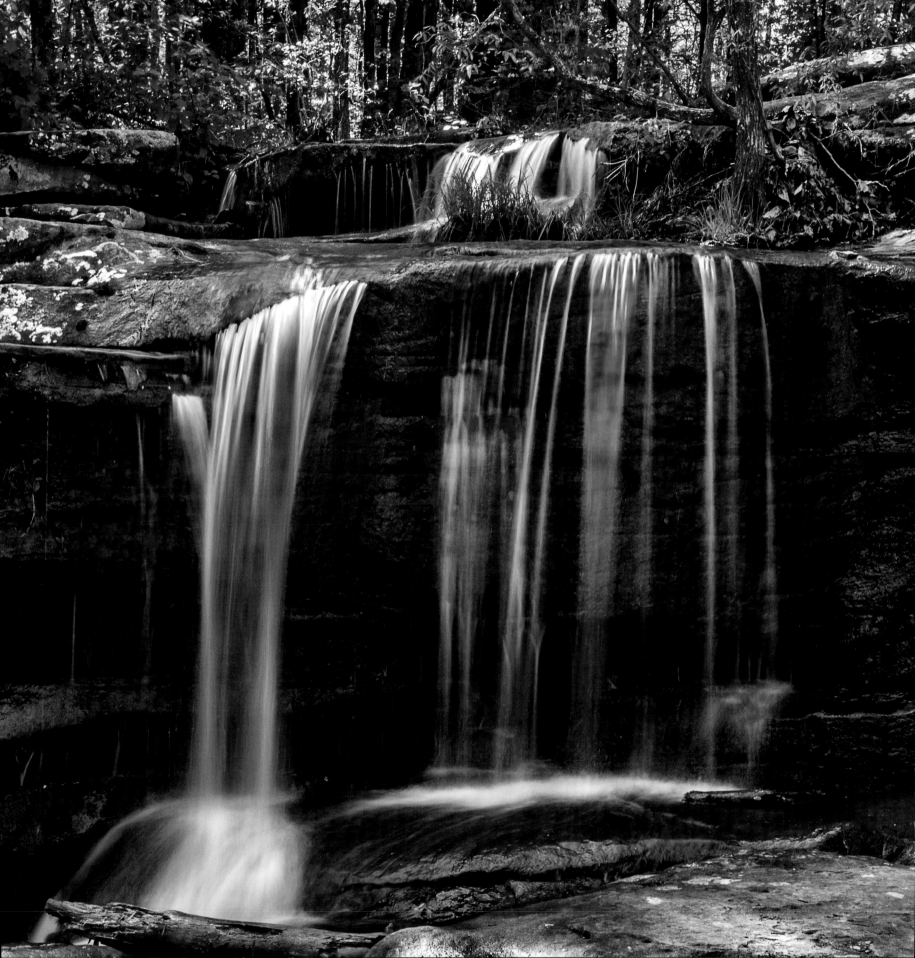

A very tight
squeeze.
*Garden of the
Gods*

FACING
A smaller
version of
Burden Falls,
the upper
falls is just as
picturesque.

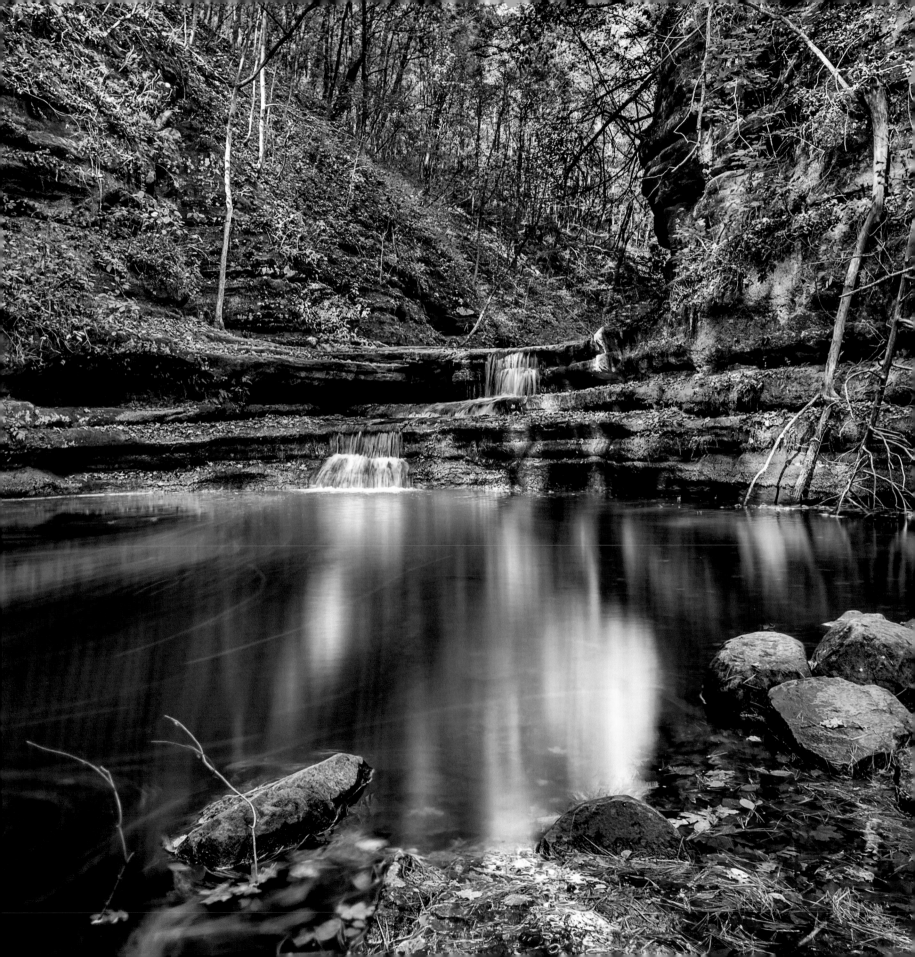

Water plummets 100 feet to give us Ferne Clyffe Waterfall.

FACING

The Giant's Bathtub. *Matthiessen State Park*

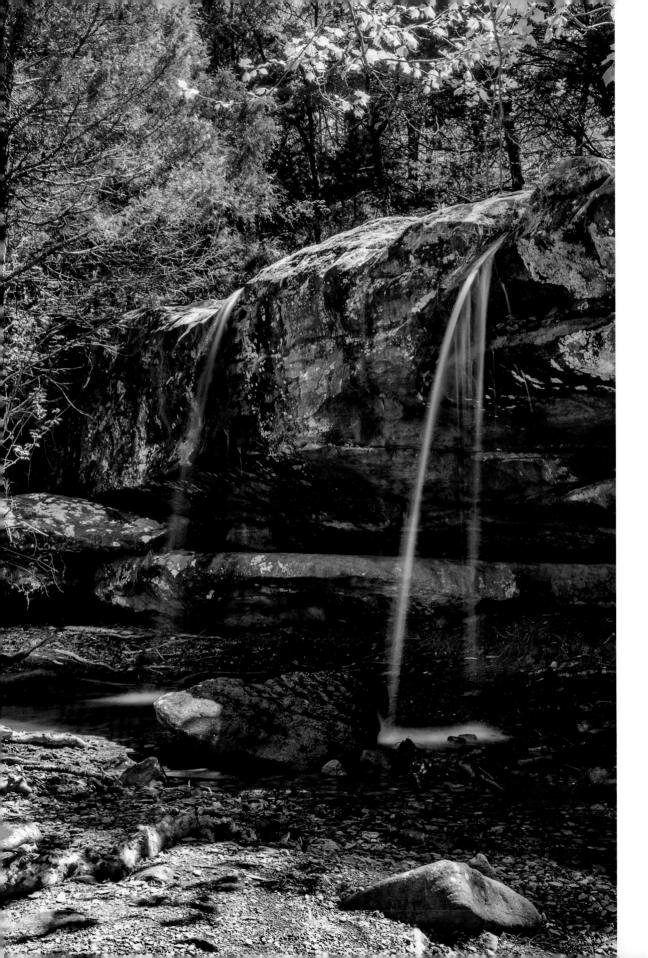

An area along
the Upper Falls
at Burden Falls.
*Shawnee National
Forest*

FACING
Cypress trees
cast a mirror-
like reflection.
*Cache River State
Natural Area*

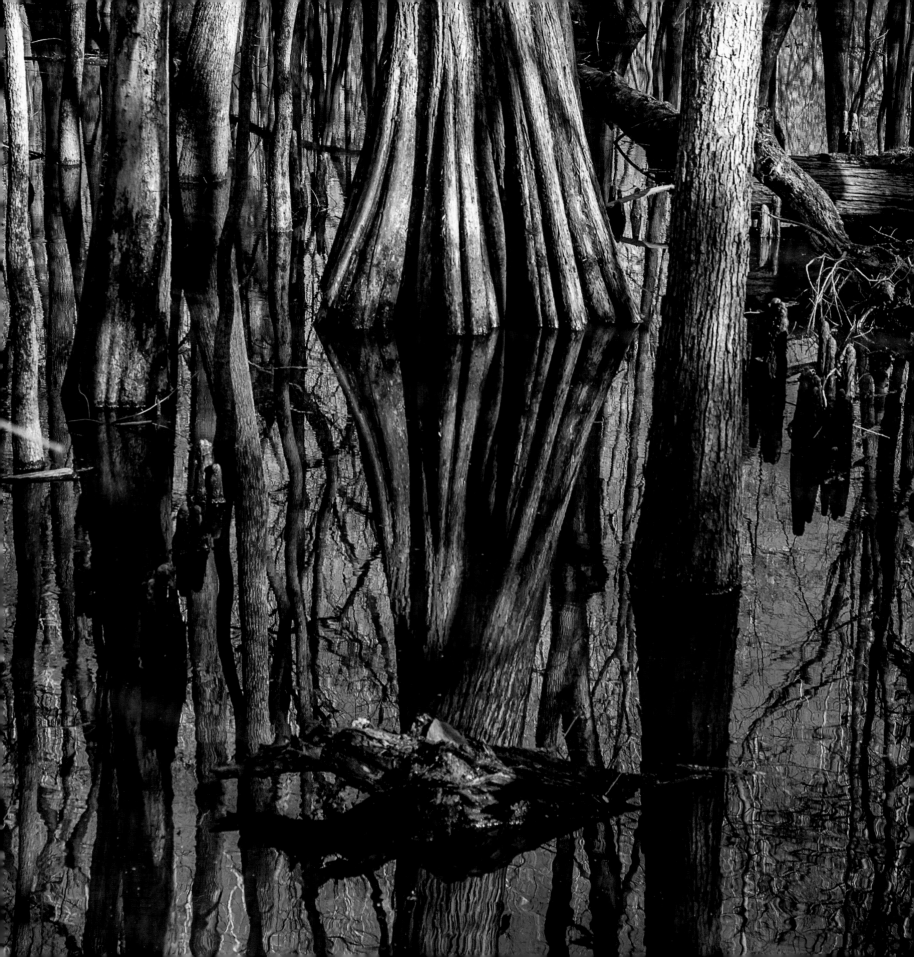

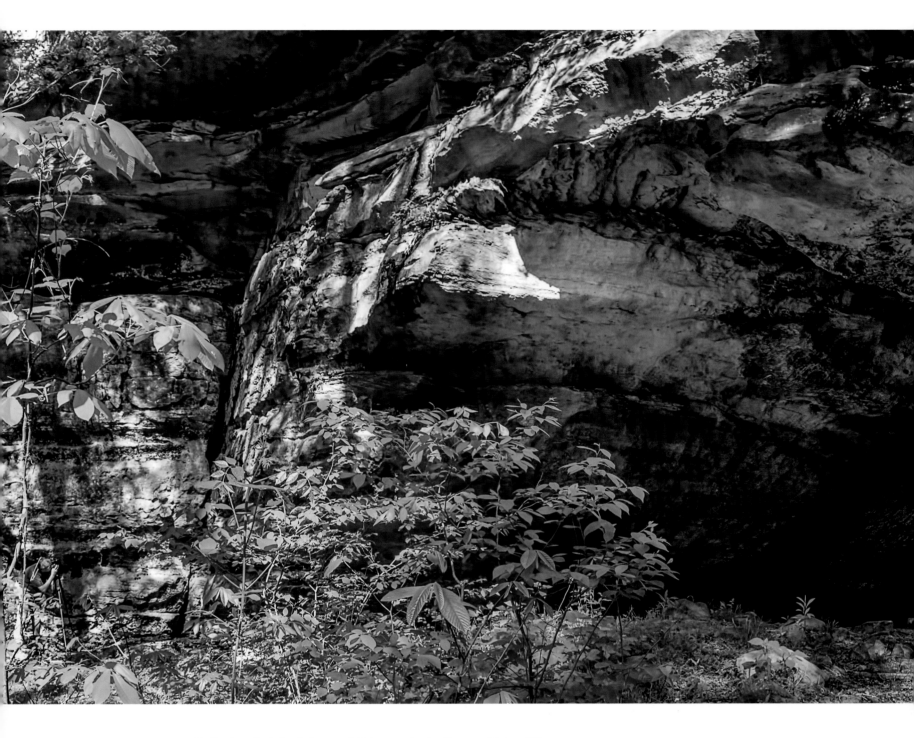

Difficult to find, Sand Cave is a hidden gem in the Shawnee National Forest.

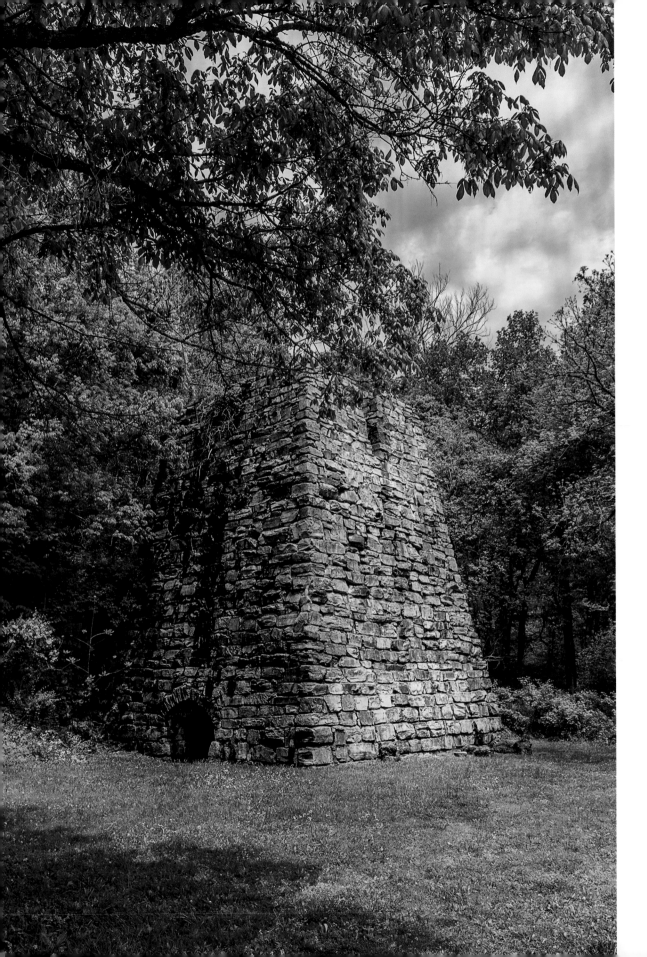

The historic
Iron Furnace.
*Shawnee
National
Forest*

FACING
Kinkaid Lake
Spillway.
*Shawnee
National
Forest*

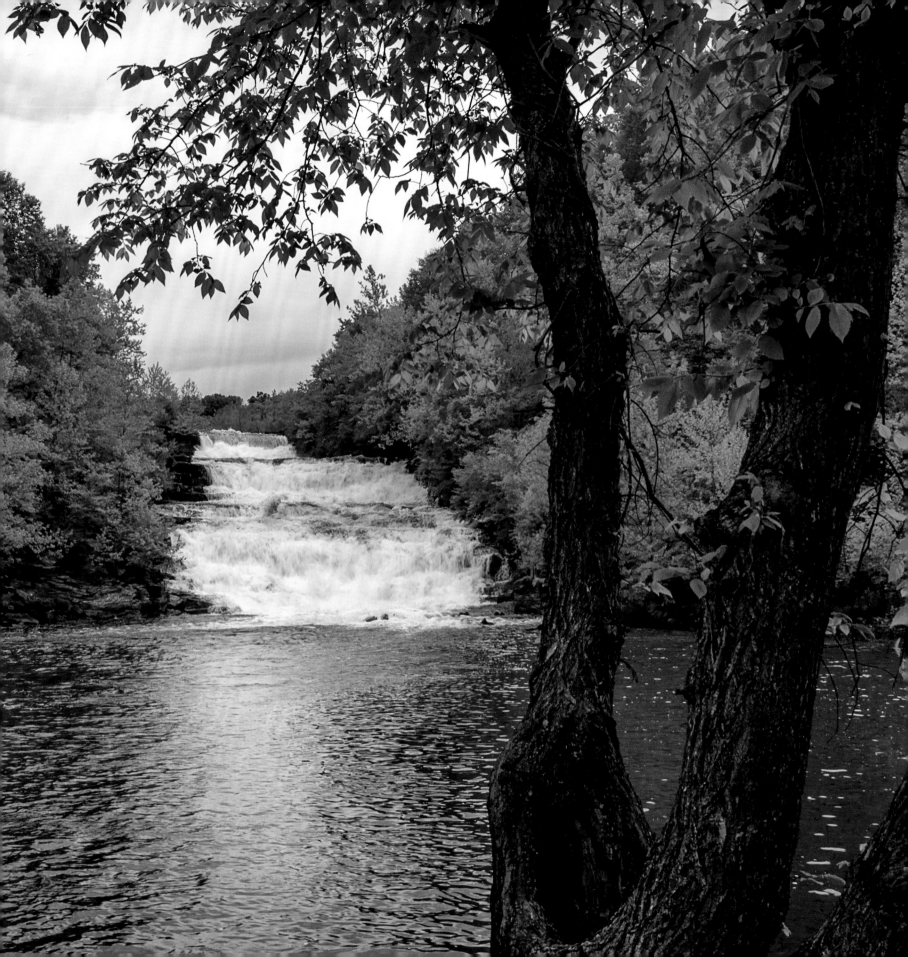

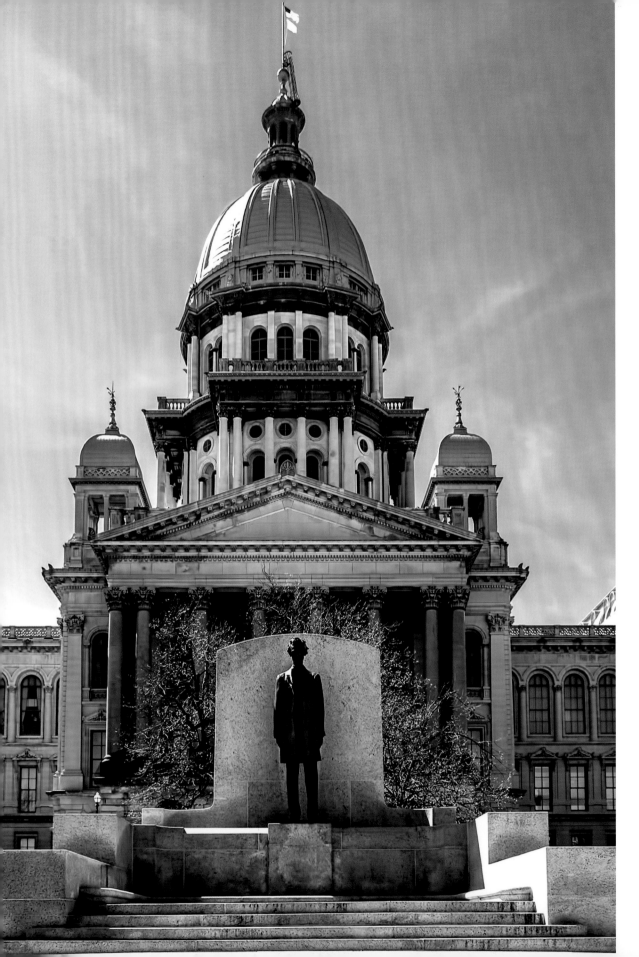

A statue of President Lincoln stands watch at the Illinois State Capitol Building.

FACING
Lincoln's original burial location, Lincoln Tomb State Historic Site.

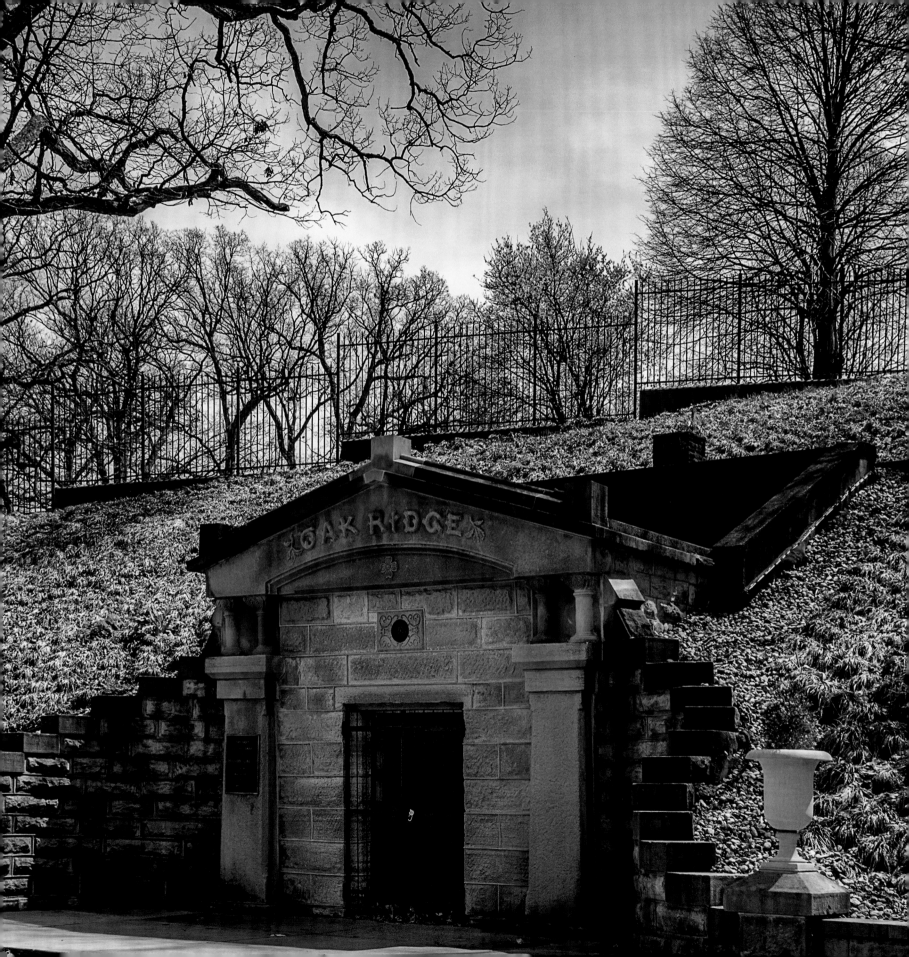

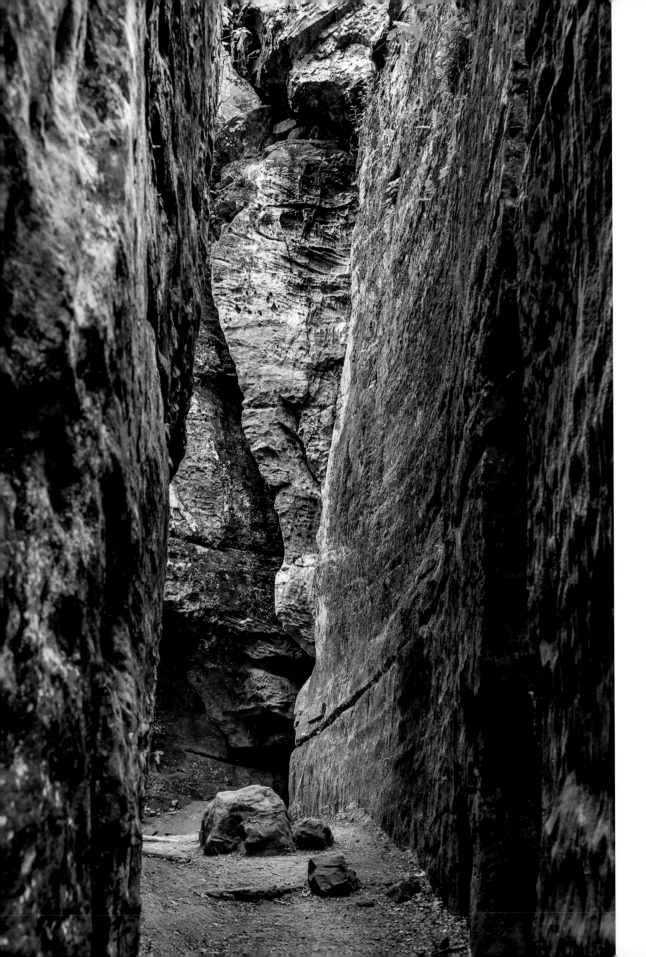

City streets are but
one of the unique
features in Giant
City State Park.

A rushing cascade.
Dixon Springs
State Park

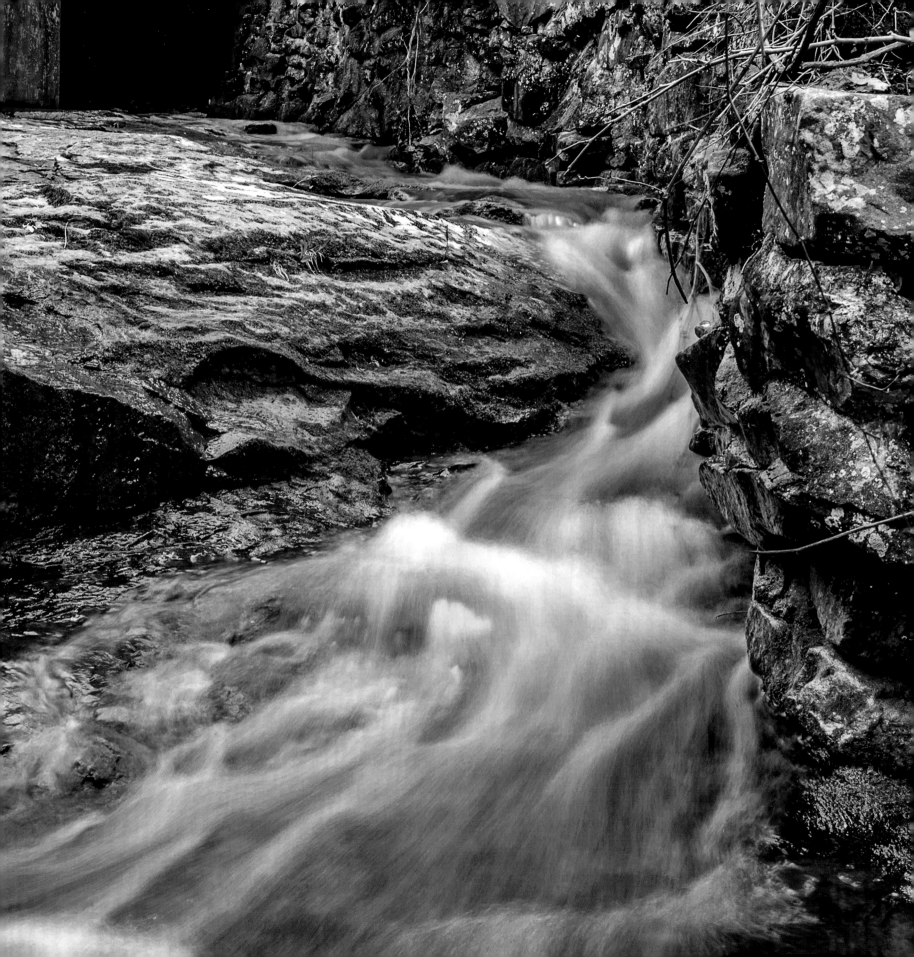

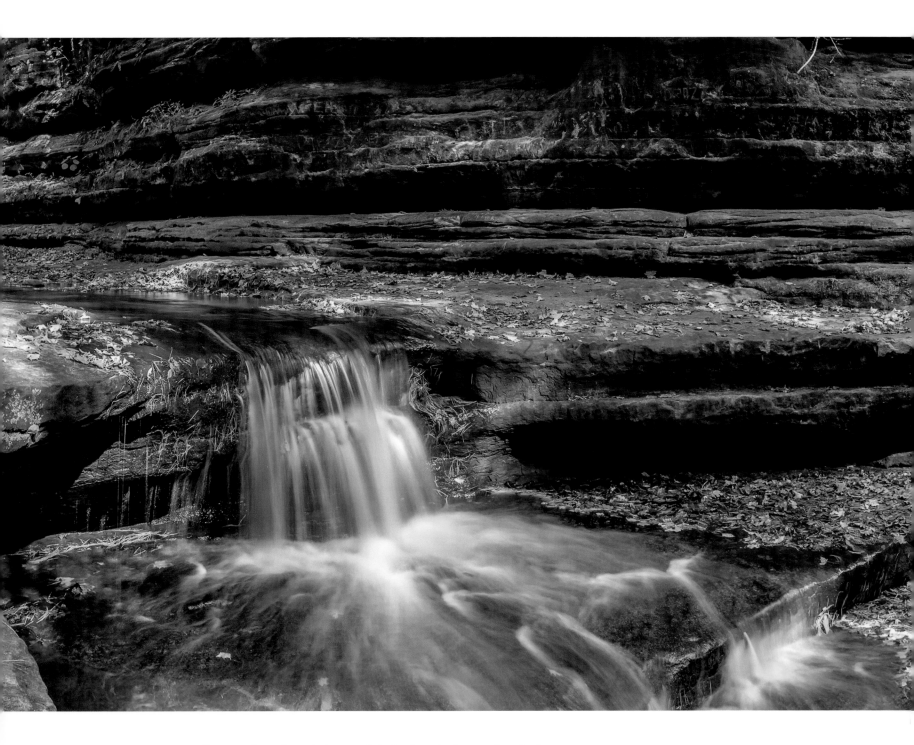

Silky water flows through the Giant's Bathtub at Matthiessen State Park.

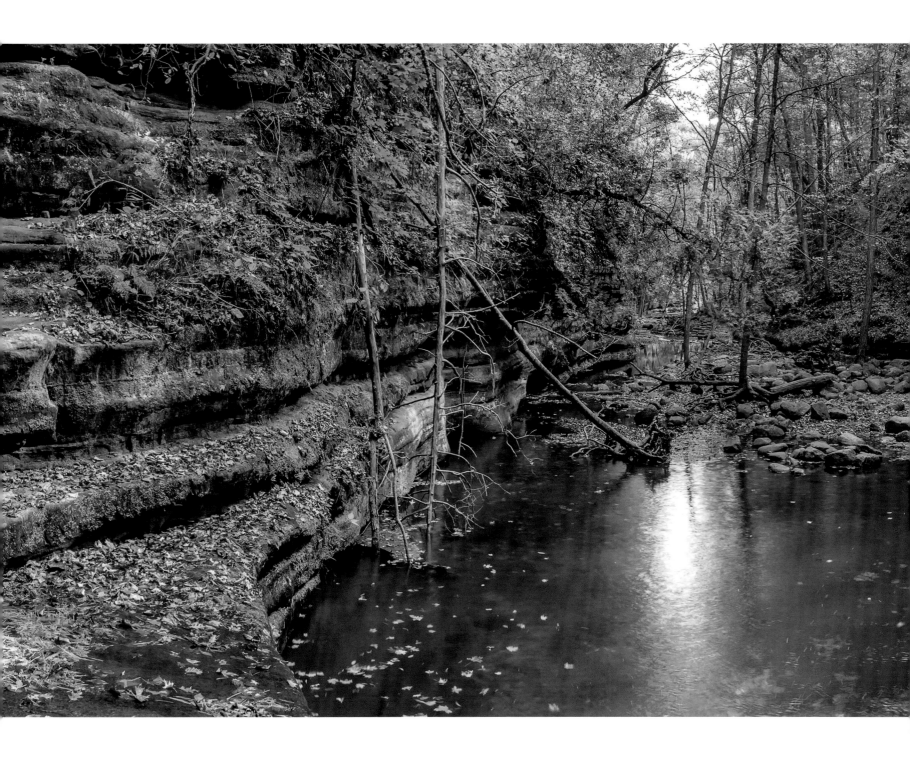

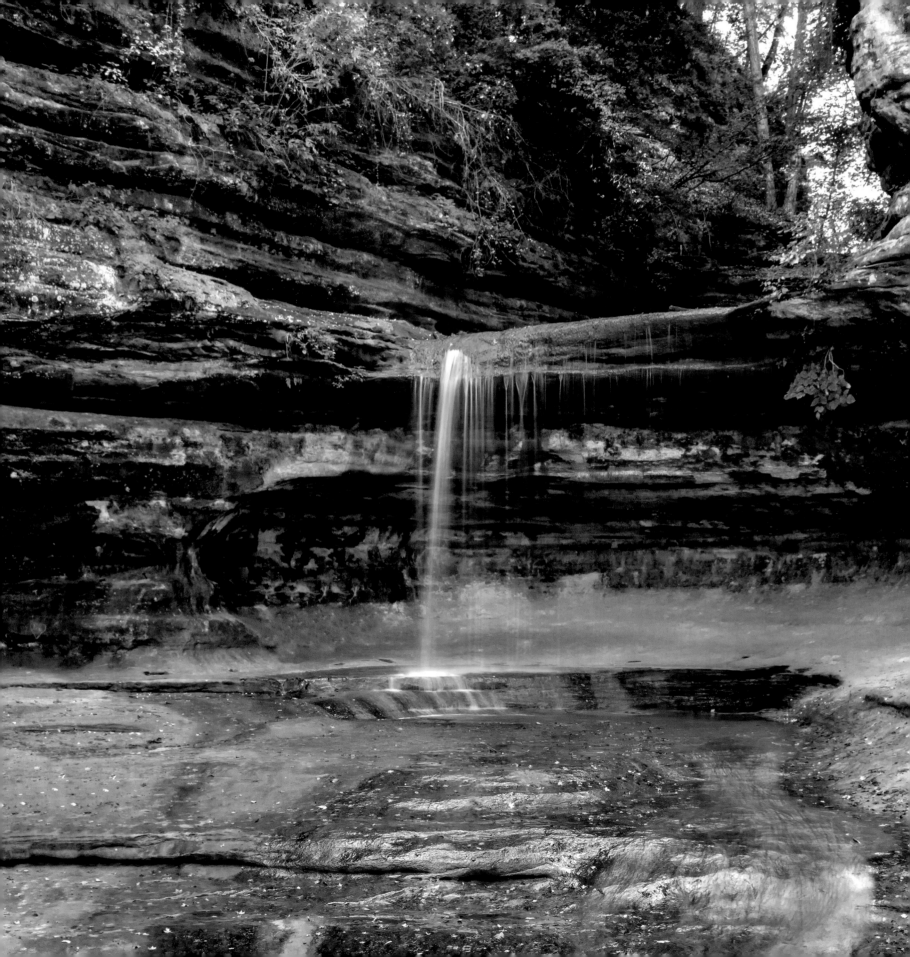

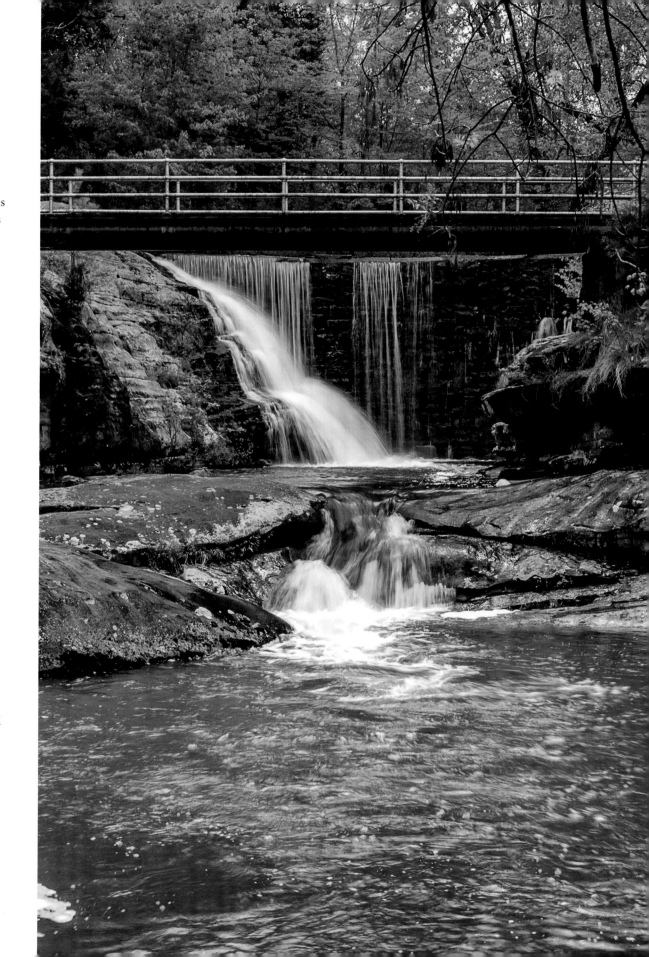

The dam and falls
at Dixon Springs
State Park.

FACING
LaSalle Canyon,
ever beautiful,
even in black and
white. *Starved
Rock State Park*

An intense sunset upon the shores of Carlyle Lake.

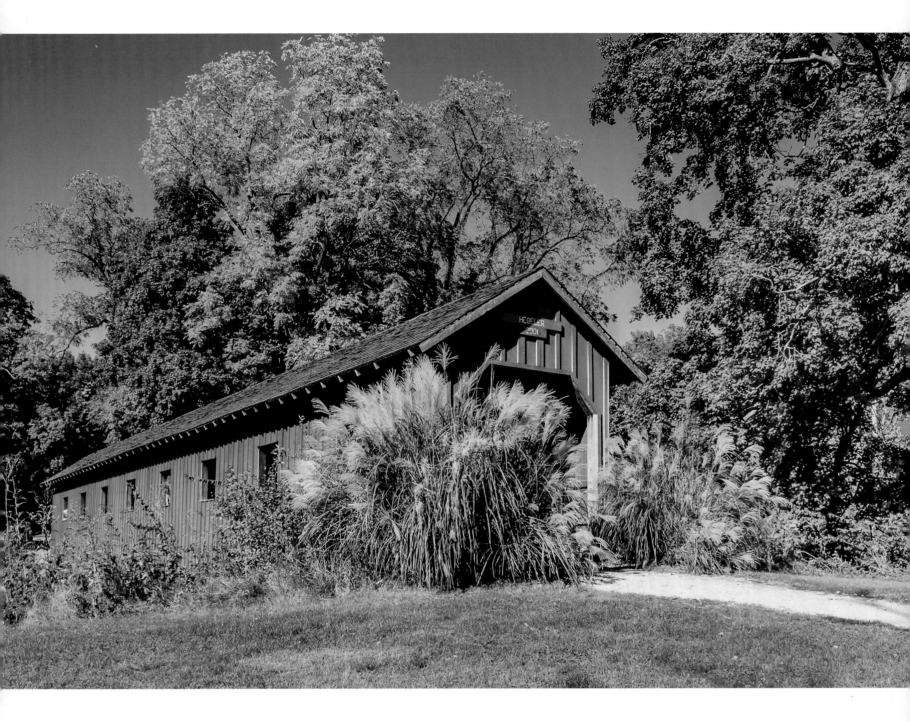

The Forest Glen Nature Preserve Covered Bridge is for foot traffic only.

FACING An interesting old barn always grabs a photographer's attention.

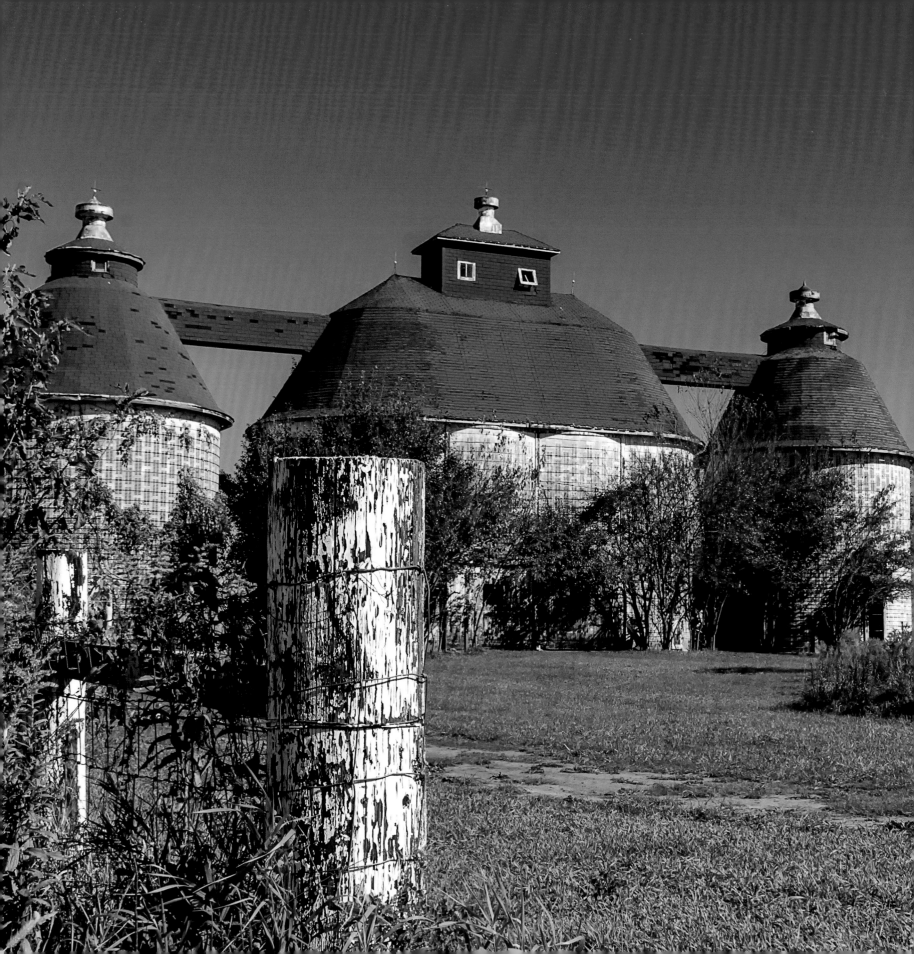

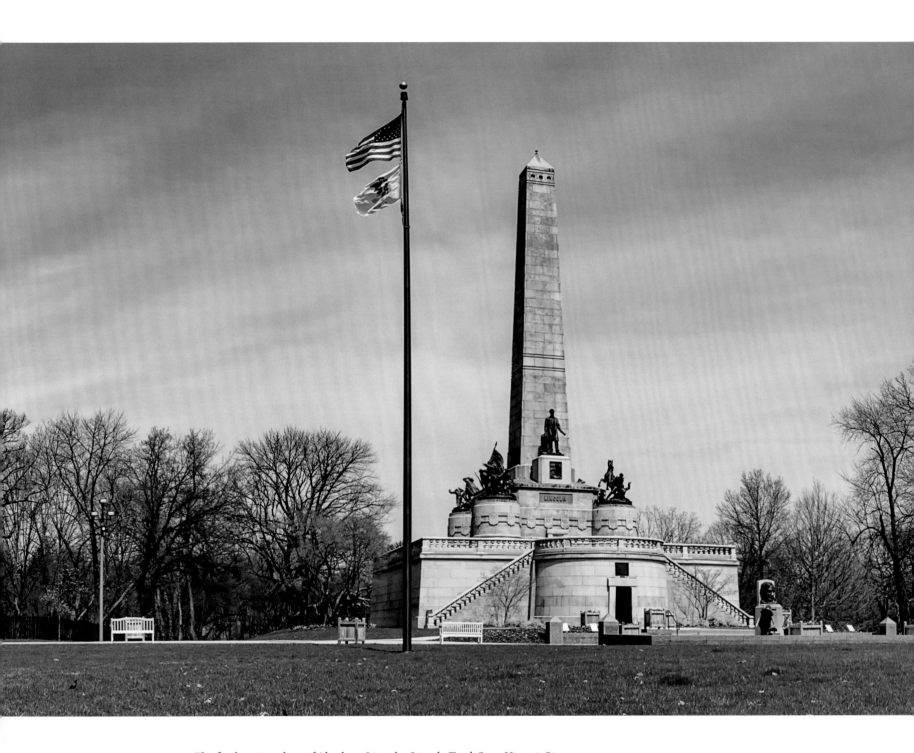

The final resting place of Abraham Lincoln. *Lincoln Tomb State Historic Site*

PHOTOGRA

One of the things I love about photography is the freedom it lends to create a composition the way I like it. That's the foundation for each image—the foundation that you will build on as your images go through the creative process. It's what sets your image apart from images made in the same location by others.

For me, nature and landscape photography resonate with the spirit of who I am. Traveling to see new places, being out in nature, and expressing my creative side all seem to come together with this art. There is something exciting about planning a trip to a place you have never been. It's an adventure! Once you have arrived at a destination, there's the anticipation of hiking along a trail and wondering what photographic gems are waiting. We usually have a goal in mind, whether it is a waterfall, ancient rock formations, or a cave, but the real adventure starts as soon as you head out on the trail. Some days it takes hours to get to the goal because there is so much to shoot. Around every corner is some little treasure just begging to be photographed. Then there is the hike back. Walking back on the trail presents all new compositions and lighting conditions. It can be like you are on a completely different trail. Other days, the prize shot is at the end of the trail, and that's all you get.

While out hiking and shooting, it's easy to walk up and take the main shot. You know, the one that most people see and take. There is nothing wrong with that, and sometimes it really is the best one. But, I try to take a moment and connect to the environment I am in. I like to slow down for a moment, take in a few deep breaths, and just be there, in the moment. This helps me let go of all the everyday concerns and appreciate where I am. It also makes me aware

PHY TALK

of things around me that I may not have noticed at first. Once I do this, I start to hear birds, water, a breeze, and lots of other sounds that I didn't notice before I intentionally connected to the environment. And I notice other things. It might be a different angle at which I can shoot the subject. Maybe a higher vantage point, maybe from a completely different spot, maybe lower to the ground where I can include some water reflections. I might notice that the light looks different from one place to another. Maybe the subject can be a little less significant in the scene and not take up the whole frame. There are so many ways to shoot one subject, and that is the foundation for your image in photography.

Once I shoot what I would consider the "main scene," I start looking for a slightly smaller composition. This would be a subject within the subject. For example, if the subject was a waterfall, I might look for a smaller section of the waterfall where the water looks interesting the way it falls over some rocks, or the way the water hits the pool at the very bottom of the waterfall and creates a rainbow. Maybe it's a tree next to the falls that managed to grow out of the rocky terrain. Once I have found all of those shots, I'll look for even smaller compositions. Then maybe micro-compositions. Then, finally, I will look for completely different subjects, like birds, creeks, wildflowers, and small wildlife. All these compositions put together a story of the place I just visited. I hope these stories will be seen for years to come.

Traveling and taking photos of our journeys with my husband is a dream come true. We go everywhere together. In the beginning, we thought we might have to make an effort to shoot different things. But, as it turns out, we don't have to try—we just do. One thing that Lee and

I have noticed is that when we sit down to go through our images at the end of the day, we are surprised at how we each came back with very different compositions from the same place. As people and artists, we see things differently. That is what makes each image unique to the photographer.

We sincerely hope that as you look through the images in this book, you will be inspired to visit Illinois and its beautiful and interesting places. Whether you are interested in history, hiking, or just traveling and sightseeing, Illinois has a lot to offer.

DeeDee

There are a different set of pressures in taking on a book or photo project such as this one, at least from a photographer's point of view. It is not an option for us to come away with no shots, regardless of the location, weather, lack of features, or even our own personal feelings about a given area. Each location has its own unique characteristics, challenges, and rewards. The shots are there, and we as photographers have to find them, even if we have to dig for them. Some areas are flat and might appear dull and boring at first glance. Some areas may only have one key feature—and that's if you're lucky. Some areas might not be as well kept-up as other areas. But no matter how any given location might first appear, you can always find something to take a photo of *if* you look for it, or rather I should say *when* you look for it. When I run into a situation where at first glance I feel like there might not be any decent photos to be taken, I get the camera out and start clicking anyway, even though I know I won't use some of the shots. I notice that very quickly things start to look a little different through the viewfinder. It usually doesn't take too long to get in the groove and come up with something likable. Before you know it, you'll have more shots than you thought, even if they are not exactly what you had in mind when you arrived. I have actually came away from this very situation with shots that have surprised me and honestly turned out to be some of my best work. I simply wasn't expecting the results I got. Experience has taught me to never judge a place based on what I think it should look like or my own personal preferences, but rather just get my camera out and start capturing photos. It works every time without fail.

Weather is another factor. Many photographers who shoot for magazines or books, whether about travel or lifestyle or what have you, are on a deadline of some sort, and there simply is no control over the weather, even if the deadline is looming. The weather is not concerned with our photography schedules. It is painfully true that landscape photographers are at the mercy of Mother Nature, for good or ill. When we aren't able to get a scene or season we want, we simply have to find the next best solution or a workaround for it. This might mean really stretching yourself to get an image that will at least convey to the viewer what season it is, even if it's not the exact weather conditions you had in mind. You do the best you can

with what you are given; you take your best shot, you learn from it, and you move on. I also find that days of inclement weather, cloudy days, slightly rainy, fog, heavy clouds and so forth can make for better, more interesting photos than what is commonly viewed as ideal photo conditions. Many people believe you should stay in on these types of days and not go out and take pictures. It comes down to being open enough to shooting under any conditions and shooting anything, even if it's not what you originally wanted to shoot. You simply have to be adaptable if you want to be successful with your photography. This goes for adapting to the weather as well as all the various photo situations you encounter.

Planning each trip is also key in making the most out of your travels. Google is definitely your friend here and almost always my first stop. Research each location you want to visit thoroughly. I find most websites are a bit inconsistent with one another, so I visit several, then average my findings. We always like to know when and where the sun and moon will rise and set. This is particularly helpful for magic and blue hour photos—that's an hour before and after the sun rises and sets for the day. The lighting during these times allows for near perfectly lit photos, hence the term "magic hour." Next, are there any good features available to place against a galaxy shot? Are there any waterfalls, historical landmarks, or anything unusual that might be of interest? Sometimes talking to locals can get you to a place that the world at large is unaware of outside of a small, confined area. These are hidden gems and usually don't disappoint. You can also look to see what others have done and decide if you should visit a place or pass on it. I find simple tourist shots that have been posted to the web to be the most helpful in my general understanding of what really is at a given area I'm unfamiliar with. Many of them give you an overall idea of what's there and what you will be presented with. This will also allow you to formulate a strategy for taking the best possible photos before you even get to the site.

Books of other interests can also be of great assistance to photographers. I'm not talking about photography books in this case, but rather books on other subjects such as hiking, camping, oddities, biking, jogging, off the beaten path, and so on. I find a wealth of information in these types of books that aid in helping me decide whether I should visit a location.

Hiking books in particular go into a good deal of detail about directions, trail lengths and difficulty, travel time, and specific or unusual features along the way. I often find them invaluable. Another thing to do is hop on the internet and request a free vacation or visitors' guide to wherever you are thinking about going. These are great for getting an idea of where to eat, where to sleep, local prices, and the areas that have the most interest and visitors. You can then look deeper into these areas and come up with a plan. Many tourist centers and state or area travel sites will also send you free maps. These are good to have in a pinch. We tend to stop at rest areas and browse the available literature. We respect that state agencies, recreation, and entertainment venues publish these for free to travelers, so we only take what is of interest to us. Today's technology allows us to see a place, make a plan, and get the most out of our time, photography, and visit all before ever leaving the comforts of home. It's a great time to be a photographer.

Lee

INDEX

FACING "Lest We Forget": Sun dial dedication at the State Capital in Springfield.

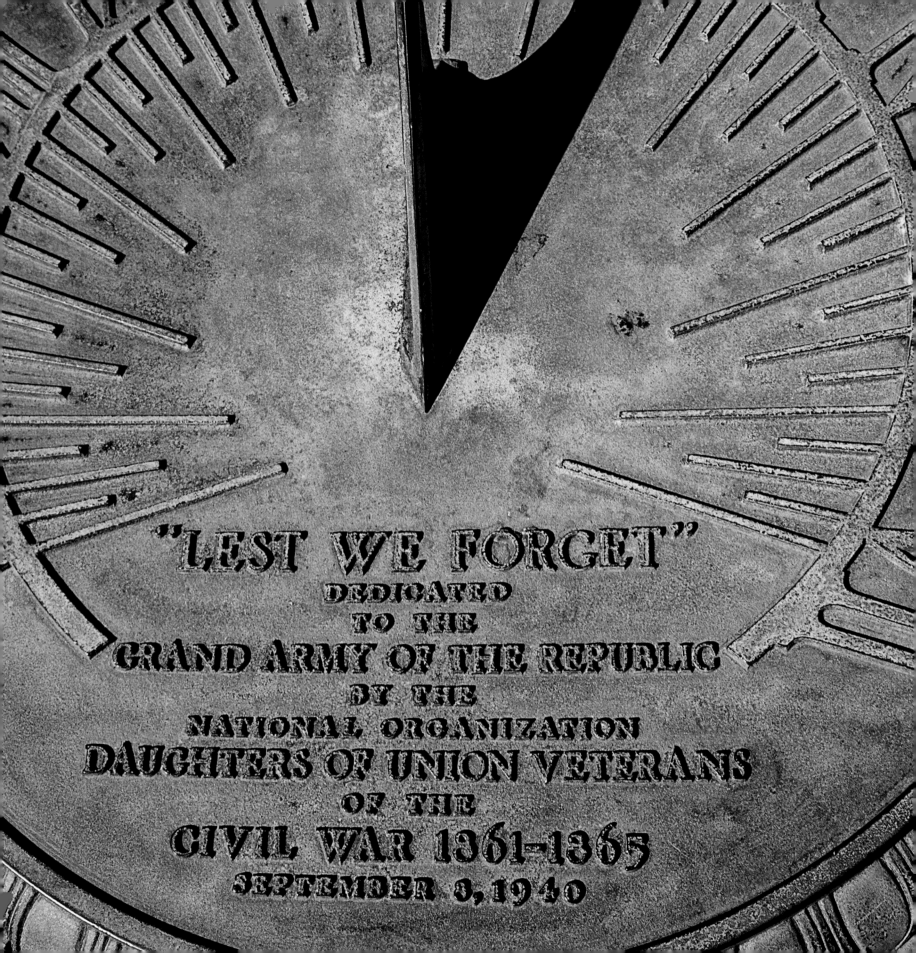

Not all photos require travel. *Authors' home in Indianapolis*